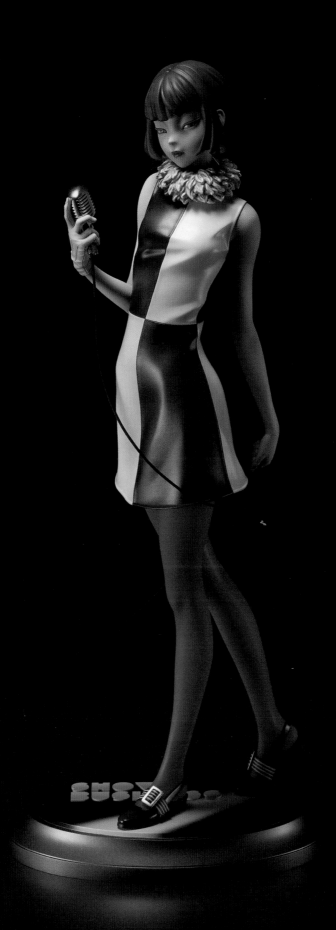

YOSHIKI FUJIMOTO

ART
WORKS

BLINK

藤本圭紀
原創
人物模型
作品集

ORIGINAL FIGURE WORKS

前言

這是2012年，在我還擔任「豆魚雷」這家角色商品店的店長時的故事。有一天，一位年輕人出現在店前，以謙遜的口吻說：「這是我做的，可以請你幫我看看嗎……？」然後，他小心翼翼地從皺巴巴的紙袋中拿出一團白色黏土，好像在確認我的反應一樣。

我仔細一看，那是一個尚未完成的異形人物模型。似乎他是在某處看到我之前提到過我是異形的狂熱粉絲，因此前來尋求我對作品的感想。

作品的完成度是一半多一點點的狀態。然而，一眼看去，就讓我屏住呼吸，因為這件作品的外形輪廓不同尋常。雖然還未完成，但特別是身體比例的平衡，還有腰部的部分，比之前發售的任何一件異形模型都更正確、更美麗。而且也看得出來他對黏土進行反覆堆塑、切削修改的堅持。

這就是我與藤本圭紀的初次相遇。

他告訴我，他是一個在人物模型原型製作公司工作的造形師，之前幾乎沒有什麼由自己掛名的作品。我感嘆著世界上還是有一些不為人知，但令人驚嘆的人物，由衷地稱讚「你這件作品真了不起」時，他縮成一團，高興地表示：「哎呀，真不好意思……謝謝你！」。

當年他被稱讚時的那副謙遜模樣，十年過去了仍然沒有改變。

後來我離開了店長的職位，轉為負責企劃和開發人物模型等工作。而藤本則成為自由創作者，除了繼續從事商業原型師的工作之外，同時也正式投入造形創作者的活動。

藤本對於追求細緻製作的態度與我很合得來，因此我們在多個產品企劃中有了合作關係。特別是為了完成"終極的異形‧雕像作品"這件作品，我們一同旅行到瑞士和德國進行資料收集，這是一生難忘的回憶。

然而，異形只是藤本擅長的創作元素之一而已。相信在各位讀者之中，可能會有人想著：「原來藤本圭紀也有製作異形……？」吧。提到藤本圭紀的作品，應該是身材豐滿的女子或是惹人憐愛的女孩才對。又或者，藤本圭紀的作品不是超人力霸王嗎？不對，是假面騎士……。其實這一切都是正確答案，但同時又都不是那麼正確。畢竟，即使是在相對近的距離內一直關注著他的活動的我來說，這10年來，我對於他的"下一件作品"的題材，還是一直感到驚訝。萬萬沒想到他居然也會選擇這樣的題材！

翻開這本作品集的每一頁，呈現出來的都是一個不斷變化的不同世界。在無法預測的下一頁，相信你可能也會感受到與我相同的驚奇。這次作品集的付梓，我也充滿期待對於藤本的眾多新鮮且豐富的作品，能夠再次重新體會到那份驚奇。

原田隼

It was 2012, when I was the manager of a character shop called Mamegyrai. When the young man appeared at the store one day, he modestly said, "I'm in the middle of this build right now, can you take a look at it?" as he gingerly took a lump of white clay from a crumpled paper bag to see my reaction. When I saw it, it was a half-finished Alien figure. Somewhere along the line, he saw that I was an alien fanatic, and he came to ask me for my thoughts.

It was little over half done. But at first glance, the unusual silhouette took my breath away. Although unfinished, you can tell that its body balance and waistline, in particular, were so right and beautiful that no Alien figure released before this could beat it, and that he was particular about the heaping the clay over and over again.
That was my first encounter with Mr.Yoshiki Fujimoto.

When I asked about him, he told me that he is a sculptor who works for a company that produces figure's original molds, and that he has done very little work in which his name appears. "This is amazing," I told him. Impressed by the fact that there are extraordinary people in the world who don't even show up under the spotlights. He said "Thank you." and curled up and humbled by my remarks. The way he reacts when someone praises him for his work is still the same after 10 years.

After that, I left my job as store manager and was put in charge of planning and development of figurines and other products. Mr. Fujimoto became a freelancer, and while continuing to work as a commercial mold builder, he began his career as a sculptor in earnest.

Mr. Fujimoto's sensitive approach to manufacturing matches my style of work and got along well, and we will be working together on a number of products. Among other things, a trip from Switzerland to Germany by the two of us to collect materials in order to realize the "Ultimate Alien statue" will be a lifelong memory.

But Alien is a one of few elements Fujimoto excels at. Some of you may be thinking, "Yoshiki Fujimoto makes Alien?" Yoshiki Fujimoto is known for glamorous girls, or rather apretty one. Or, when it comes to Yoshiki Fujimoto, it's Ultraman, or Kamen Rider. All correct, but that's not everything. Even though I have watched his activities from a relatively close distance, I have been constantly amazed by his "next work" for 10 years, like "He really chose this for next project!?"

The world changes as you turn the pages of this collection. I hope the unpredictable next page will give you the same surprise I've had. I will be amazed and entertained by Mr. Fujimoto's many works that are original and resonant no matter how many times I see them.

Shun Harada

❶個展及作品集使用的LOGO商標
❷原田隼（左）和作者（右）在首次個展「LITTLE GARDEN」合影
❸❹個展會場的一景

❶Logo used in private exhibitions and anthology.
❷Mr. Harada (left) and the author (right)
 at their first solo exhibition "LITTLE GARDEN"
❸❹Scene at the exhibition hall

❶

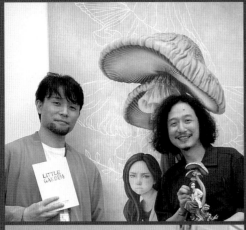

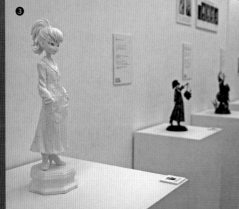

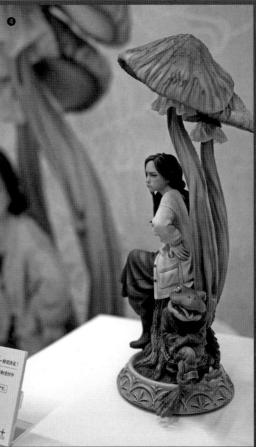

❸

❹

Shun Harada

原田 隼

1978年出生。擔任角色商品店「豆魚雷」的商品企劃開發，以及服裝品牌「TORCH TORCH」的總監及設計師。與藤本圭紀合作製作許多商品，包括1979年的電影《異形》1/3比例雕像和1/2比例頭像。自2018年起，負責藤本作品的套件LOGO商標和標籤設計。2022年舉辦了藤本圭紀的首次個展「LITTLE GARDEN」並在2023年負責作品「The Garden～Take your time～」的量產企劃。

Born in 1978. Product planning and development director for character shop "Mamegyorai", and director and designer of apparel brand "TORCH TORCH." He produced many products with Yoshiki Fujimoto, including the 1/3 scale Alien statue and the 1/2 scale Alien head from the Classic sci-fi movie "Alien". Since 2018, he has designed logos and labels for kits of Fujimoto's works. In 2022, he hosted Fujimoto's first solo exhibition, "LITTLE GARDEN," and in 2023 was responsible for the mass production of Mr. Fujimoto's work, "The Garden: Take your time".

Yoshiki Fujimoto

1983年生於大阪市,現居千葉縣。

原型師.造形創作者。

從有記憶以來,就對奇怪形狀的事物,尤其是怪獸等造形物感
興趣。在怪獸軟膠玩具、塑膠模型當中遊玩,一有空就沉浸在
畫畫中度過童年時光。

中學時期加入橄欖球隊,高中時期加入柔道部,經歷了動感充
實的青春期後,進入大阪藝術大學美術學科。

高中到大學時期也熱衷投入樂隊活動(擔任主唱),有著多彩
多姿的經歷。

大學入學初期主修油畫,但隨著對立體造形的興趣增強,三年
級轉科到雕塑科。

畢業後加入專門製作人物模型原型的M.I.C公司。

在進行商業原型製作的同時,自2012年起參與各種造形會展
活動,發表自己原創的作品。

2017年獨立。2022年9月,在自己度過青年時期的高円寺舉
辦了首次個展。在商業原型作品中,透過對原畫和角色個性的
真誠解讀,再以立體的形態重新詮釋的風格受到好評。

此外,每次發表原創作品的新作,都會因為獨特的世界觀而
引起話題,深深吸引了眾多造形愛好者的心。

Born in Osaka 1983. Currently lives in Chiba.

Sculptor and modeling artist.

He has been interested in mysteriously shaped objects, especially monsters and other
sculptures, ever since he could remember. He spent his boyhood playing with monster
soft vinyl figures and plastic models, and immersing himself in drawing pictures when he
had time. After an active adolescence of belonging to the rugby team in junior high
school and the judo team in high school, he entered the art department of Osaka
University of Arts. He also has a diverse background, having been passionately involved
in a band (vocal) during his high school and college year.When he first entered the
university, he majored in oil painting, but as his interest in three-dimensional art grew
stronger, he switched to the sculpture department in his third year. After graduation, he
joined M.I.C. Corporation, which specializes in the production of figure prototypes. While
producing commercial prototypes, he began presenting original works at various events
in 2012. He became independent in 2017. In September 2022, he held his first solo
exhibition at Koenji, where he spent his youth. In commercial production works, he is
well known for his stereoscopic interpretation that faithfully interprets the author's
intention and character's personality from the original. Moreover, the unique view of the
world that the original works depict has become a topic of conversation every time a
new work is released, and has captured the hearts of many molding fans.

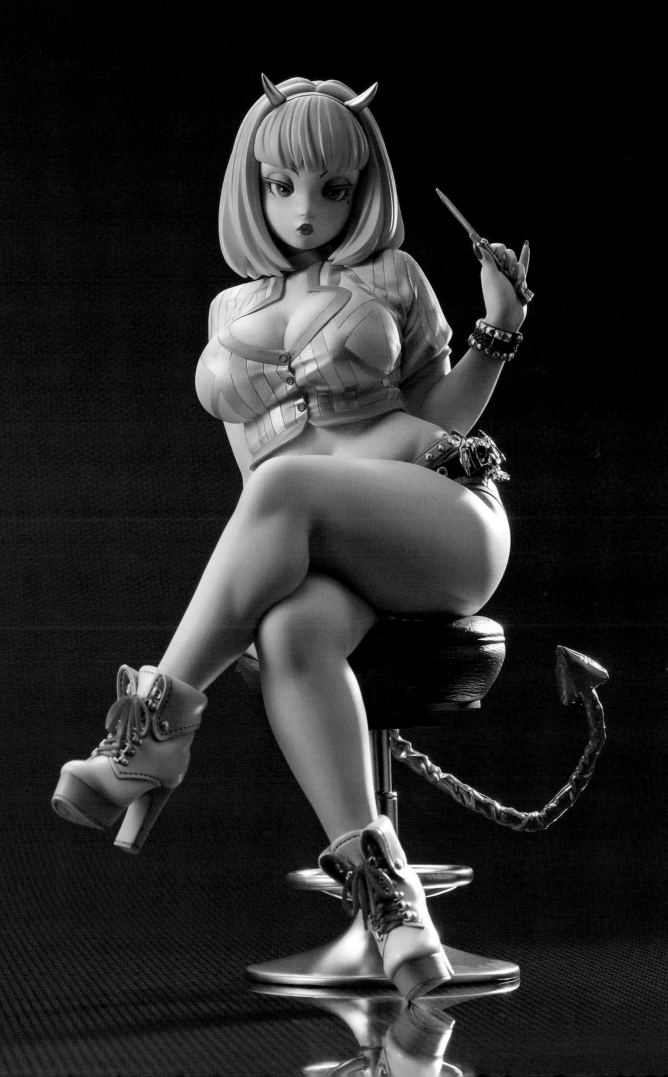

Contents

▲為這本作品集全新創作的
草稿。
New roughs for this collection.

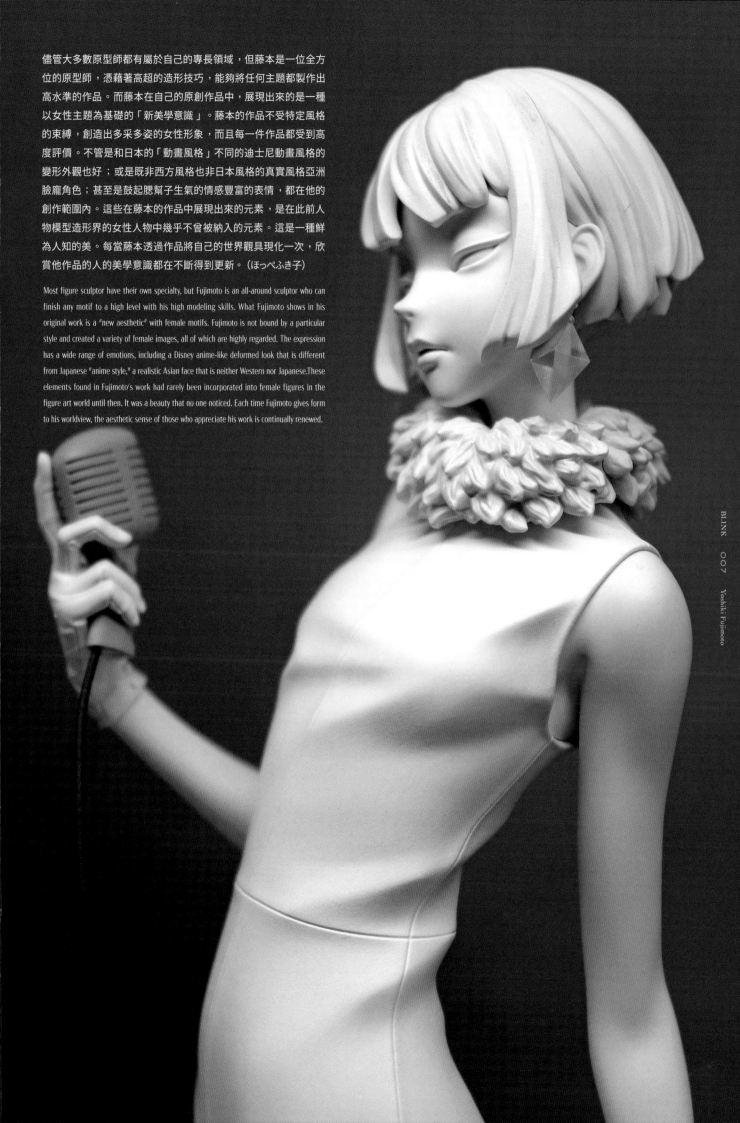

儘管大多數原型師都有屬於自己的專長領域，但藤本是一位全方位的原型師，憑藉著高超的造形技巧，能夠將任何主題都製作出高水準的作品。而藤本在自己的原創作品中，展現出來的是一種以女性主題為基礎的「新美學意識」。藤本的作品不受特定風格的束縛，創造出多采多姿的女性形象，而且每一件作品都受到高度評價。不管是和日本的「動畫風格」不同的迪士尼動畫風格的變形外觀也好；或是既非西方風格也非日本風格的真實風格亞洲臉龐角色；甚至是鼓起腮幫子生氣的情感豐富的表情，都在他的創作範圍內。這些在藤本的作品中展現出來的元素，是在此前人物模型造形界的女性人物中幾乎不曾被納入的元素。這是一種鮮為人知的美。每當藤本透過作品將自己的世界觀具現化一次，欣賞他作品的人的美學意識都在不斷得到更新。（ほっぺふき子）

Most figure sculptor have their own specialty, but Fujimoto is an all-around sculptor who can finish any motif to a high level with his high modeling skills. What Fujimoto shows in his original work is a "new aesthetic" with female motifs. Fujimoto is not bound by a particular style and created a variety of female images, all of which are highly regarded. The expression has a wide range of emotions, including a Disney anime-like deformed look that is different from Japanese "anime style," a realistic Asian face that is neither Western nor Japanese.These elements found in Fujimoto's work had rarely been incorporated into female figures in the figure art world until then. It was a beauty that no one noticed. Each time Fujimoto gives form to his worldview, the aesthetic sense of those who appreciate his work is continually renewed.

BLINK 007 Yoshiki Fujimoto

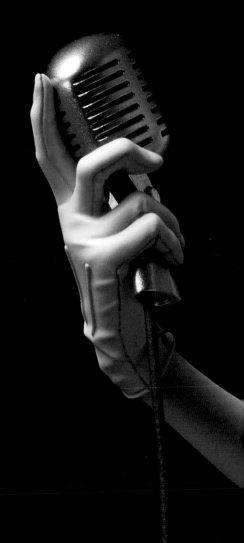

SHOW BUSINESS

SHOW BUSINESS

□data _ 2023　　　　□size _ 全高約275㎜

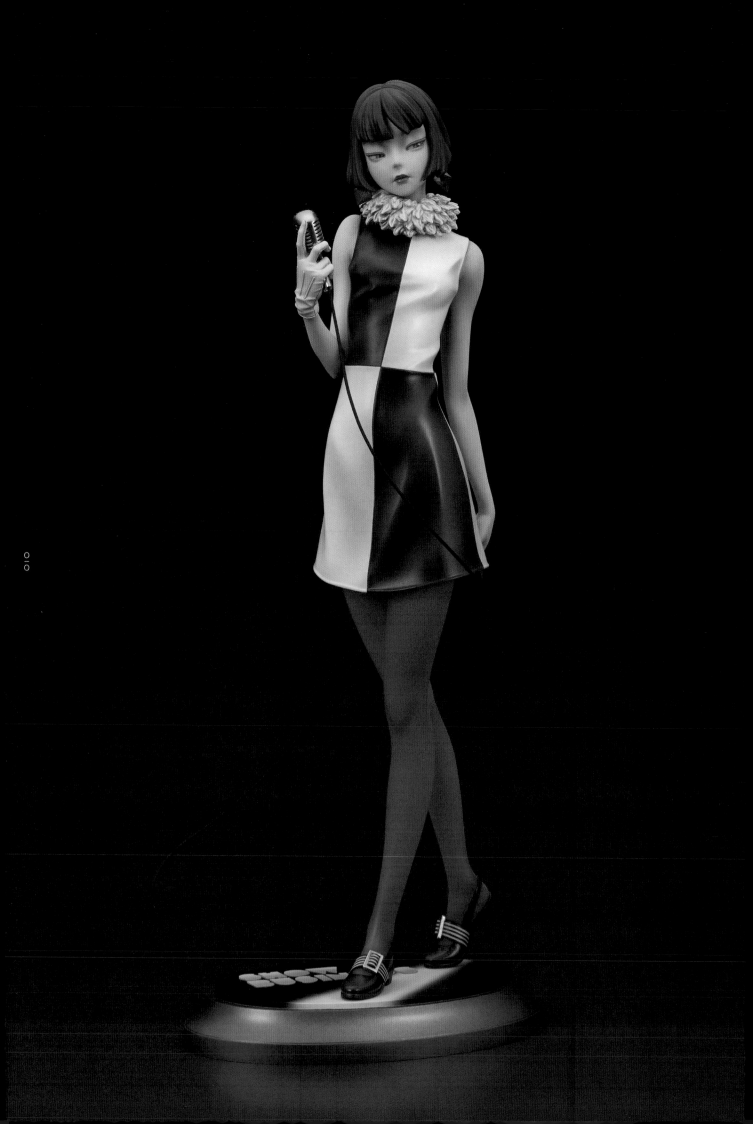

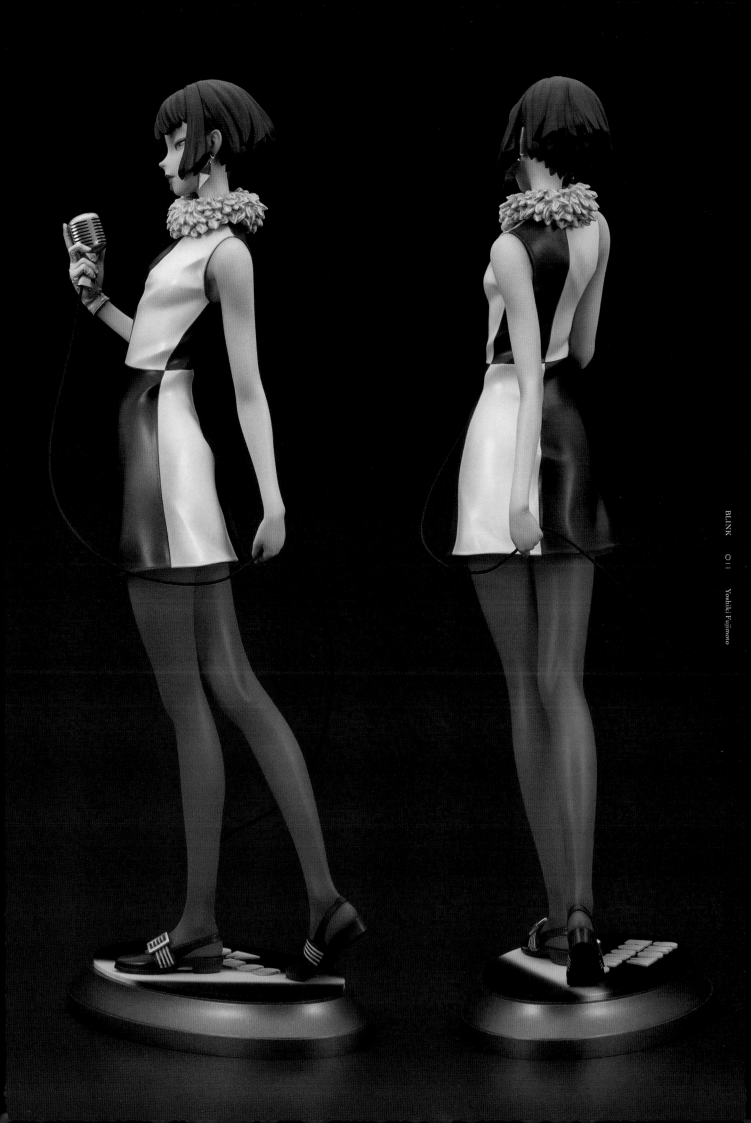

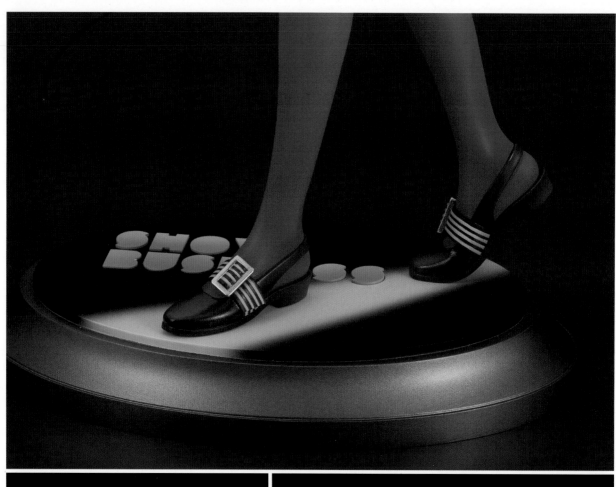

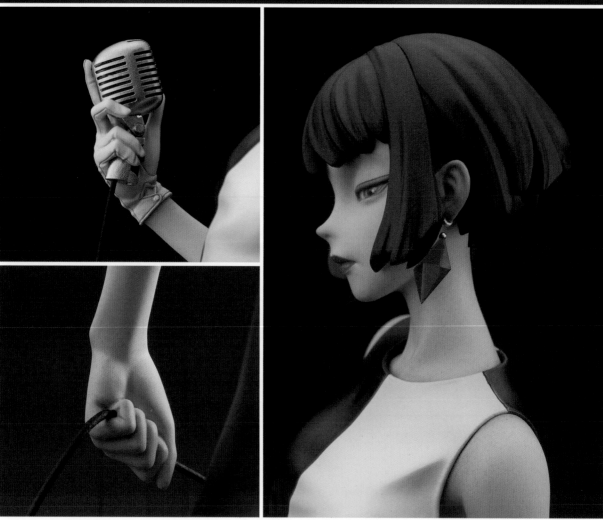

A little spooky night -premonition-

A little spooky night -premonition-

□data — 2023　　　　□size — 全高約150㎜

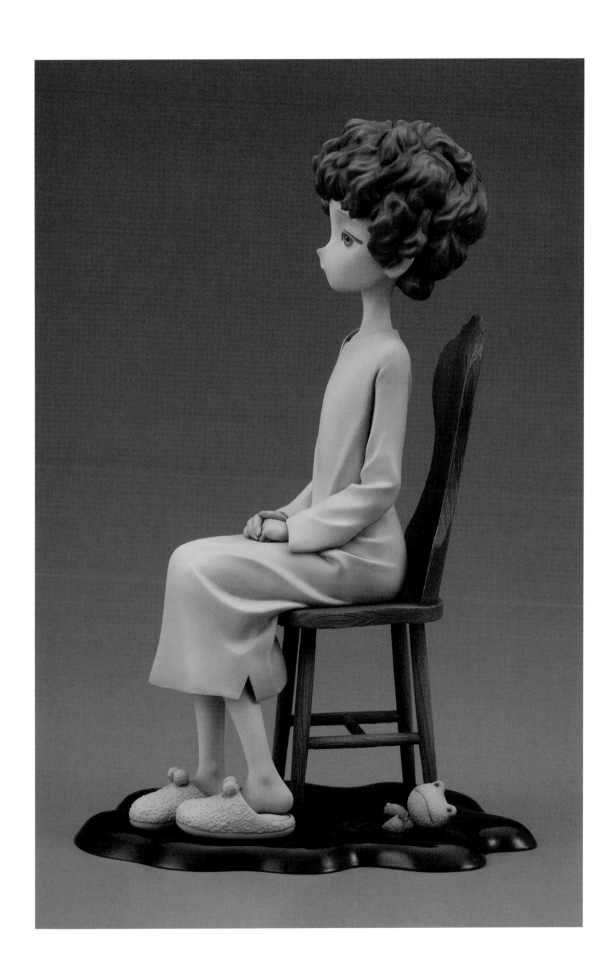

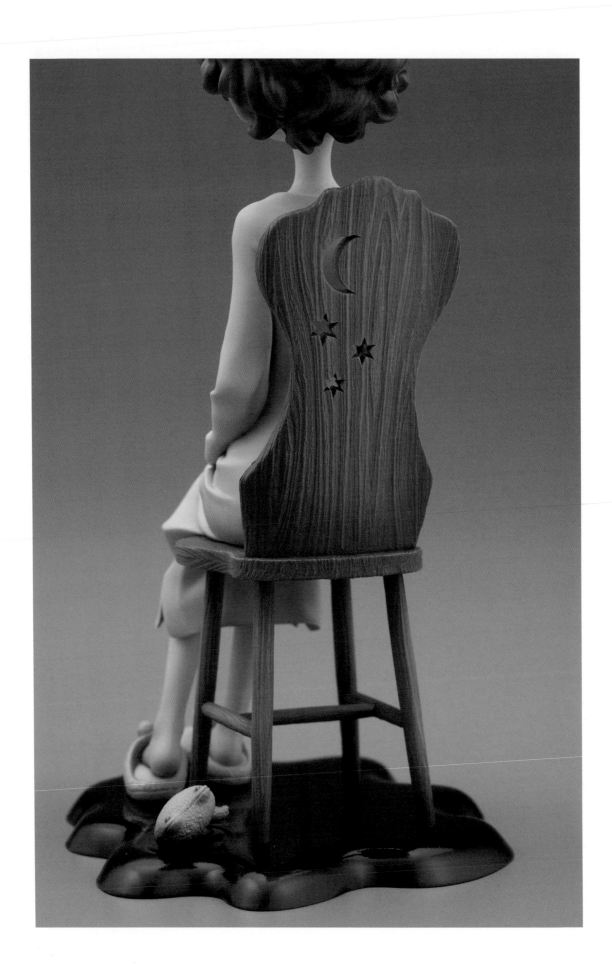

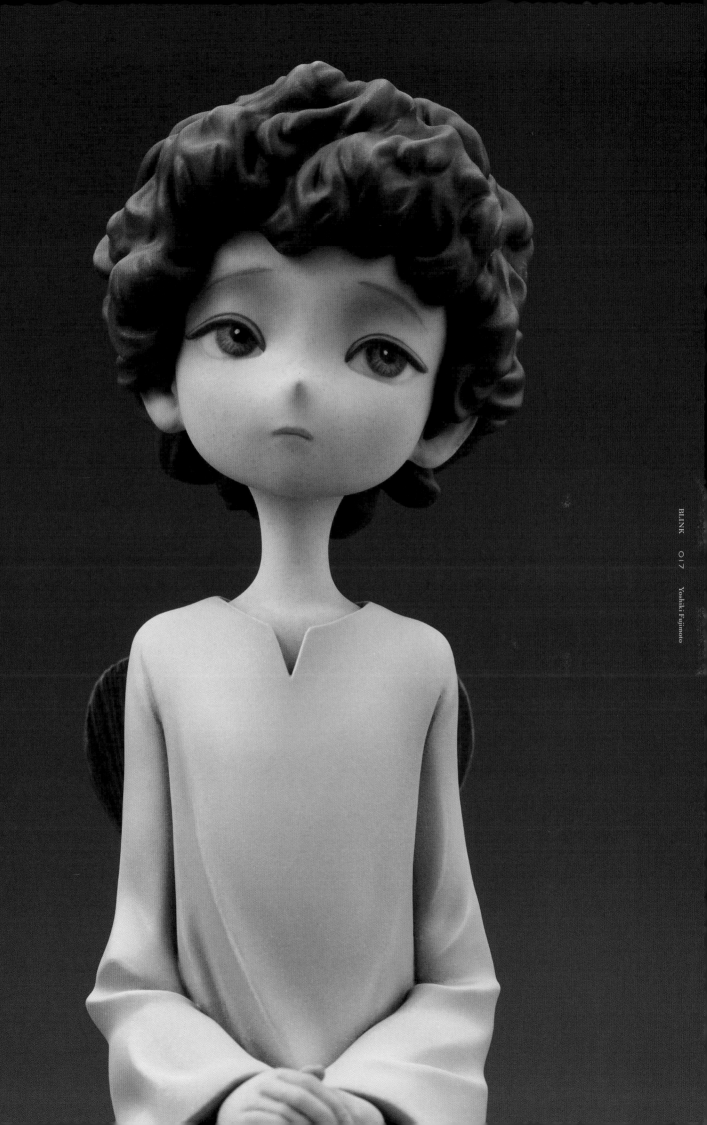

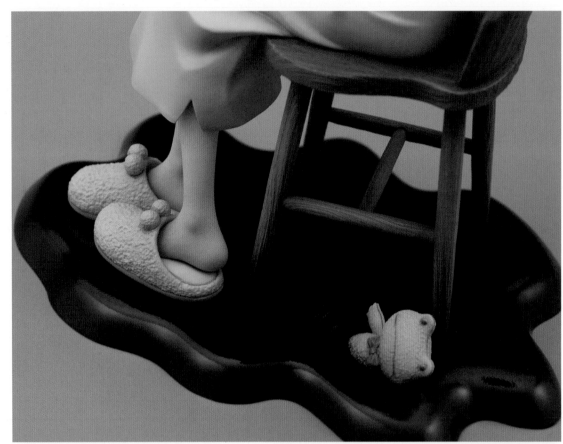

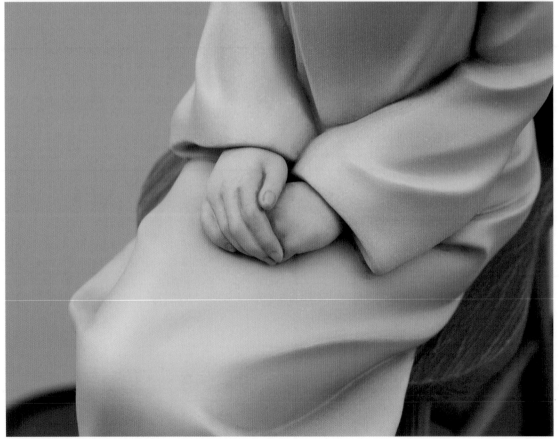

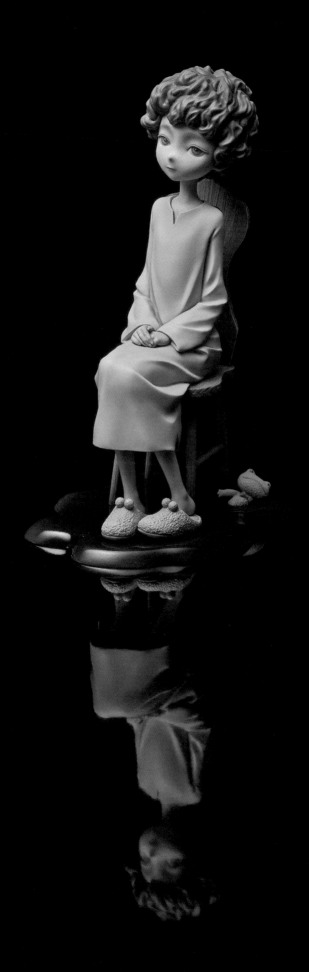

這一系列照片展示了為這本書全新創作的兩件作品製作過程。在考慮如何表現作品的世界觀時，藉由在畫面上選擇和放棄各種元素進行思考。一邊思考著如何表現作品的世界觀，一邊在畫面上選擇以及挑選各種元素。在考慮立體作品〝統整性〞的同時，透過多次的暫時列印輸出，最終形成了如今的模樣。輸出的原型還要以手工的方式進行微調，連上色都是由藤本圭紀親自完成。

This series of photographs shows the production process of two pieces created for the book. The artist considered how to express the world view of the work on the screen, selecting and choosing various elements. The current form was created after repeated provisional printouts while considering the "cohesiveness" of the three-dimensional work. The prototype was fine-tuned by hand, and even the coloring was done by Mr. Fujimoto himself.

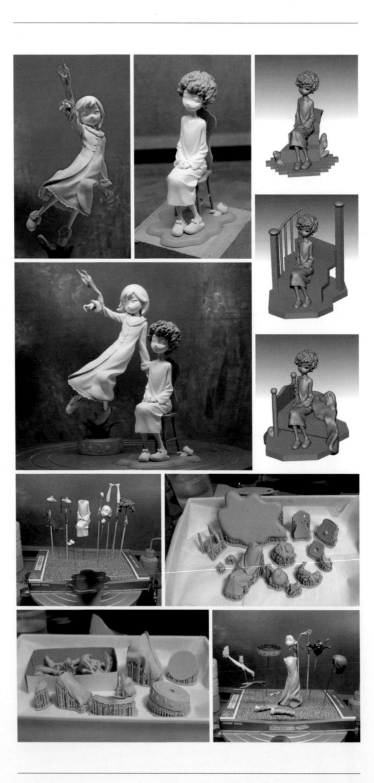

BLINK 021 Yoshiki Fujimoto

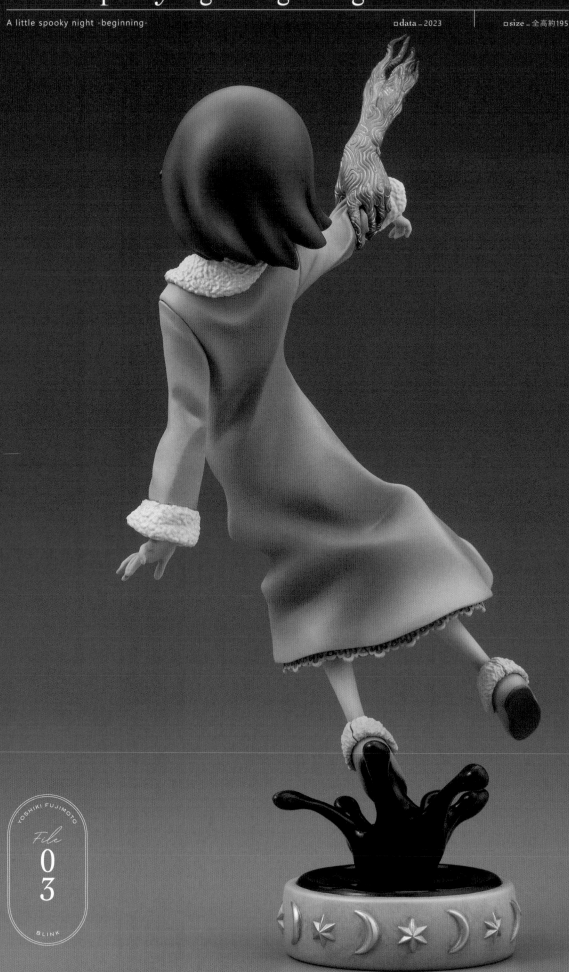

022

YOSHIKI FUJIMOTO

File

0
3

BLINK

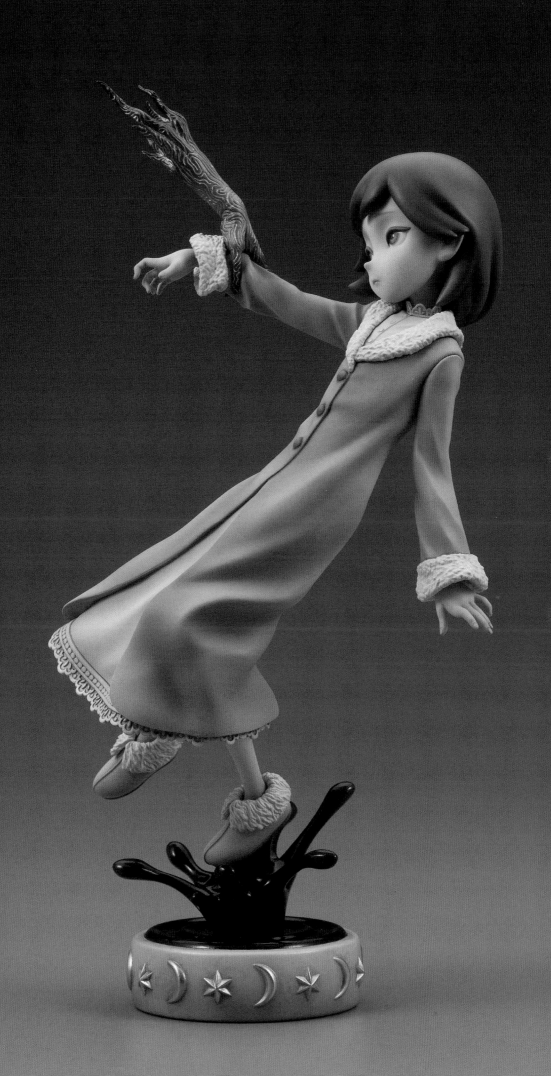

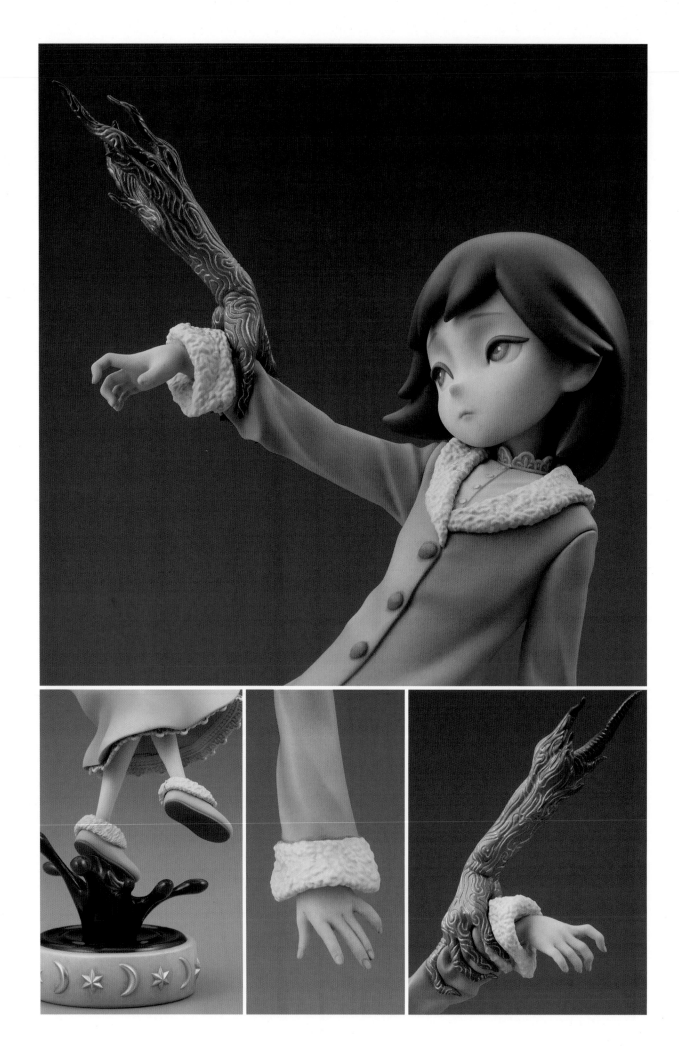

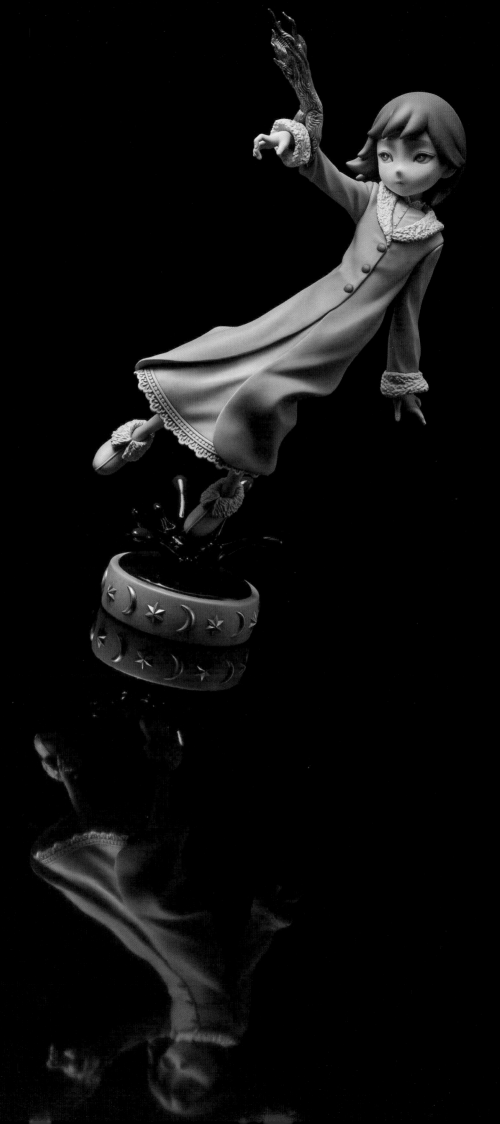

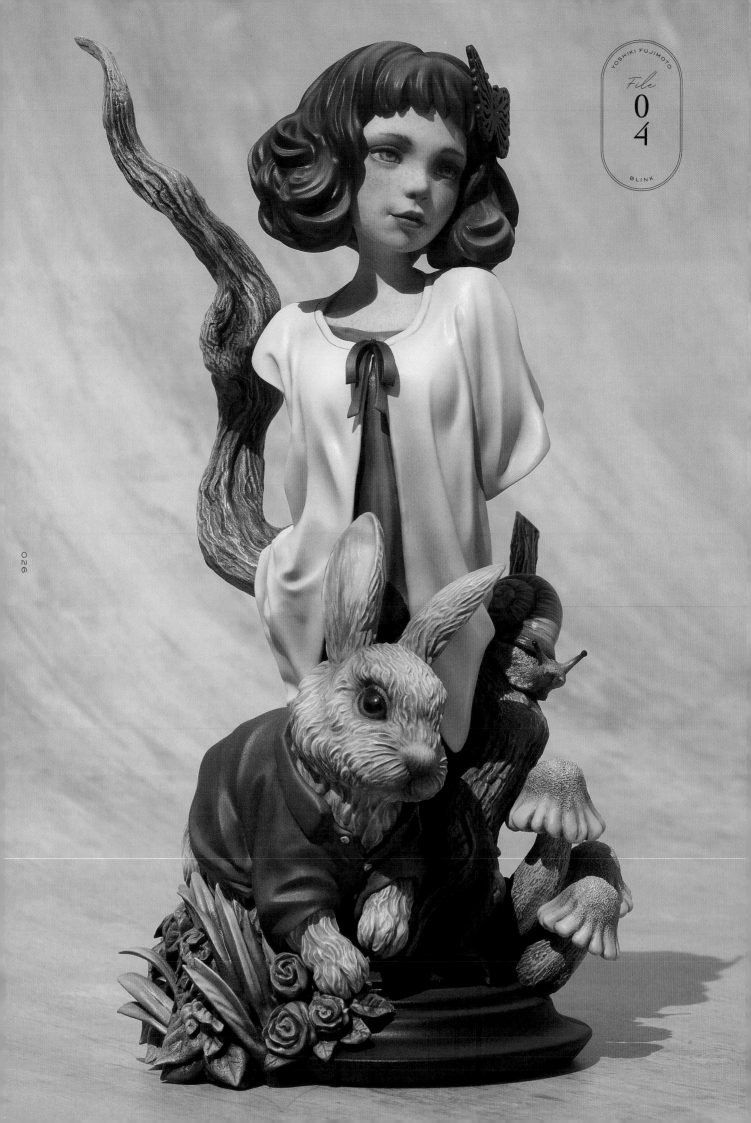

The Garden

The Garden

□data _ 2018　　　□size _ 全高約205㎜

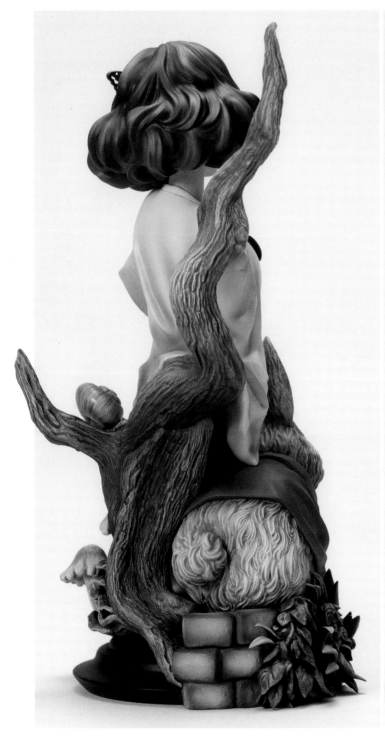
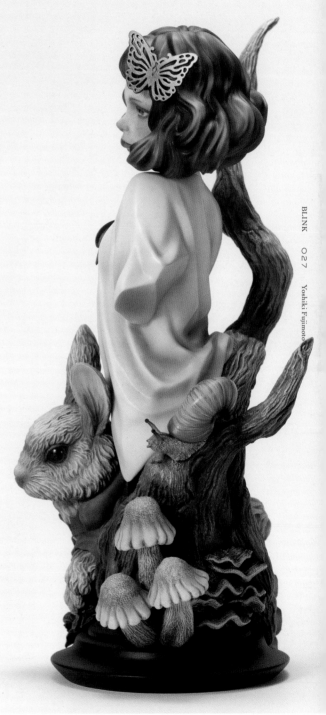

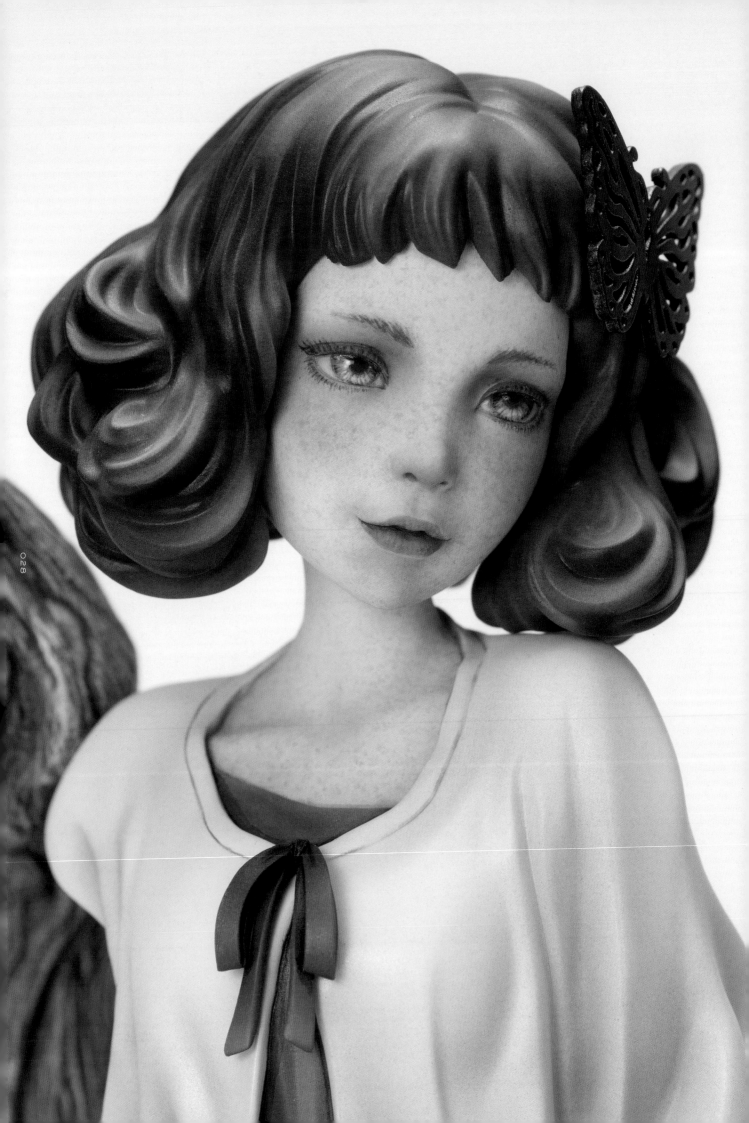

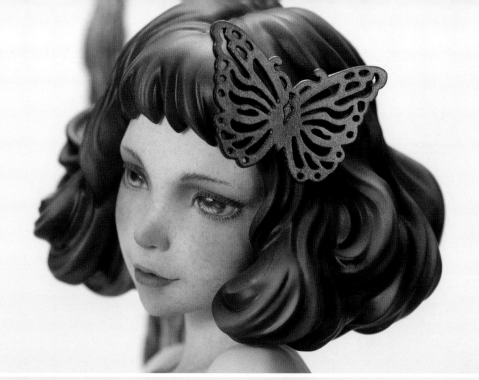

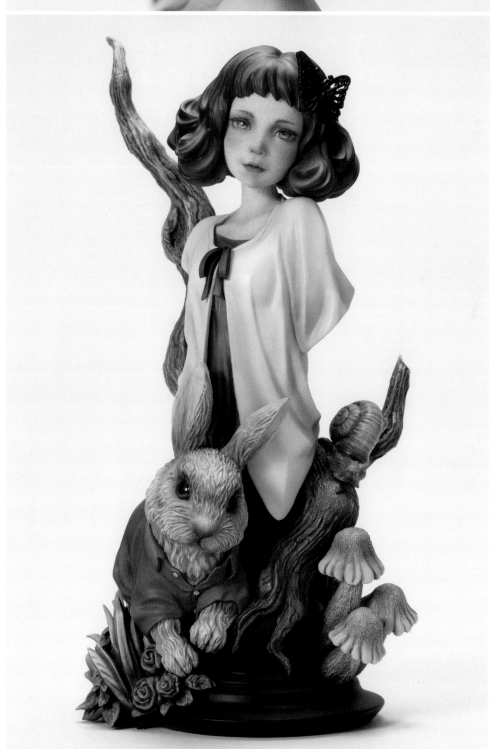

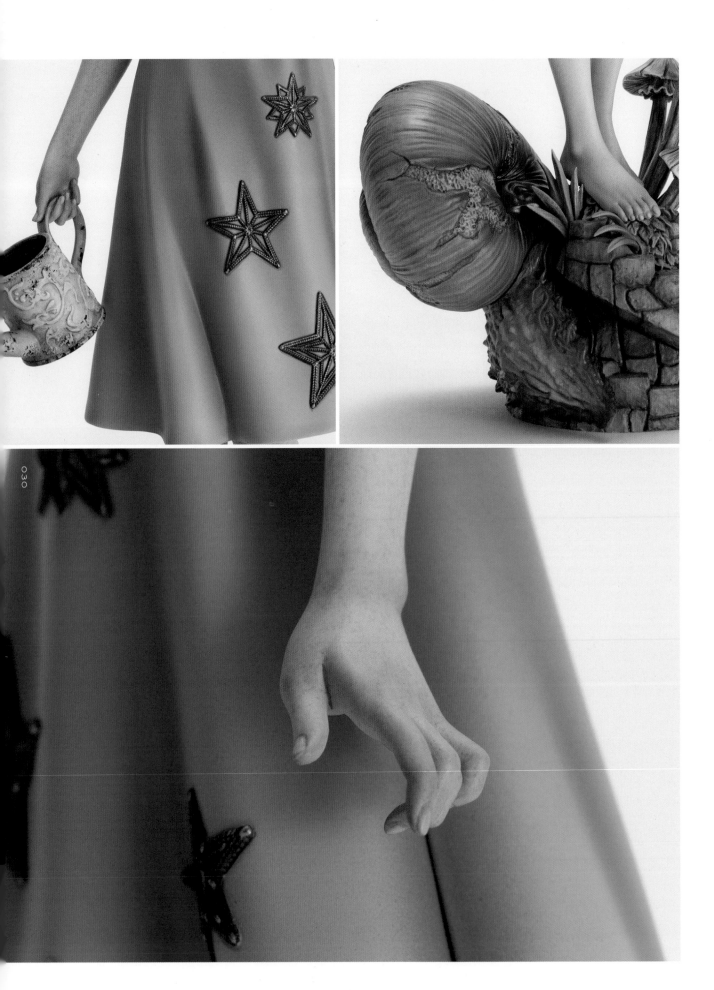

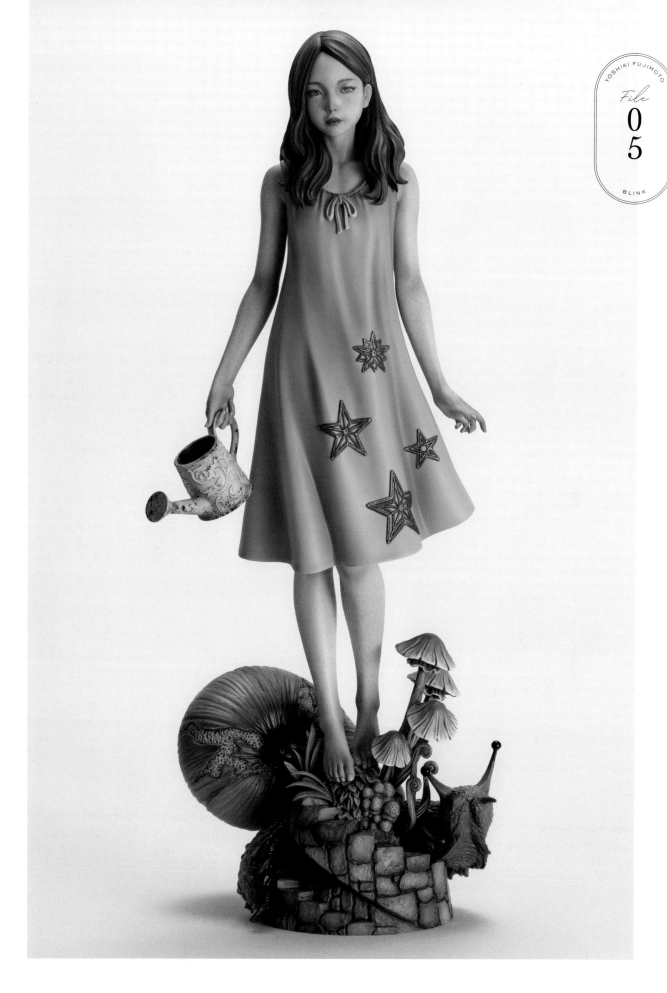

The Garden ~Awakening~

The Garden ～ Awakening ～ □data _ 2020 □size _ 全高約270㎜

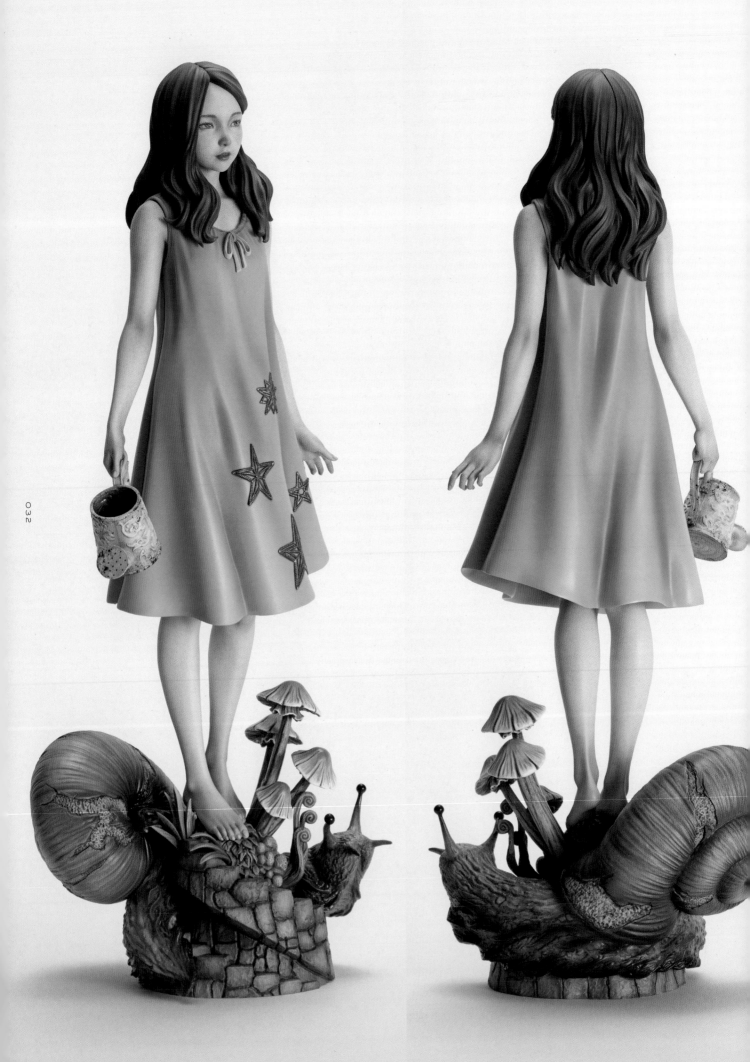

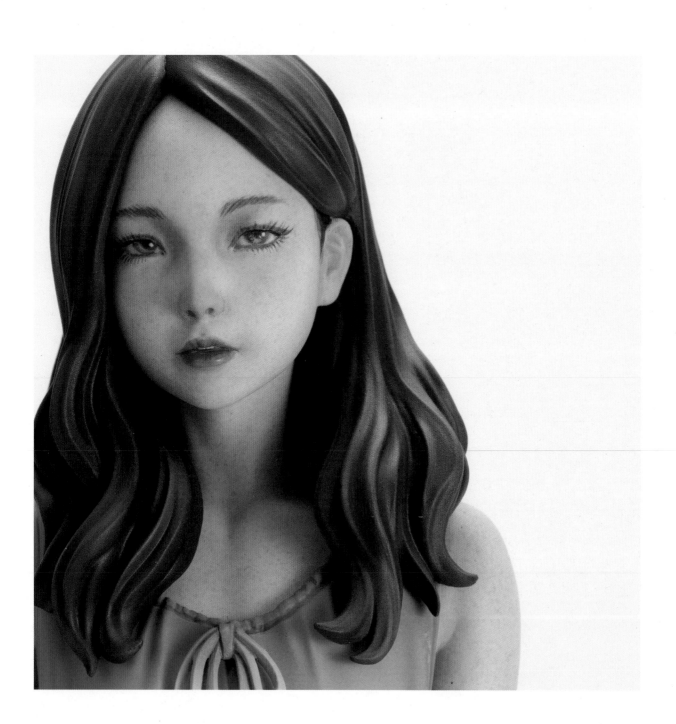

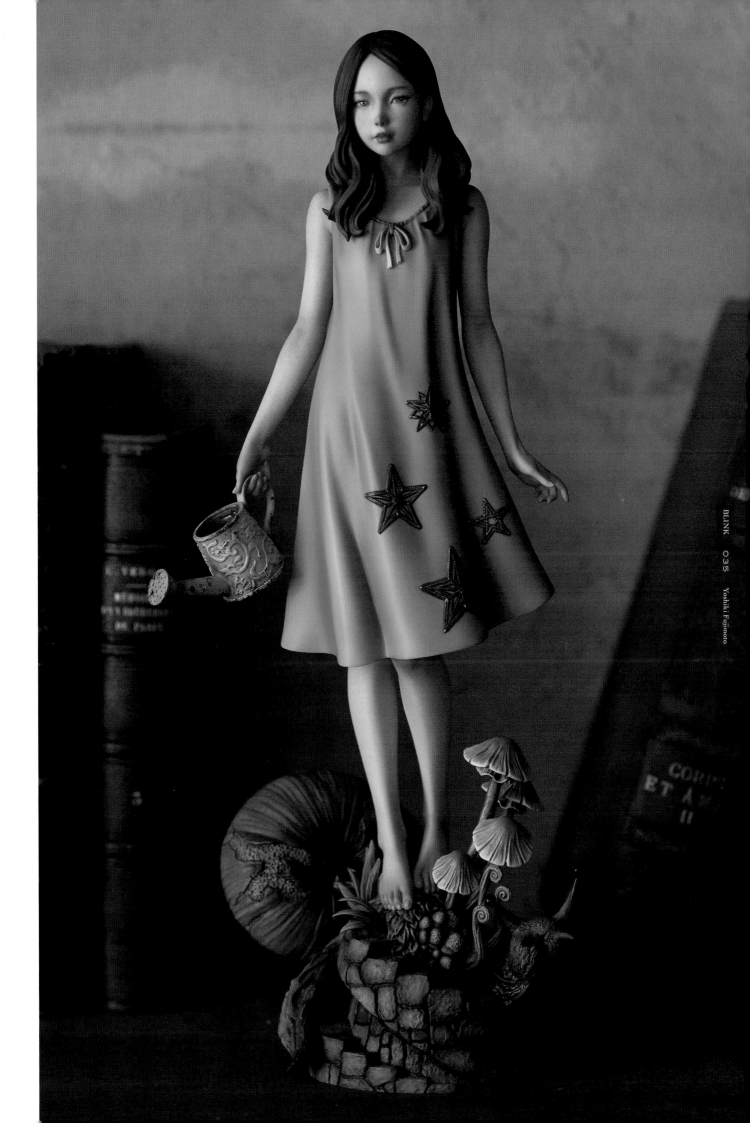

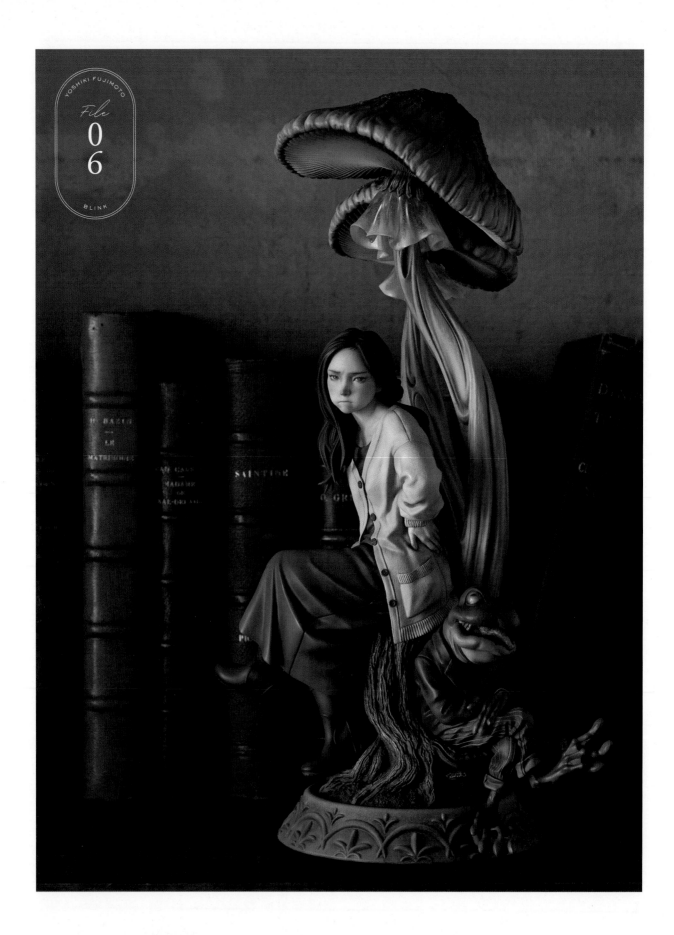

The Garden ~Take your time~

The Garden ～ Take your time ～ | □data — 2021 | □size — 全高約290㎜

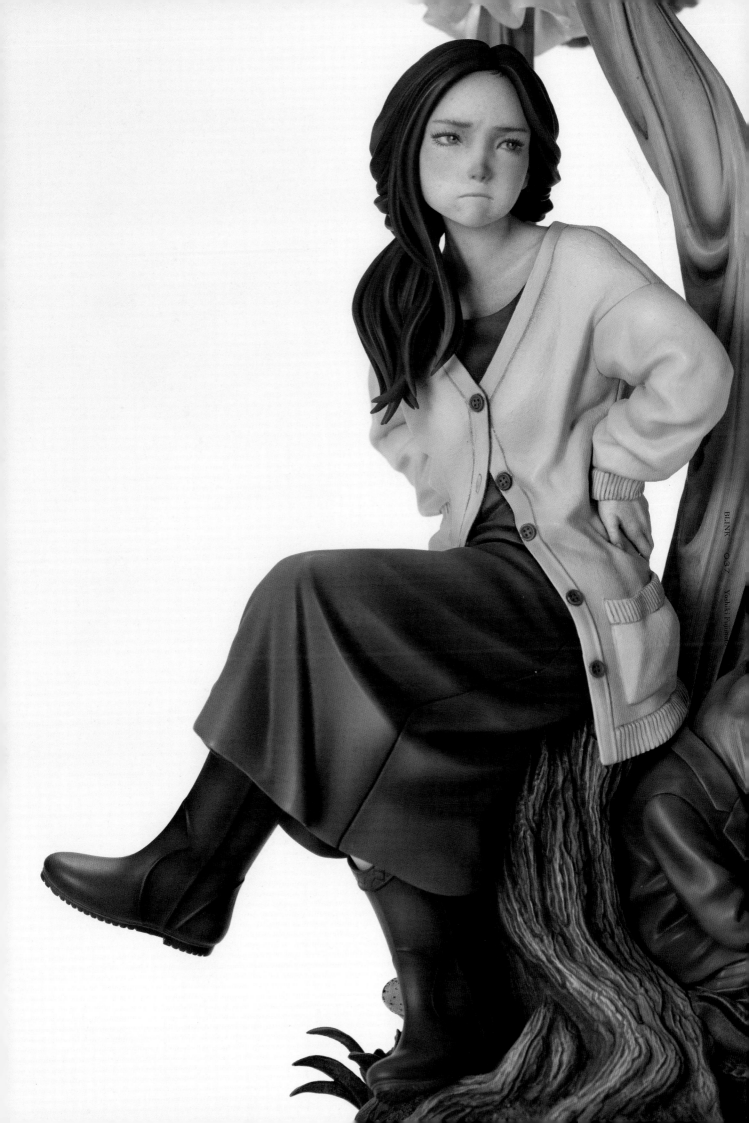

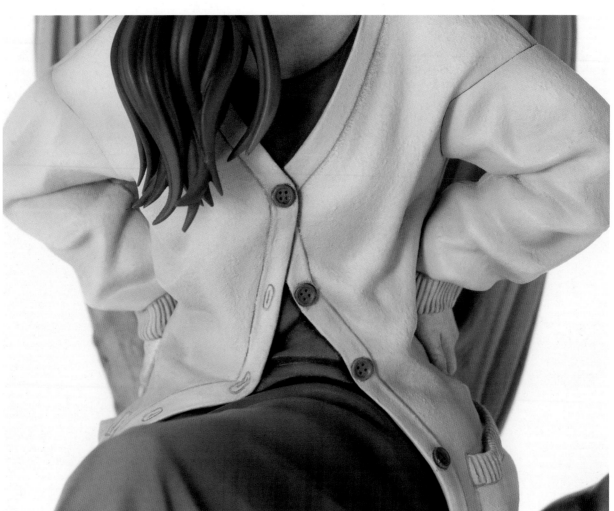

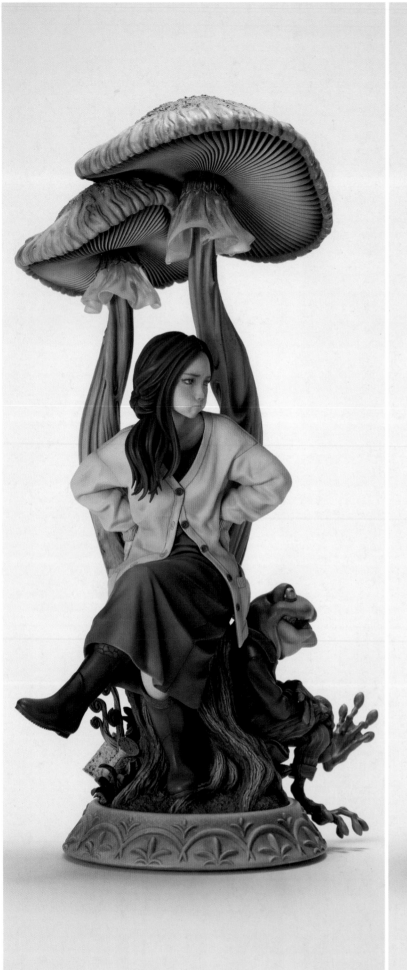
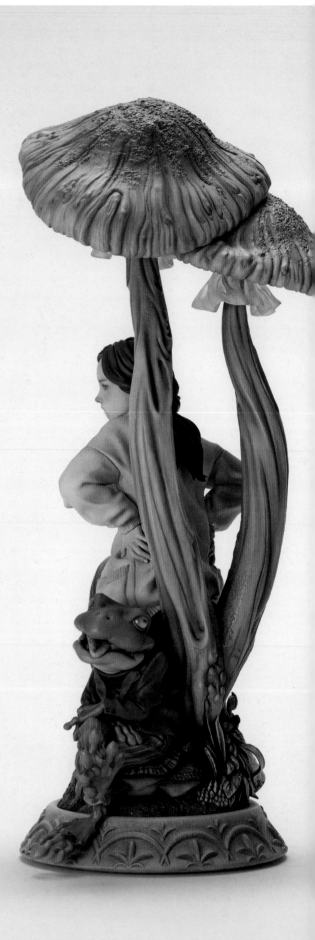

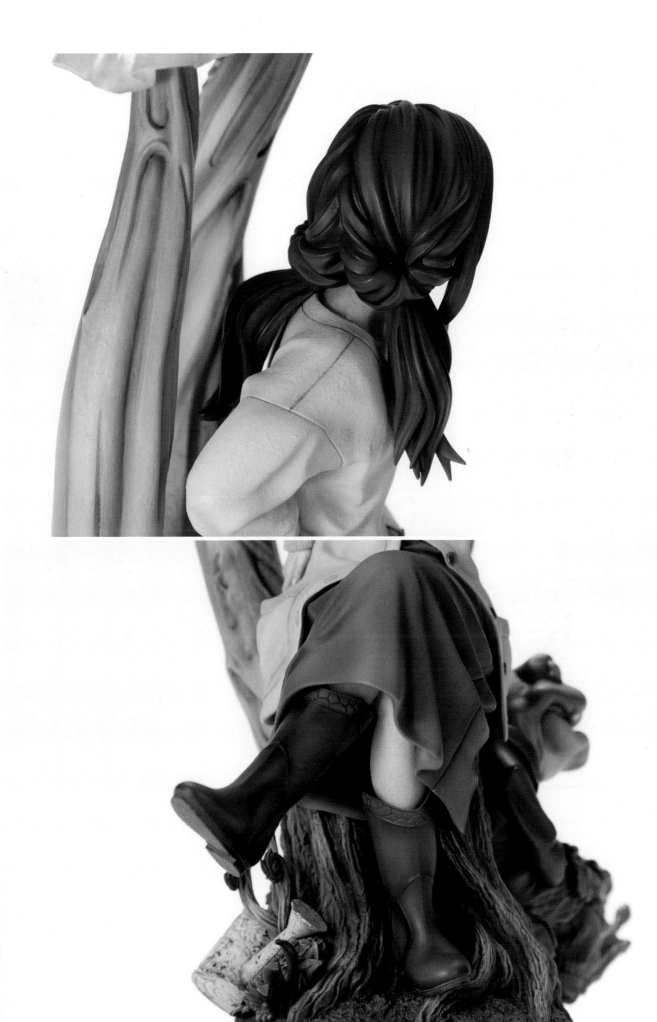

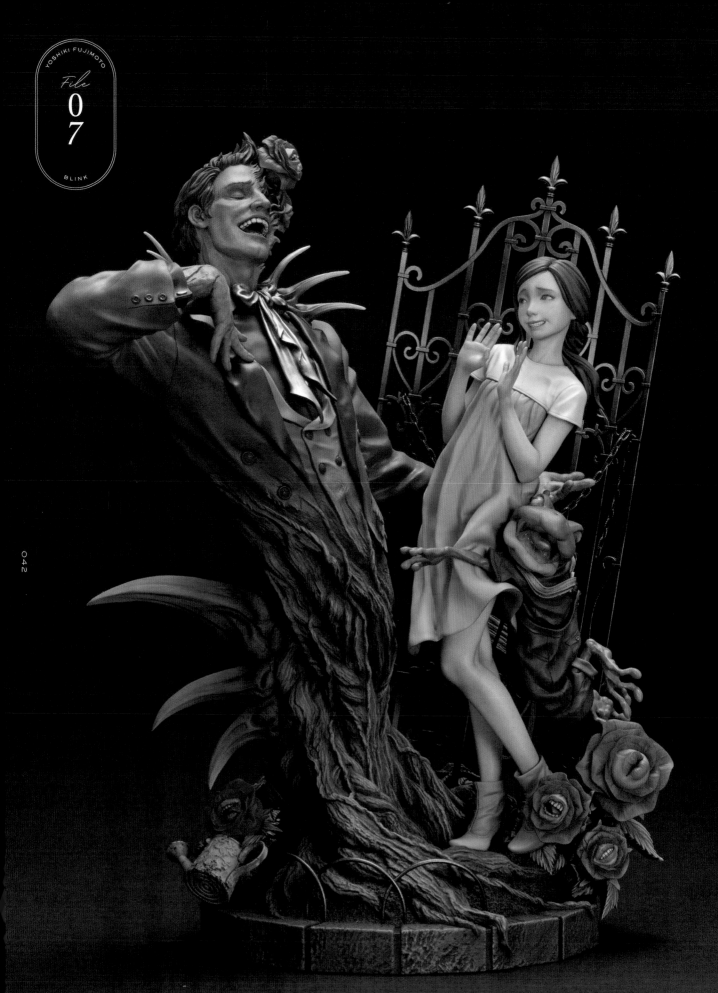

The Garden ~Rose of Passion~

The Garden ~Rose of Passion~ □data — 2023 □size — 全高約250mm

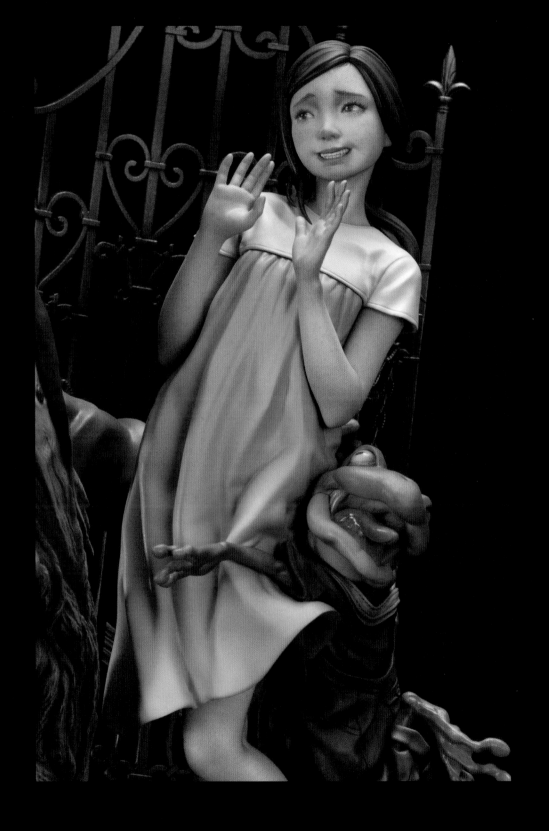

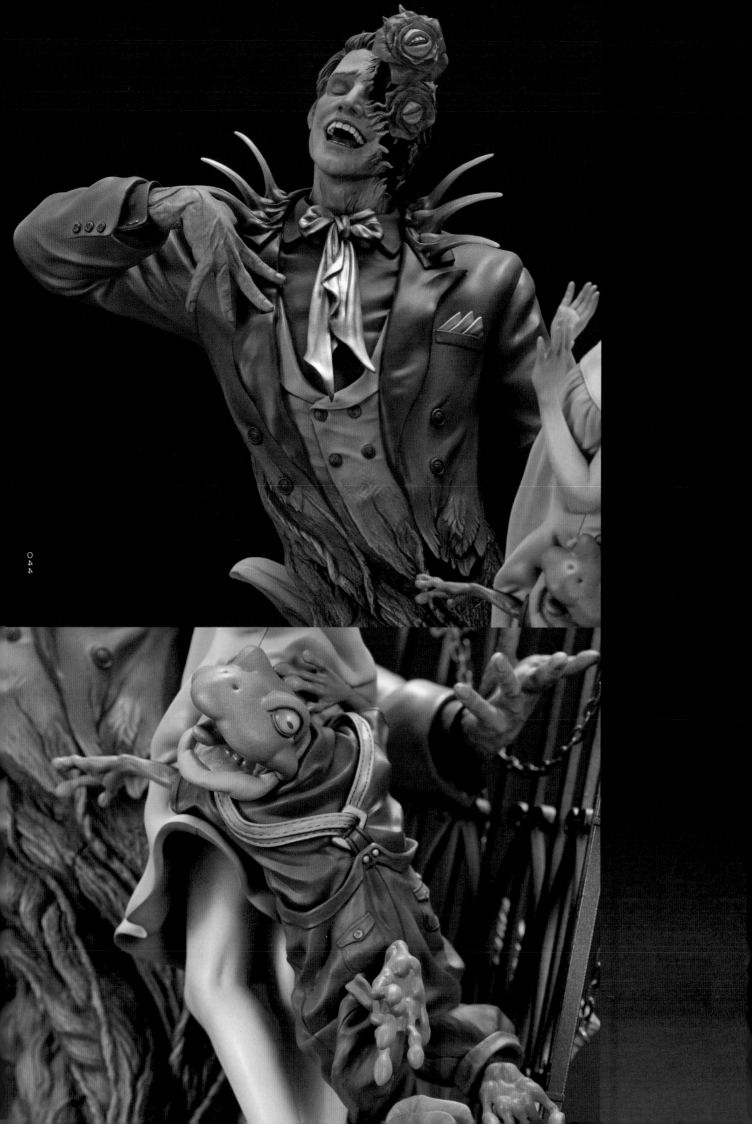

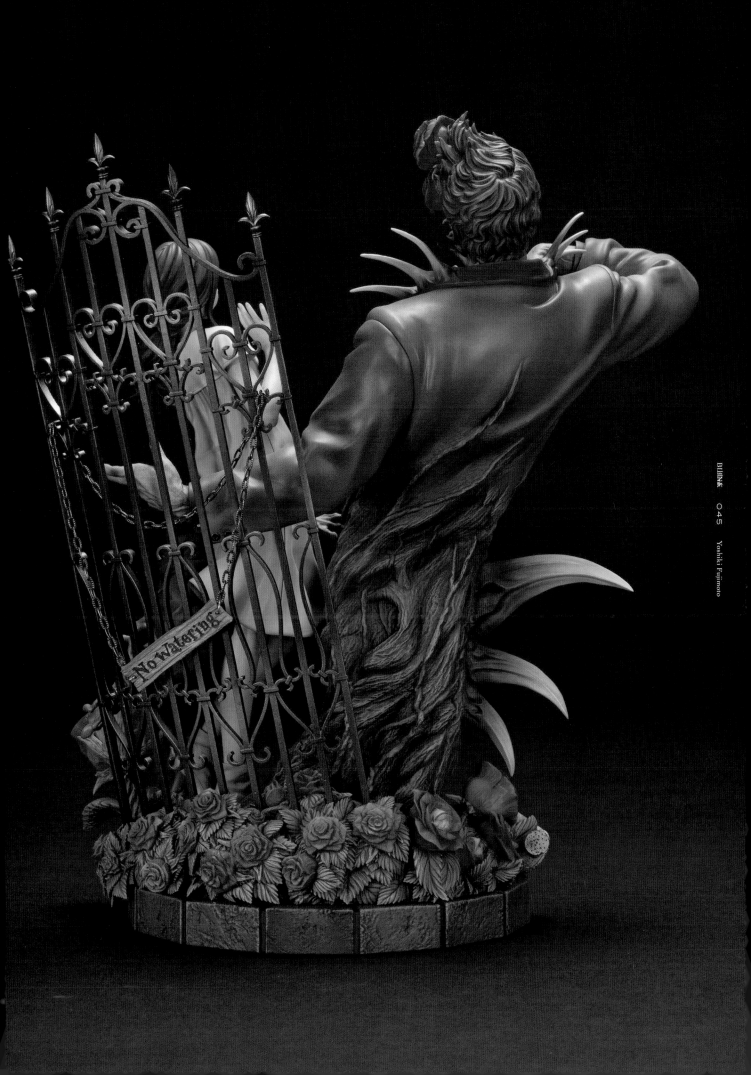

No Watering

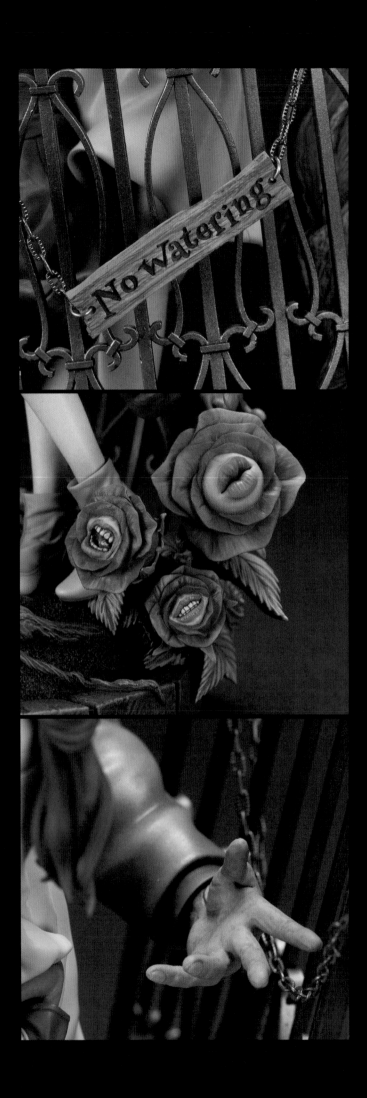

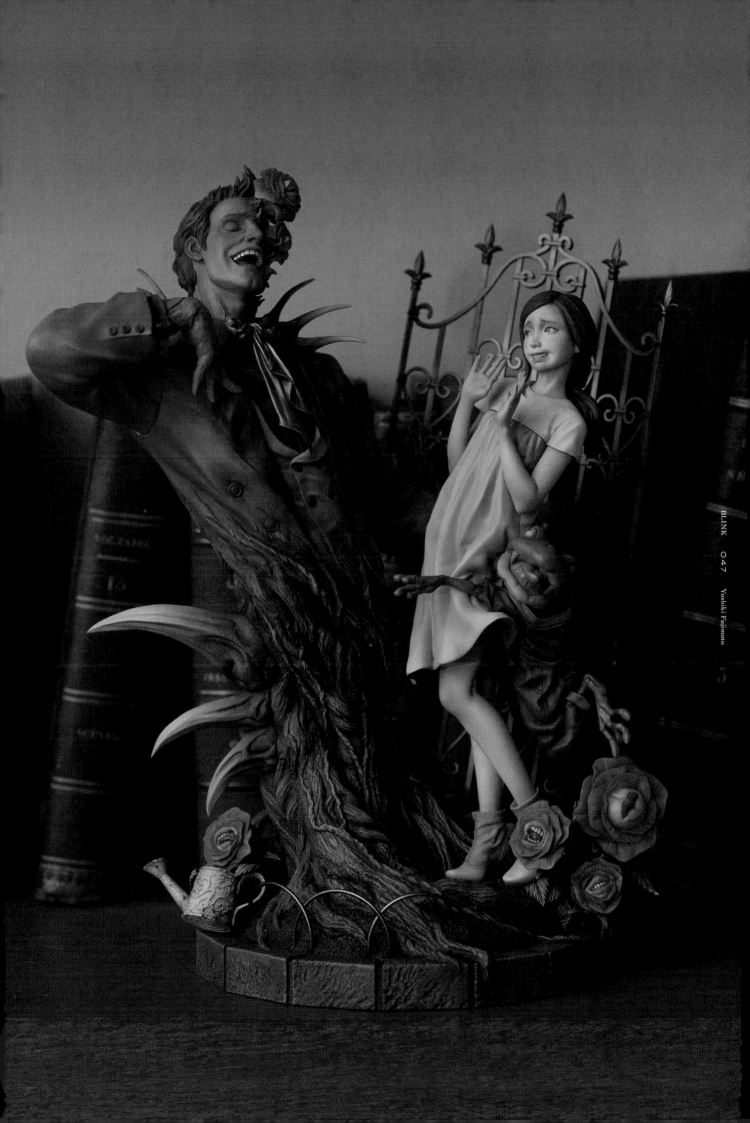

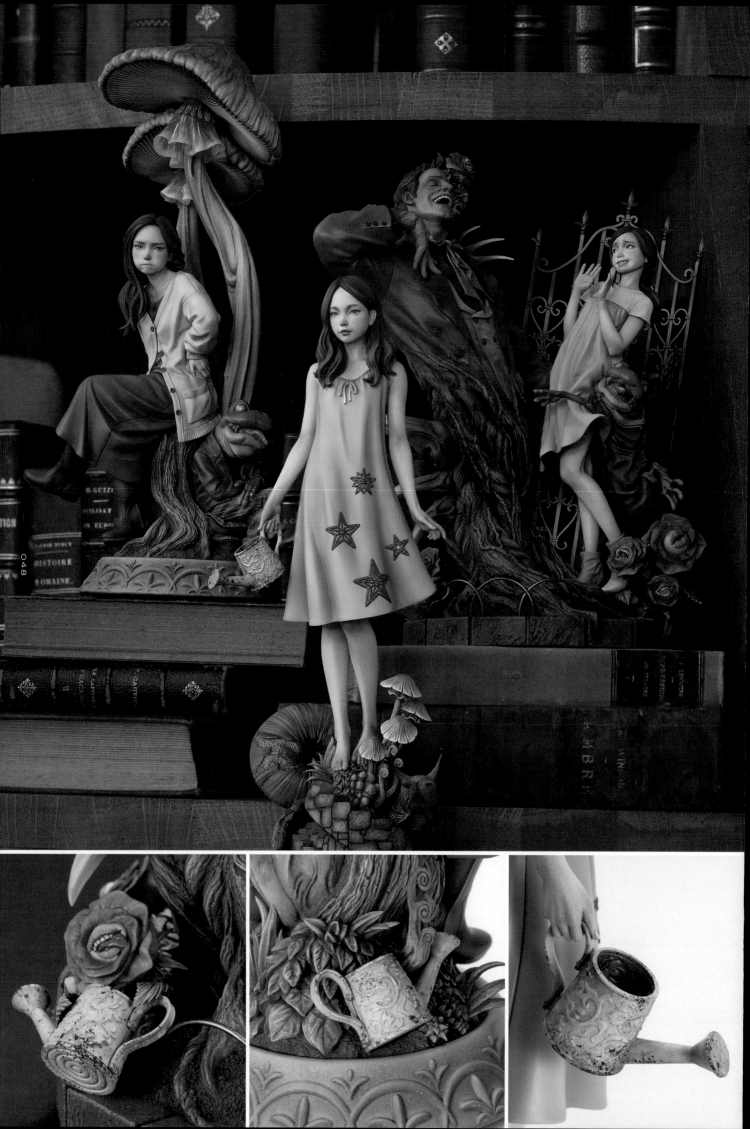

作品誕生的工作室

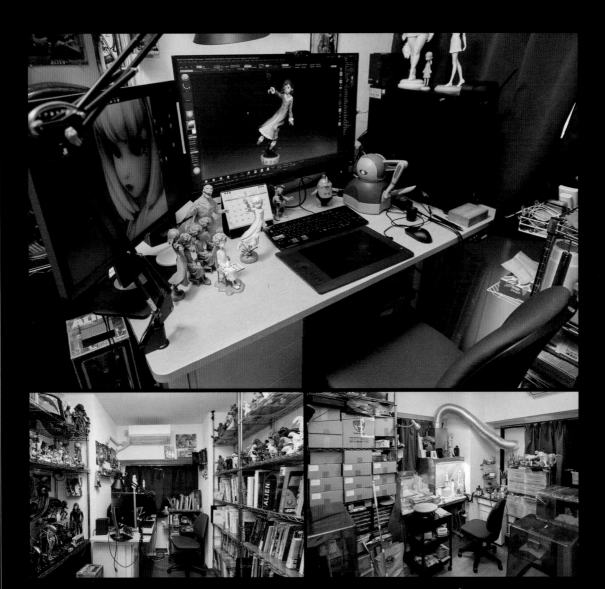

在他家中保留兩間房間作為作業空間，分別專門用於數位作業和手工作業（如塗裝、3D輸出件的打磨修飾等）。數位作業的房間包含了一張主要的工作桌，以及一個擺滿資料參考書籍和人物模型的書架。桌上擺放著一台電腦、顯示器和繪畫用的平板，還有用於確認形狀的暫時輸出件與當時喜愛的人物模型。椅子出奇地普通，但實際上藤本經常是站著工作的。桌子是可以電動調節高度的款式。塗裝區設有一個特別訂做的大型塗裝箱。除此之外還配備了數台3D列印機，以確保能夠隨時輸出並進行確認。

Two rooms in his home are reserved as work spaces, each dedicated to digital work and analog work (painting, finishing 3D output, etc.). The digital workroom contains the main desk and a rack lined with books and figures for reference. On the desk are a PC, display, and tablet for drawing, as well as temporary outputs for shape confirmation and favorite figures of the moment. The chairs are, not surprisingly, common ones, but in fact, he often works while standing. The desk is electrically height-adjustable. The painting booth is a large, custom-built one, and several 3D printers are available for immediate output of data for checking.

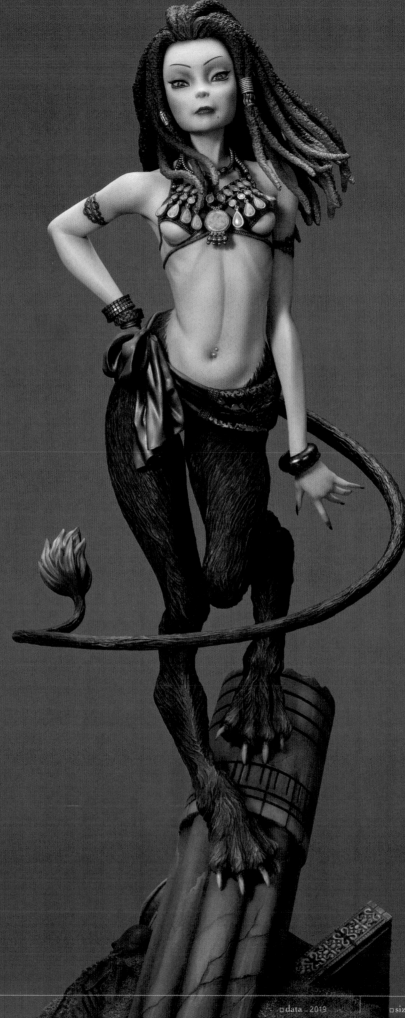

DUEL

DUEL

□data – 2019　　　　□size – 全高約340㎜

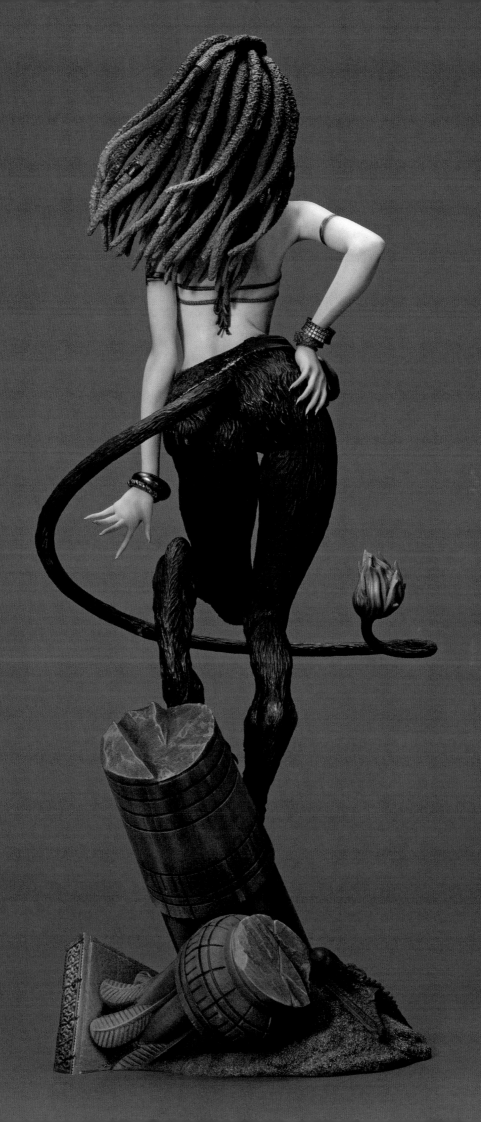

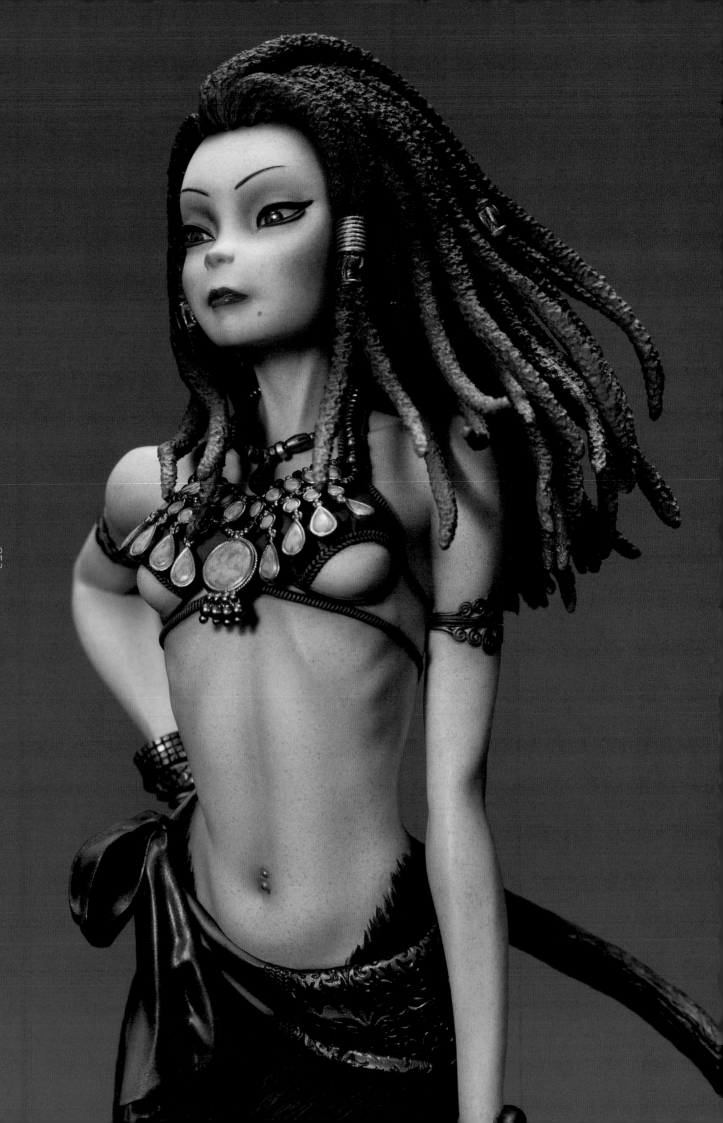

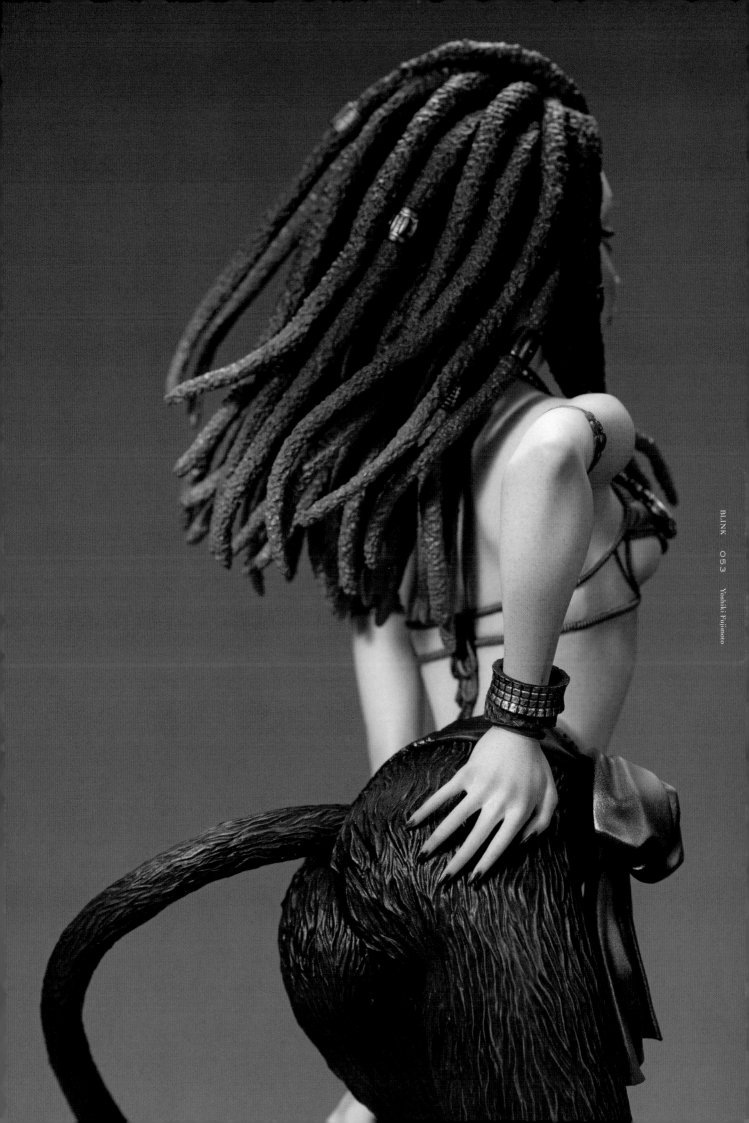

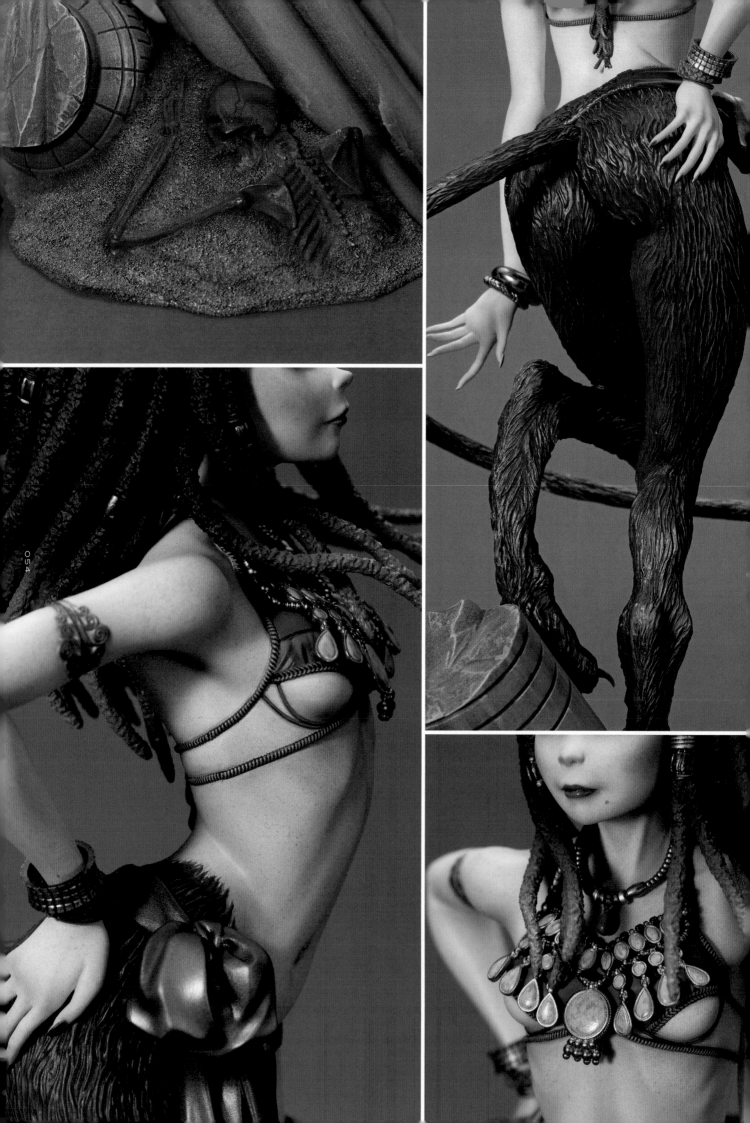

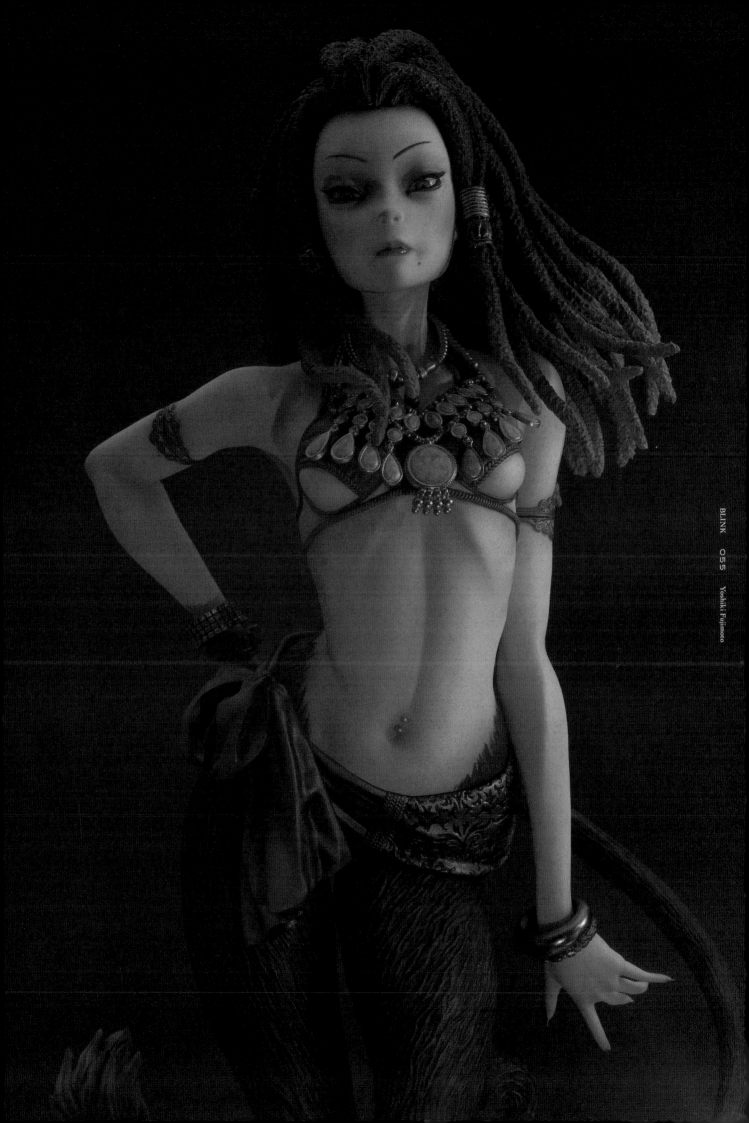

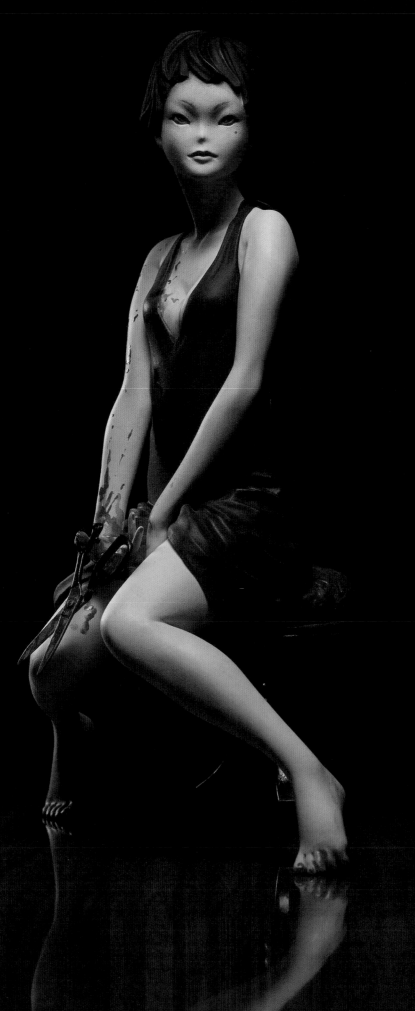

File
0
9

YOSHIKI FUJIMOTO

BLINK

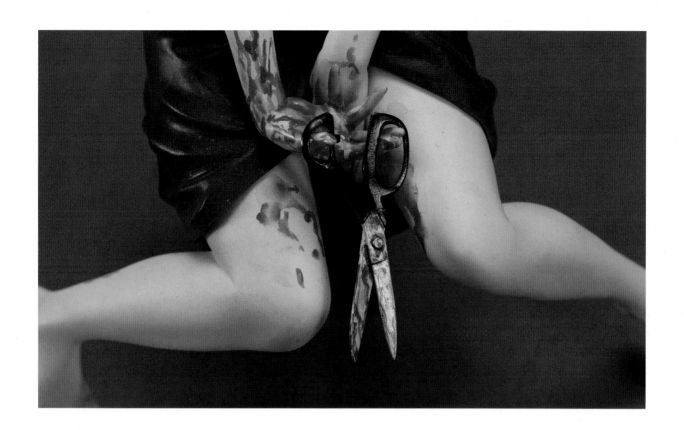

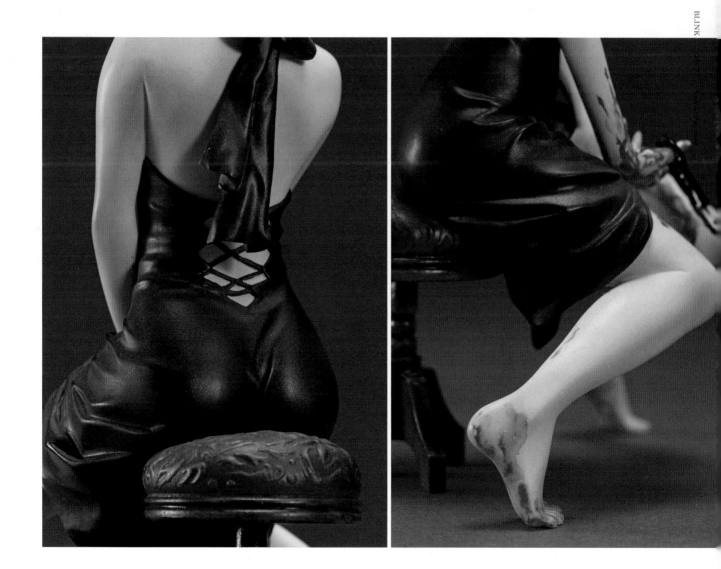

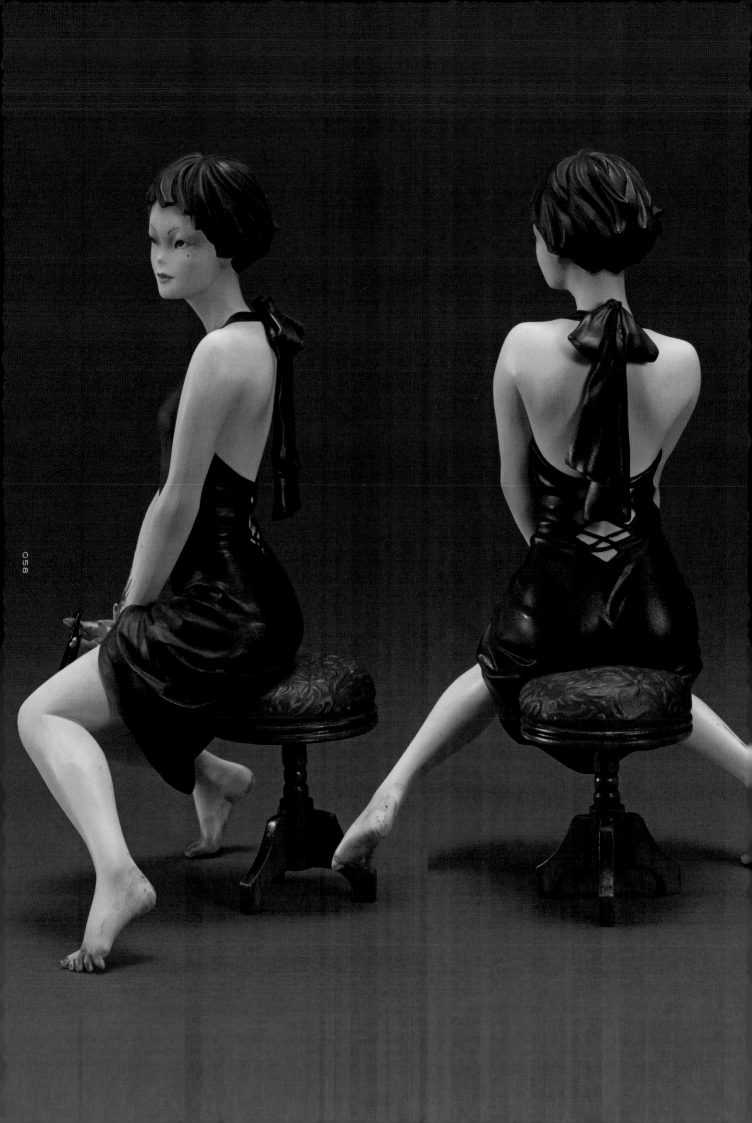

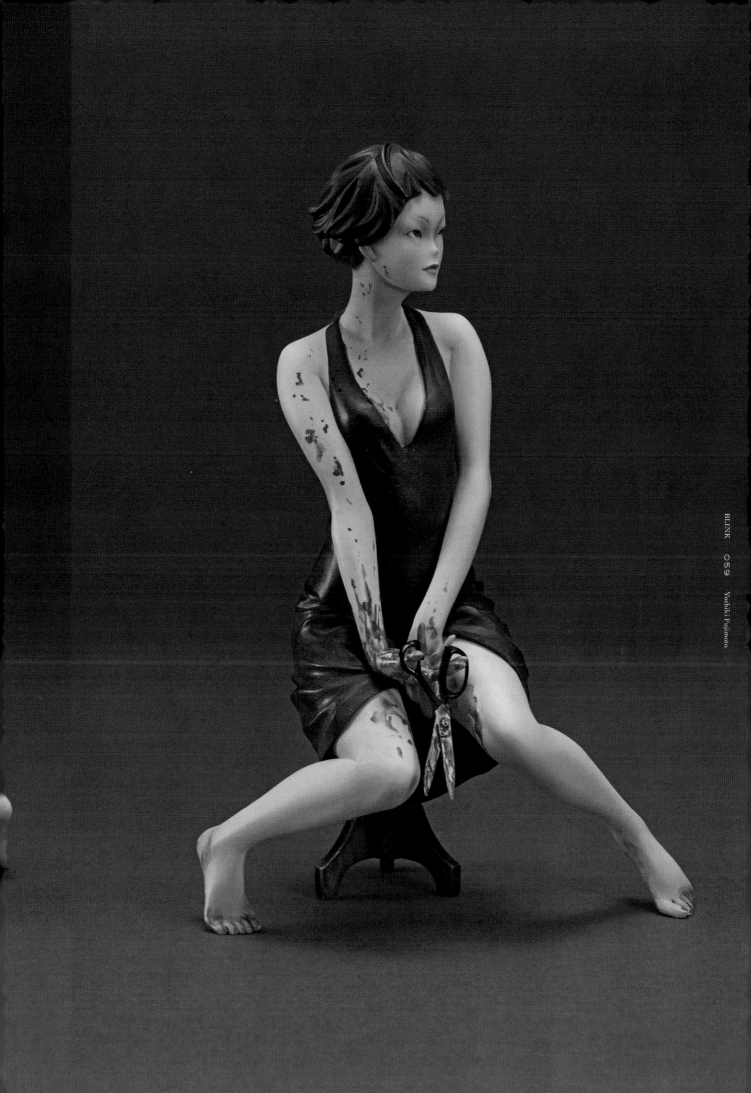

貓咪與鋼琴家

cat and pianist

□data＿2022 | □size＿全高約260㎜

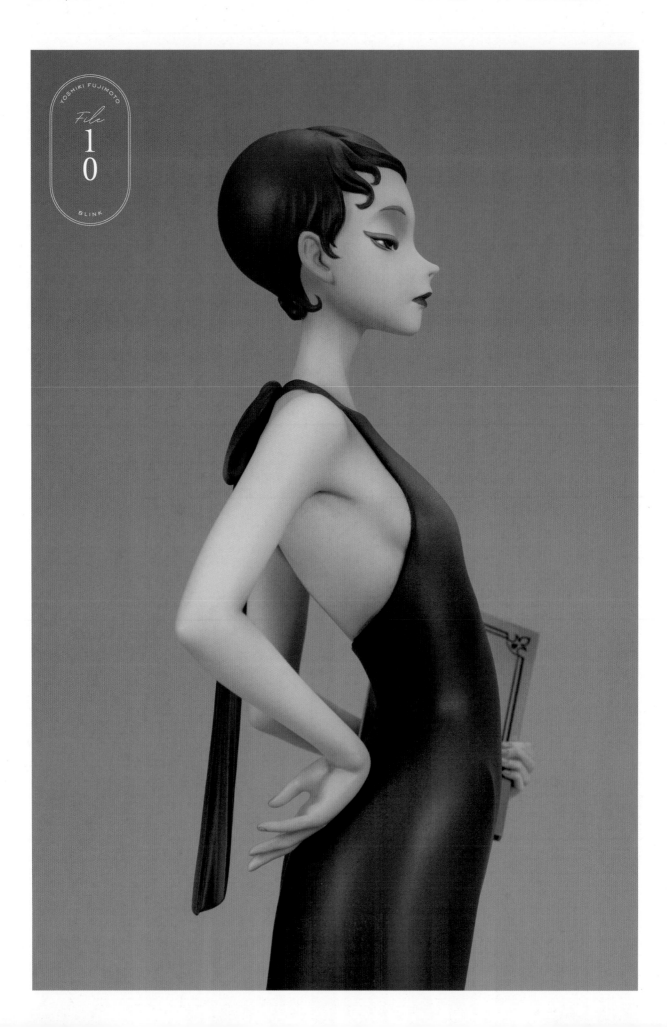

貓咪與鋼琴家

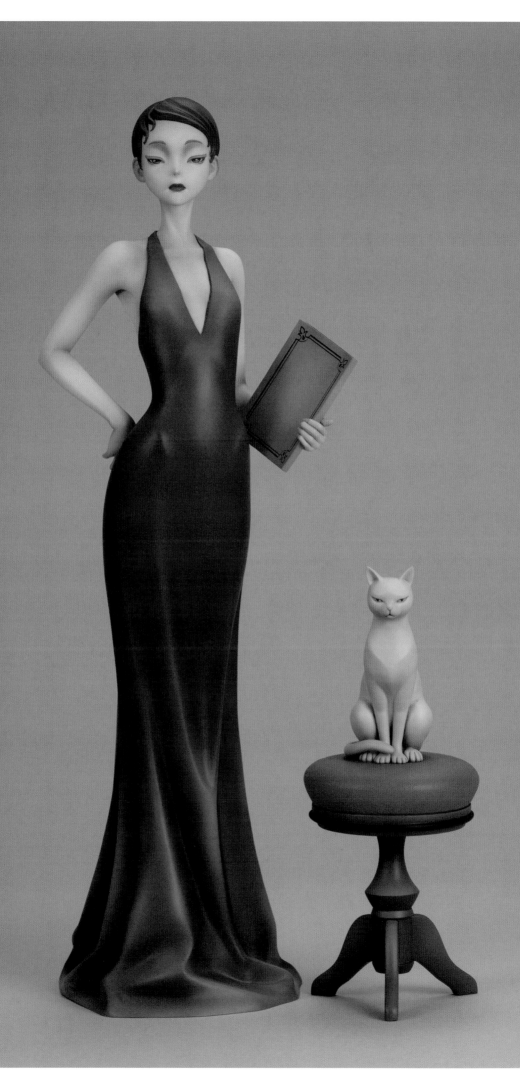

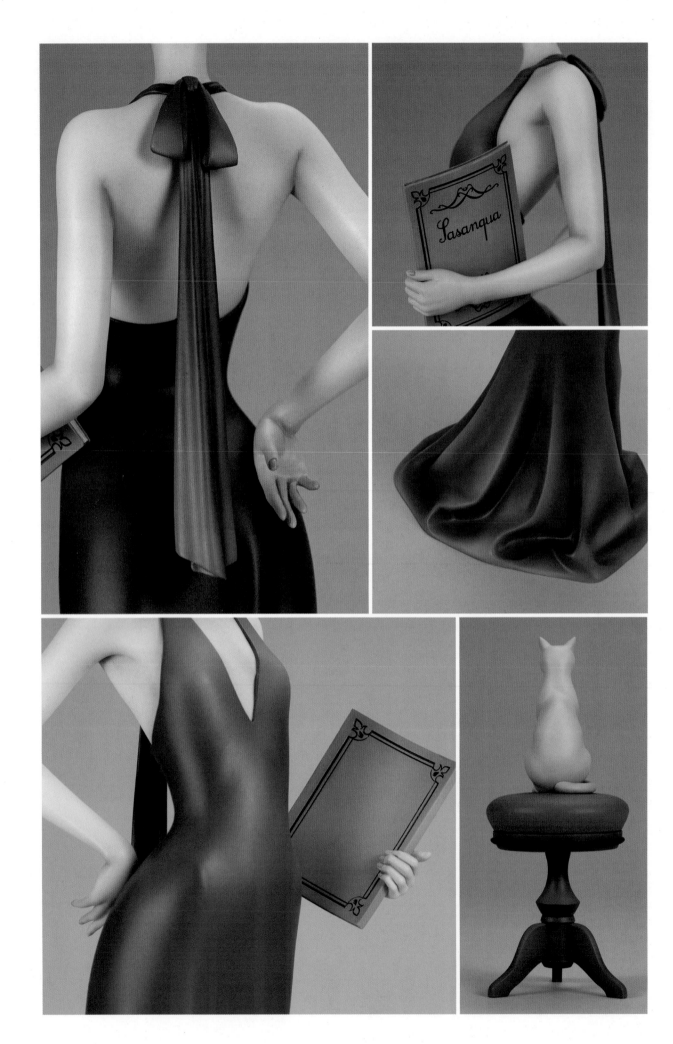

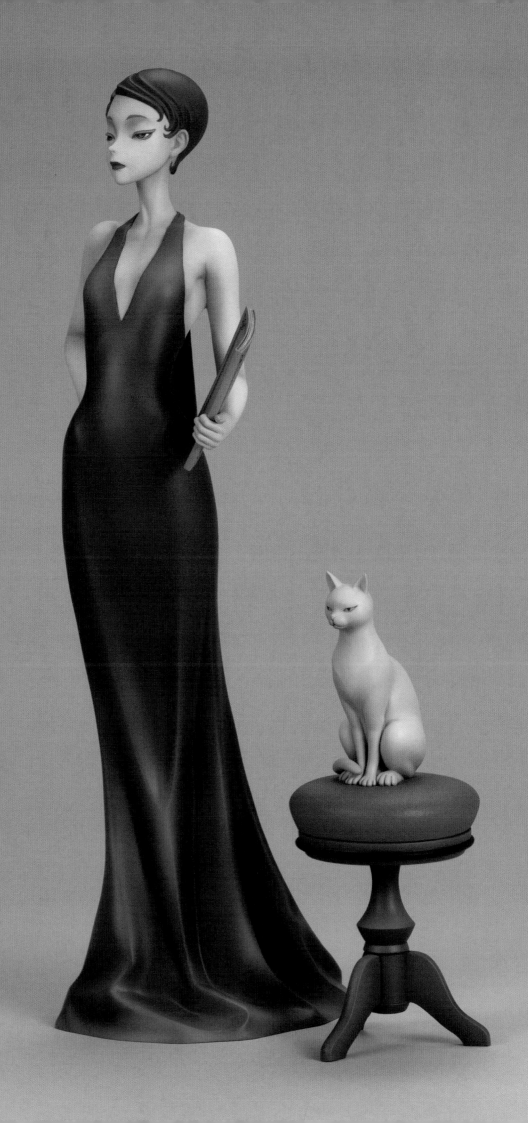

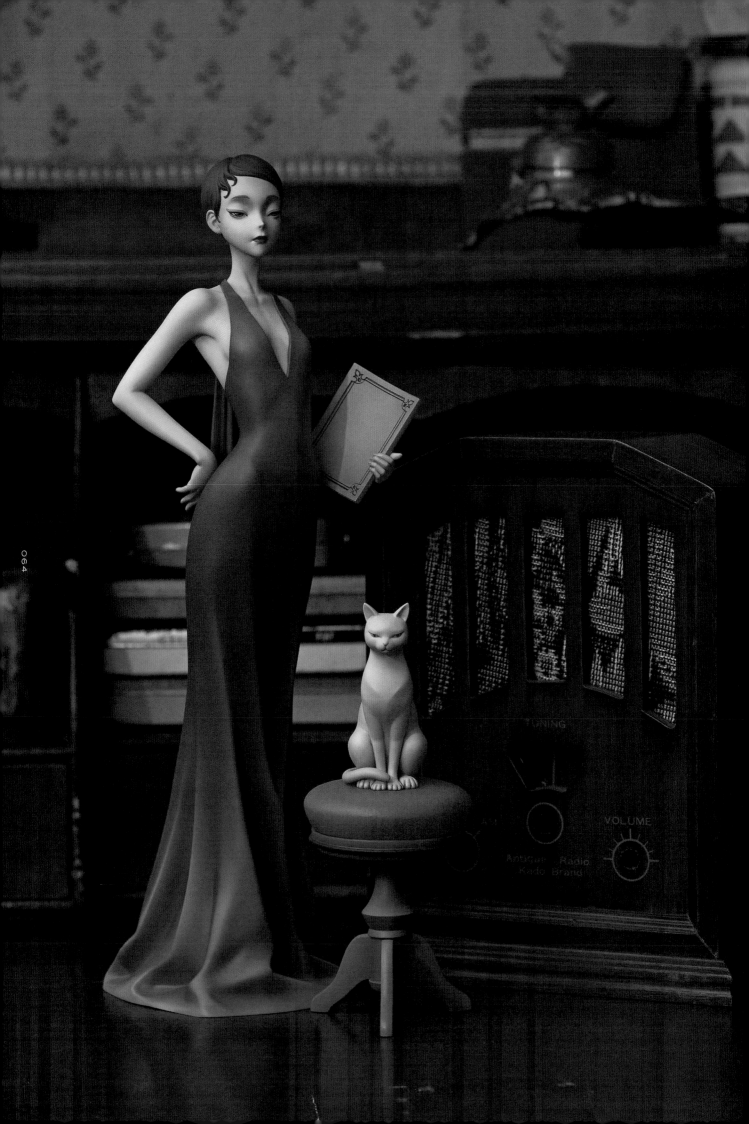

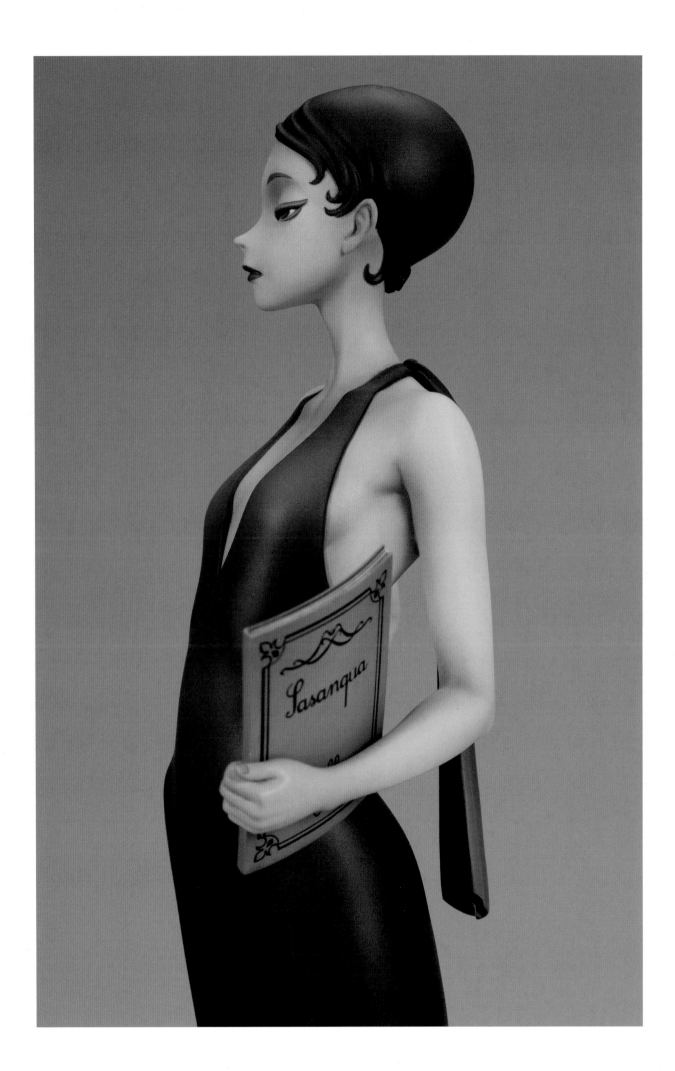

關於造形師 · 藤本圭紀的二三事

Junji Ito

伊 藤 潤 二

我第一次得知藤本圭紀的名字，是在他擔任KOTOBUKIYA推出1/10比例的異形 Big Chap原型製作的時候。

H.R.吉格爾所設計的異形既詭異而且複雜，但又同時具備一種調和的美感，而KOTOBUKIYA的Big Chap不僅整體形狀優美，特別是從雙重構造的可怕嘴巴延伸到長長的頭部尾端的線條極為巧妙，能夠重現到這種程度的人物模型可以說真的是難得一見。我在一瞬間就能夠看出製作出這個原型的藤本圭紀是一位真正的藝術家。

之後，藤本圭紀與豆魚雷的原田隼合作，推出了1/3比例的彎腰姿勢異形、1/2比例的頭像模型，還有以狂熱的概念為設計基礎的終極異形雕像。能夠擁有這些作品，實在讓我感到無上的喜悅。

因此，對我來說，一直將藤本圭紀認知為異形Big Chap的原型師，但最近我才知道，實際上他的作品不僅如此，原來他同樣擅長創作極具吸引力的女性人物模型。藤本先生的女性角色作品風格迥異，或者擬真寫實，或者經過變形，但所有的作品都以柔和的線條迷倒我們。表情生動，衣物的色彩美麗，充滿了無與倫比的才華。

透過異形的相關作品，已經證明了他擁有獨特的「洞察力」，以及將對象主題轉化為引人入勝的立體物的資質。我想感謝真正的藝術家藤本圭紀，感謝他能夠來到這個世界。

藤本先生，請繼續保重身體，為我們這些粉絲創作出更加精彩的作品吧！

2023年5月　伊藤潤二

I came to know Keiki Fujimoto when he sculpted the original mold for 1/10 Alien Big Chap from Kotobukiya. While the aliens designed by H.R. Giger are grotesque, intricate and yet beautifully harmonious, Kotobukiya's Big Chap, not to mention its overall form, was particularly exquisite in its lines, which shifted from a gruesome mouth with an inner mouse to a long head, and figures that could replicate this were rare. After that, Mr. Fujimoto teamed up with Mr. Jun Harada from Mamegyorai to bring 1/3 big-scale crouching aliens and the 1/2 scale Big Chap head, the ultimate alien statues backed by maniacal concept and detail. I couldn't be happier to own those pieces. For this reason, I had a perception that Mr.Fujimoto was the original mold sculptir of Alien Big Chap, but I recently learned that he is also masterful at sculpting attractive female figures.

Mr. Fujimoto's female characters are so varied, realistic and sometime deformed, but every work charms us with its soft lines. The expression is lively, the colors of the clothes are beautiful, and there is an unrivaled brilliance.

His Alien statues proves his ability see with his good eye and to create objects attractively. I would like to thank the real artist, Keiki Fujimoto, for his good fortune in coming to life. I would like to thank my good luck that a real artist, Keiki Fujimoto, has come into this world. Mr.Fujimoto, please take care of yourself and continue to create wonderful works for us fans!

May 2023 Junji Ito

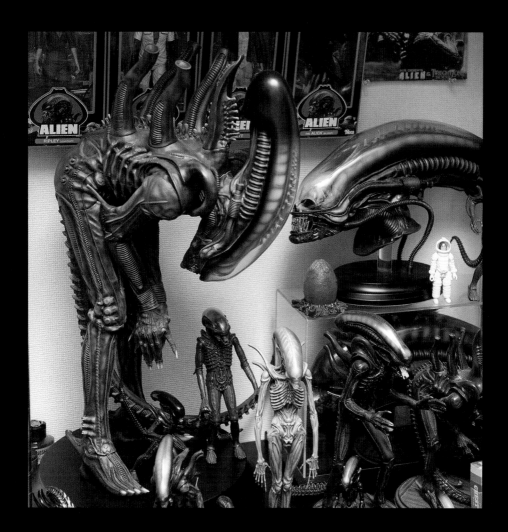

1963年7月31日，出生於岐阜縣中津川市。高中畢業後，進入牙科技工學校，從事相關工作，後來因為想要讓楳圖一雄看看自己的漫畫作品，投稿了《月刊ハロウィン》（朝日ソノラマ）新創設的新人漫畫賞「楳圖賞」。1986年，以投稿作品《富江》獲得佳作。這部作品成為他的出道之作，也是代表作之一。3年後，辭去牙科技工的職務，專心從事漫畫家的事業。他創作了一系列傑作，如《沒有道路的街道》、《人頭氣球》、《雙一》系列，以及《至死不渝的愛》等。自1998年起，在《ビッグコミックスピリッツ》（小學館）上連載《漩渦》。

之後，他繼續發表了像《魚》以及《潰談》等獨一無二的作品。在世界上最具權威性的漫畫獎之一，美國艾斯納獎上，他的作品《伊藤潤二傑作集第10卷 科學怪人（英文版）》在2019年榮獲「最優秀改編漫畫作品獎」，開啟了一系列的榮譽，於2021年獲得兩項獎項，並於2022年連續獲得該獎，共計四次獲獎。而在2023年，他的卓越成就受到肯定，獲得法國安古蘭國際漫畫節的特別榮譽獎。

He was born in Nakatsugawa City, Gifu Prefecture on July 31, 1963. After graduating from high school, he enrolled in a dental technician's school and was hired, but after the establishment of the "Monthly Halloween" (Asahi Sonorama) New Artist's Manga Award "Umezu Award," he submitted his work with a single-minded determination that he wanted Mr. Umezu to read his work.In 1986, he received an honorable mention for 'Tomie', the manga that will be his debut and representative work. Three years later, he quit his job as a dental technician to focus on the comic book writing and went on to create such masterpieces as "Town of No Roadsku" "The Hanging Balloons", "Soichi" series, and "Lovesickness". In 1998, he began serializing "Uzumaki" in Big Comic Spirits magazine (Shogakukan).He continued to release his one-of-a-kind works such as' Gyo 'and' Smashed'. At the Eisner Awards in the United States, one of the most prestigious comic book awards in the world, Junji Ito's 10 volume Frankenstein (English version) won the Best Comicalized Work award in 2019, and since then he has won the award in 2 categories in 2021 and again in 2022, winning a total of 4 times. In 2023, he was awarded a Special Honor Award at the Angoulême International Comics Festival in France in recognition of his achievements.

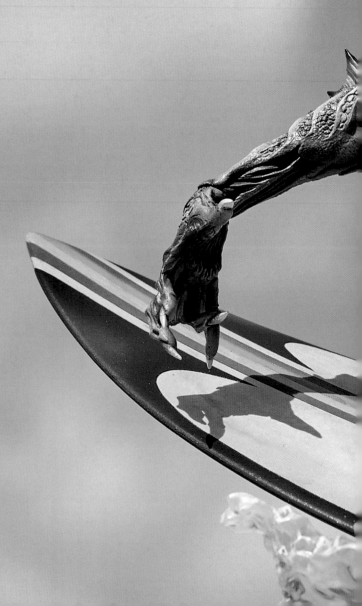

Candy Lagoon

Candy Lagoon □data＿2019 □size＿全高約190㎜

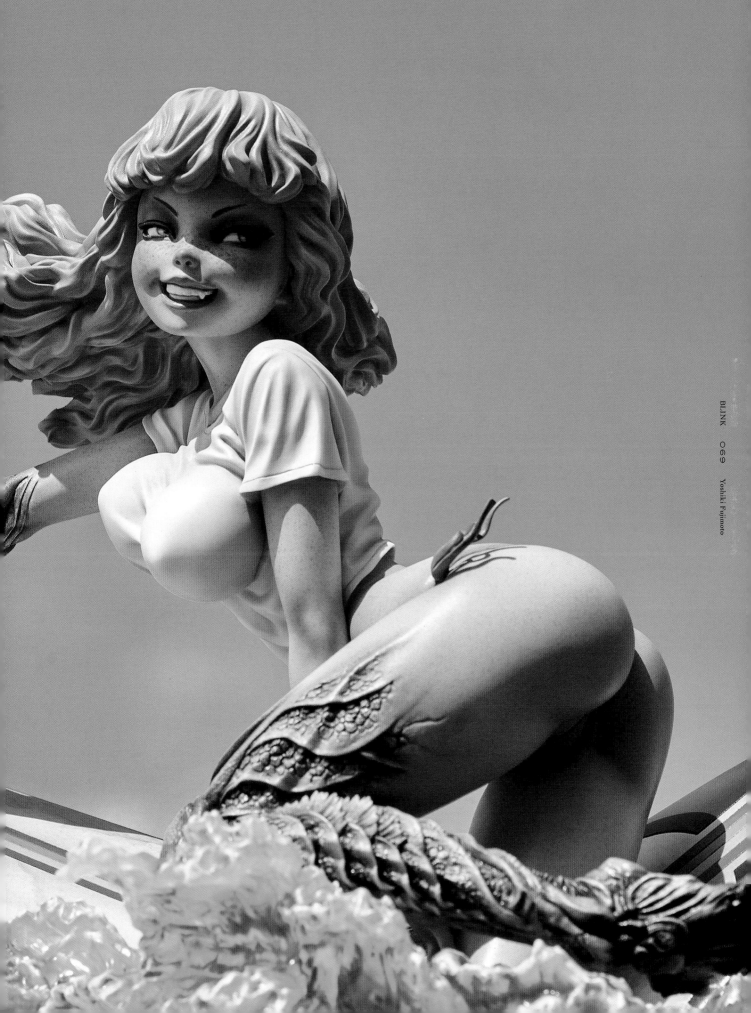

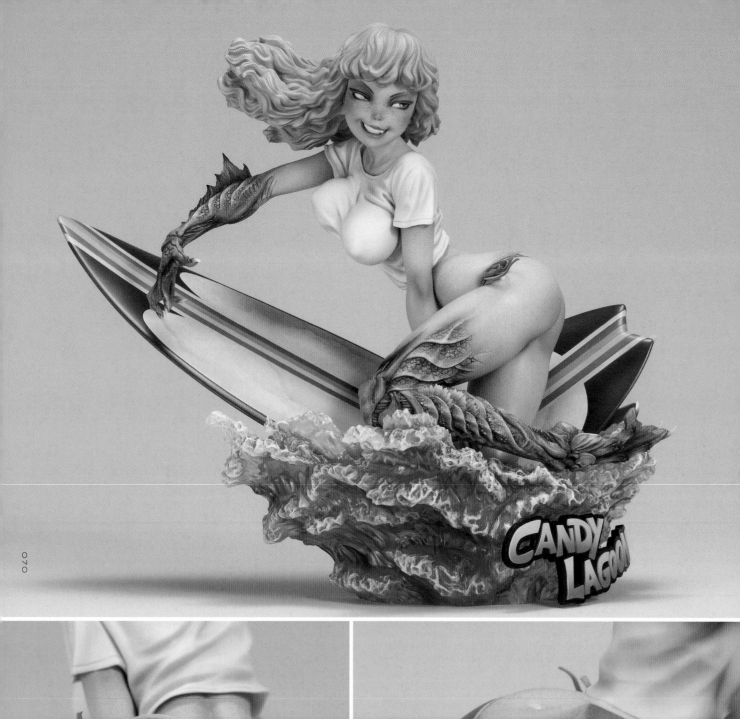

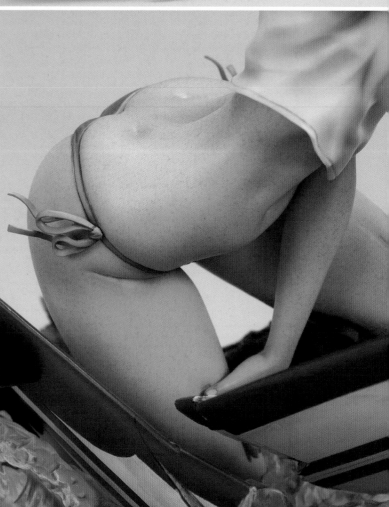

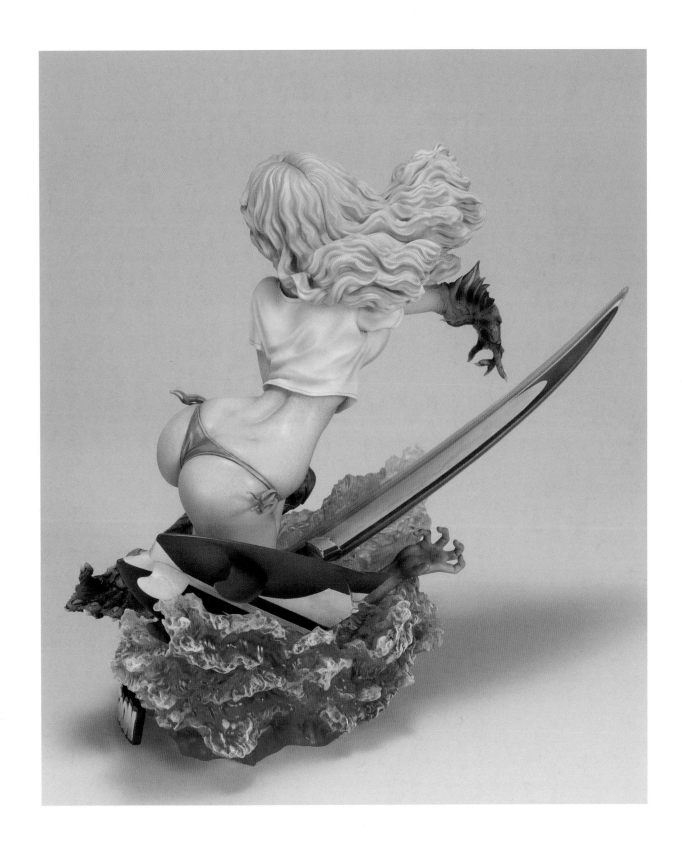

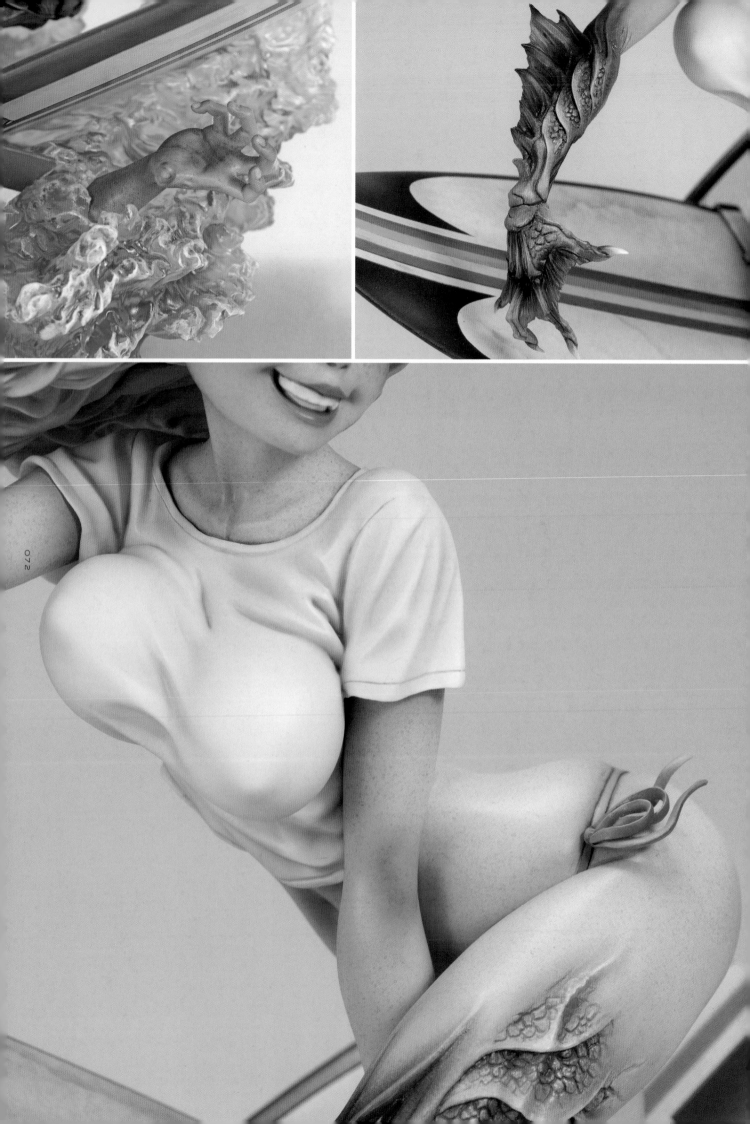

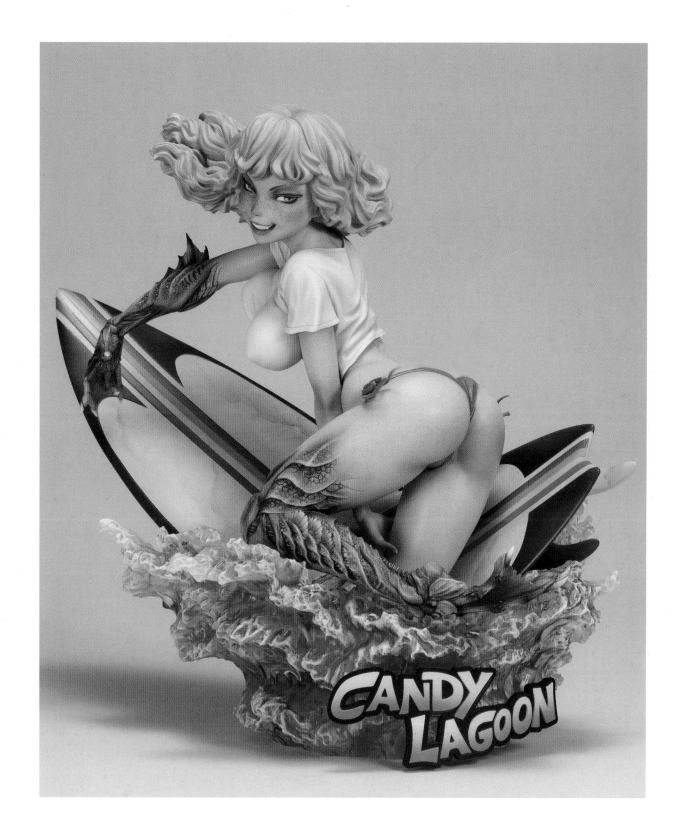

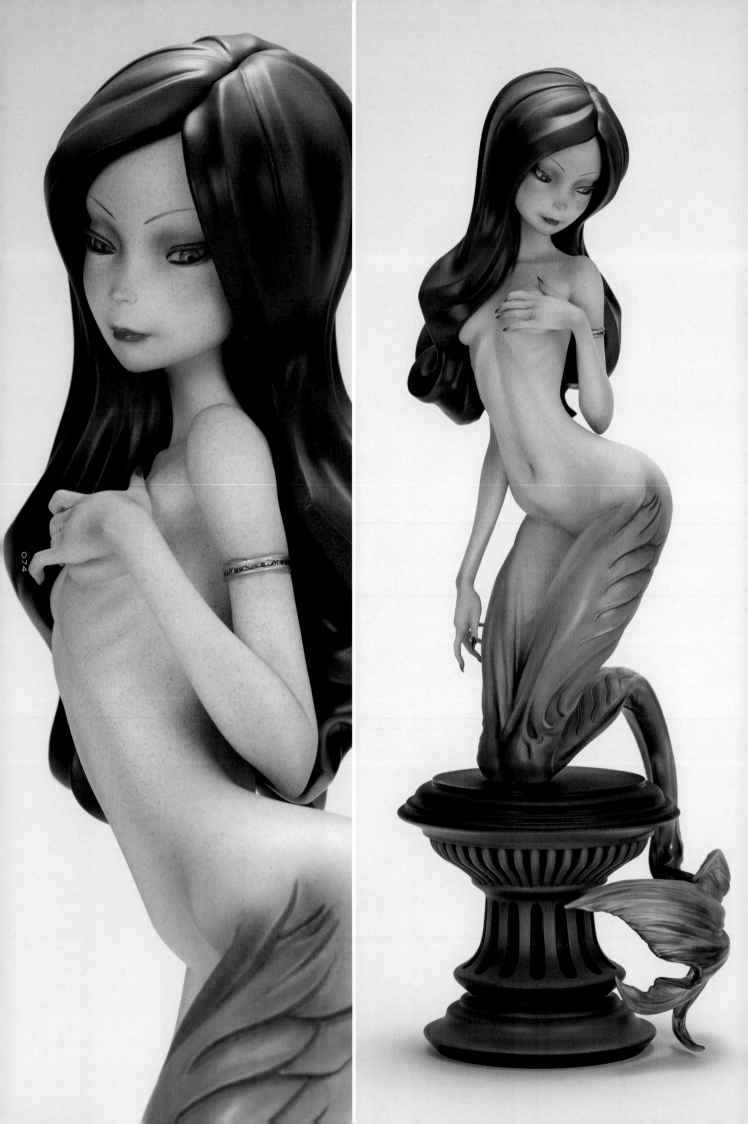

魅伊

May

□data _ 2017　　　　□size _ 全高約300㎜

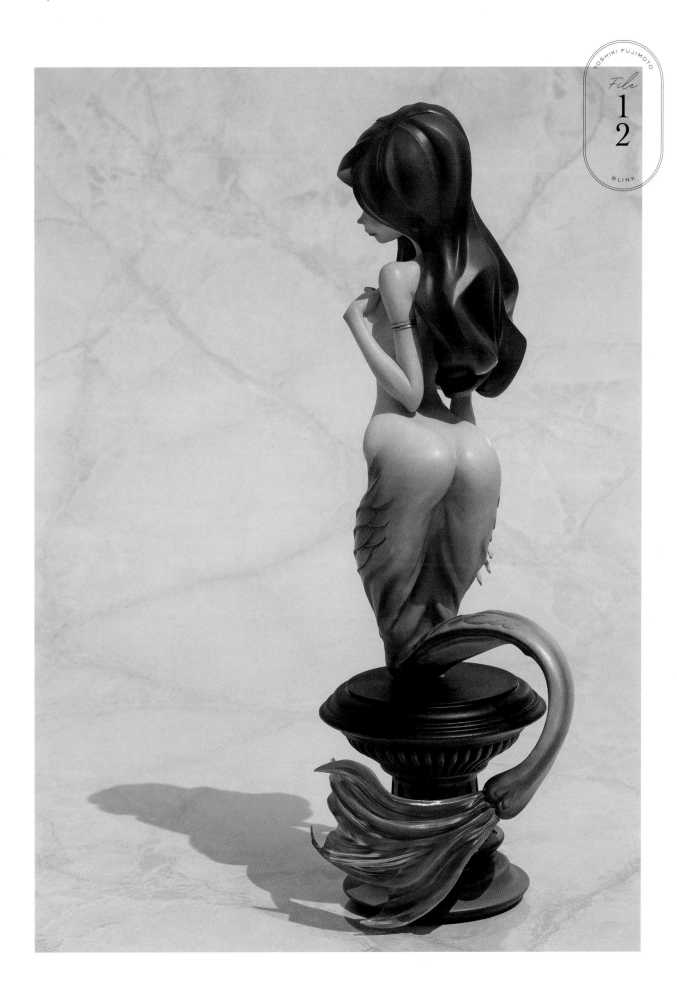

YOSHIKI FUJIMOTO

File

1
2

BLINK

BLINK　075　Yoshiki Fujimoto

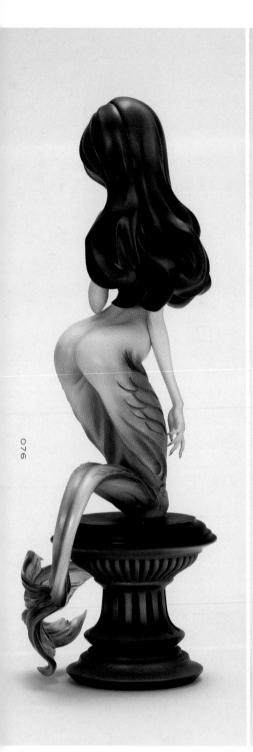
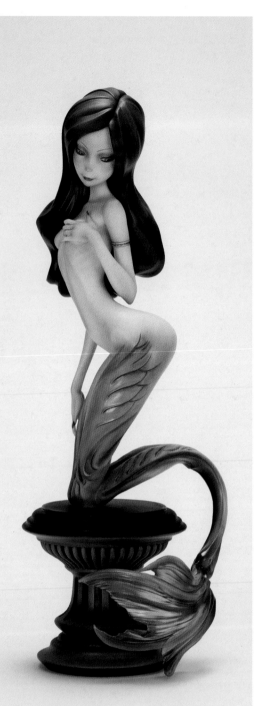
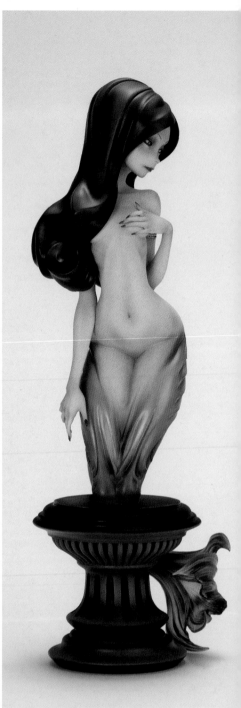

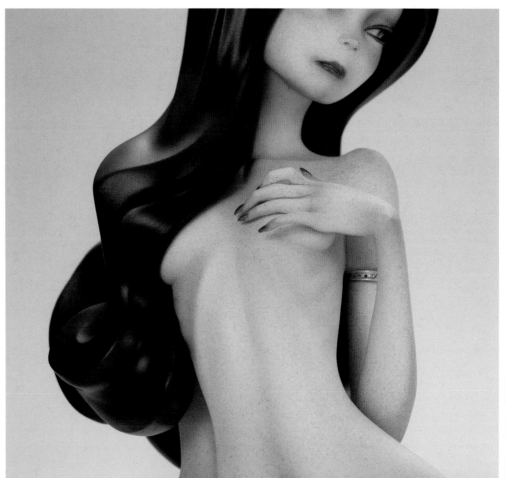

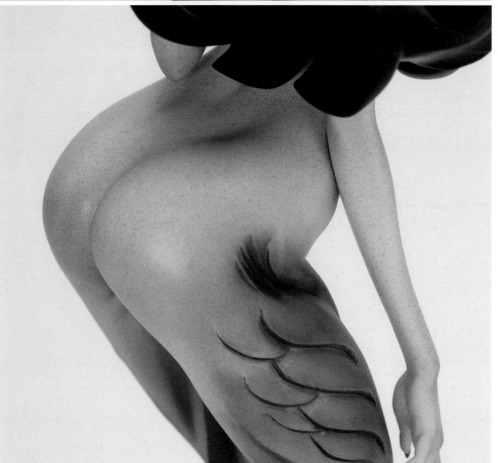

Embrace the Pain

Embrace the Pain

□data — 2022 | □size — 全高約180㎜

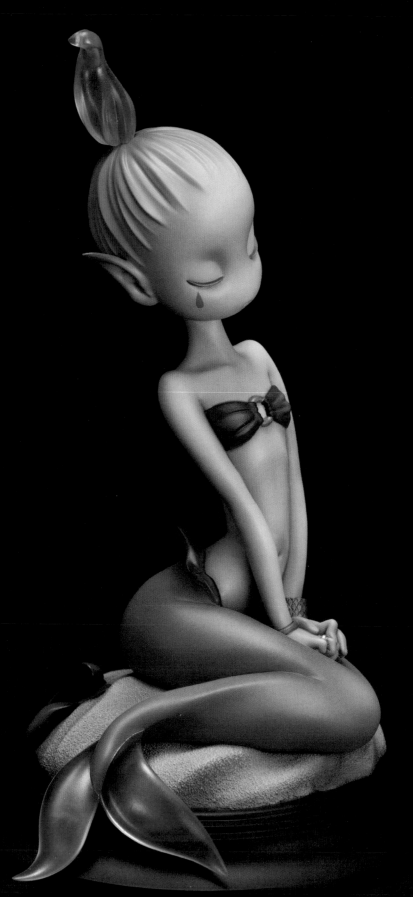

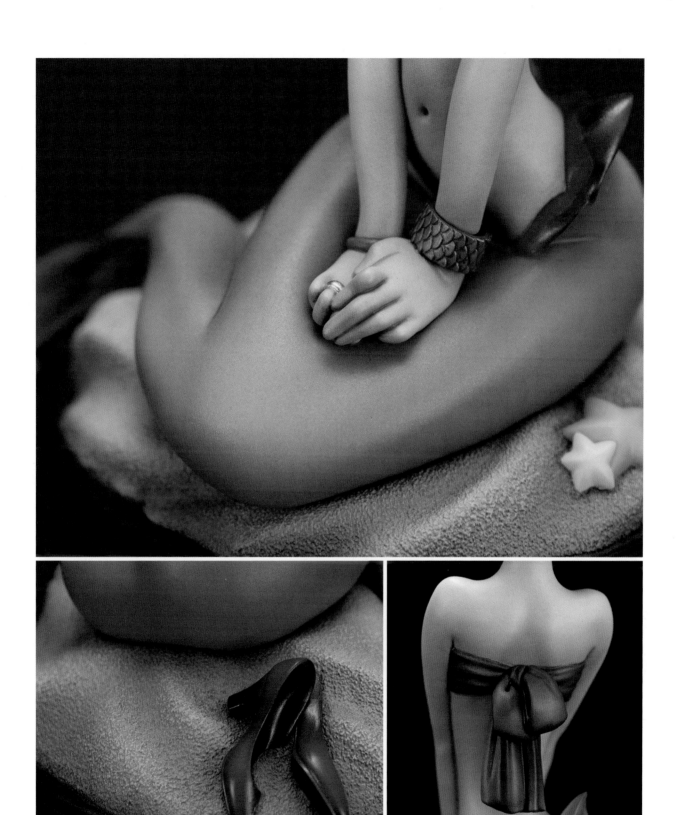

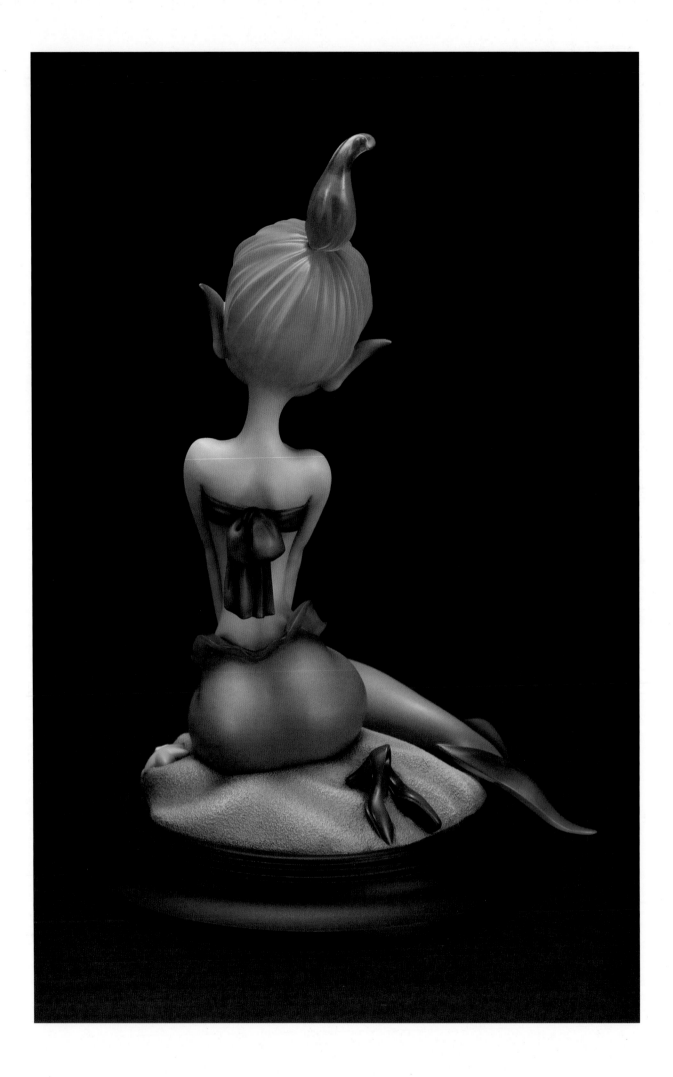

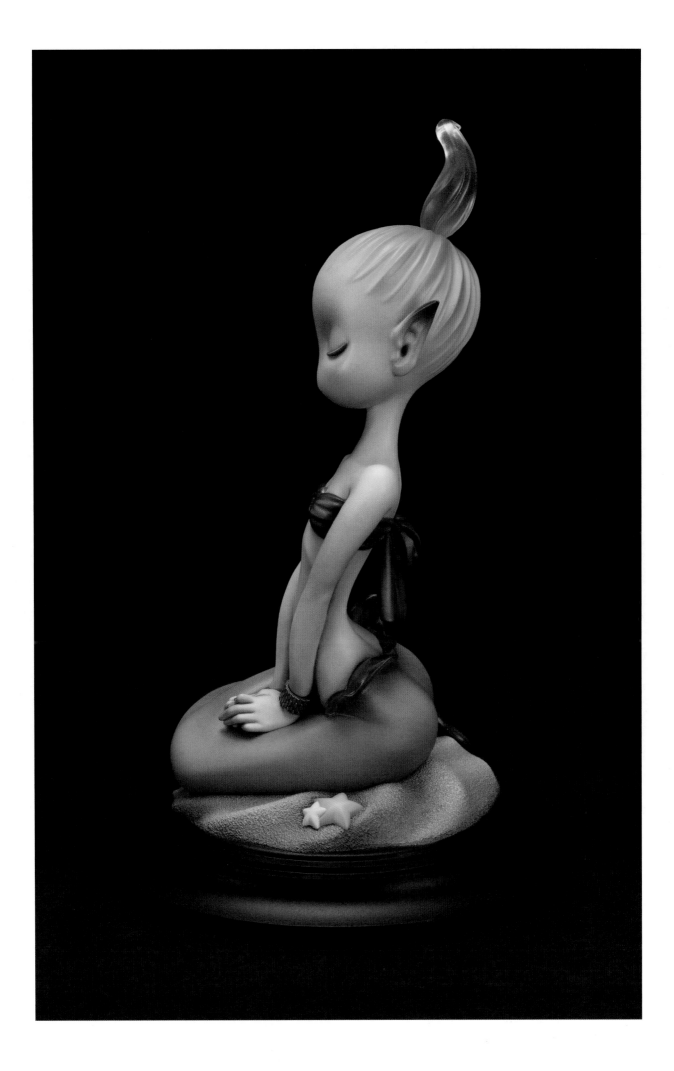

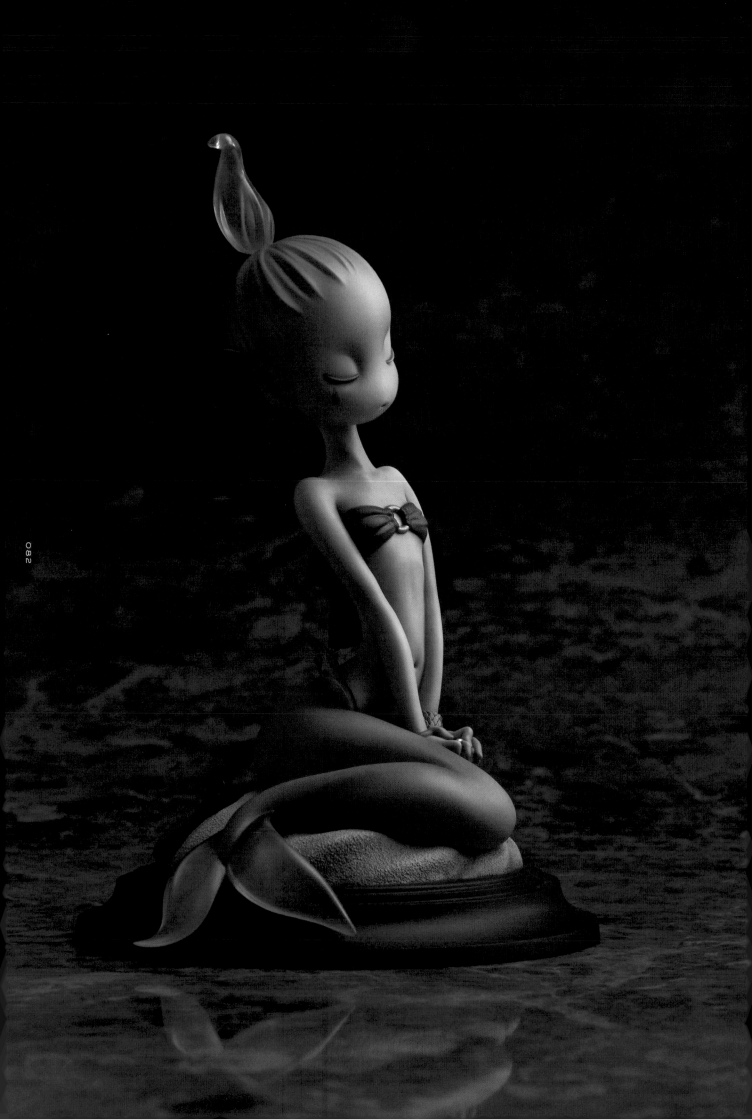

構成藤本圭紀的元素

1 依興趣收集的玩具和人物模型，以及作為商業原型參與的工作，都陳列其中。**2** 藤本在幼年時期接觸到大貫妙子的《 Metropolitan Museum 》這首歌的影像作品，對他影響深遠，甚至可能是現在所有一切的根源。樂曲搭配人偶動畫的畫面，深深地觸動了藤本少年的心靈。**3** 書架上收納了許多書籍，包括繪本、兒童文學（最喜歡的是姆米）和插畫集，其中還有特攝作品的人物模型。**4 5 6 7** 藤本在剛到東京時的水彩畫，描繪了一個女孩在屋外玩耍的情景。這種獨特的世界觀與他現在的作品風格仍然相通。

1 Toys and figures that he collected as a hobby, as well as those he worked on as a commercial prototype, are also on display. **2** A video work that had such a great influence on me that I think it may have its roots here is Taeko Onuki's "The Metropolitan Museum of Art," which I encountered as a child. The music and the puppet animation images pierced the young Fujimoto's heart sharply. **3** The racks that hold picture books, children's literature (his favorite is Moomin), illustration books, and many other books are lined with special effects figur **4 5 6 7** A watercolor painting she did when she first moved to Tokyo depicts a young girl playing outside her house.

BLINK 083 Yoshiki Fujimoto

藤本圭紀從小就喜愛畫畫和玩黏土。在父母的影響下，他也有很多接觸電影和音樂的機會。青少年時期，他熱衷於樂隊活動，不僅擔任主唱，還進行原創歌曲的作詞和作曲。儘管曾經考慮過朝向音樂之路發展，但同時他對繪畫和雕塑的興趣愈來愈濃厚，加上受到曾經學習過繪畫的母親的影響，他最終決定進入藝術大學就讀。在大學期間，他曾經擔任過兒童繪畫課的講師，並從孩子們身上學到了很多。漸漸地，藤本開始萌生「我也想要親手創造出曾經讓自己在幼年時期從各種藝術作品中感受到的那份感動」，並開始探索實現這個目標自己所能做的事情。有一段時間，他想成為一位繪本藝

術家，並且致力於水彩畫的創作。然而，他對「實際可以觸摸的東西」，如立體物件以及造形物等，產生了濃厚的吸引力，最終選擇了造形的道路。幻想、想像和記憶，這是他自小以來構想的世界。表達這個世界最適合的方式就是透過造形。藤本表示，他感覺到造形和音樂創作有共通之處，都是透過添加伴奏（細部細節）的方式，來完善以旋律（內芯）為軸心的作品。他認為這樣的過程和造形的步驟，感覺上好像是使用相同的大腦功能。藤本進一步的表示「我想要創造的東西是無窮無盡的」。在他內心裡，總是有一件又一件等待著誕生到現實世界的事物。

Yoshiki Fujimoto has loved drawing and playing with clay since she was a child. Her parents also gave her many opportunities to be exposed to movies and music. In his youth, he was passionate about playing in a band, where he not only sang vocals but also wrote lyrics and composed original music. He once considered a career in music, but at the same time his interest in painting and sculpture grew, and under the influence of his mother, who had taken painting lessons in the past, he decided to enter an art college. While at the university, he taught children's art classes and learned a lot from the children. Eventually, Fujimoto began to develop a desire to "create his own works of art, which he had been moved by when he was a child," and he sought out what he could do to achieve this goal. There was a time when he wanted

to be a picture book artist and worked on watercolor paintings. However, he was strongly attracted to "things that can actually be touched," such as three-dimensional objects and sculptures, and he finally chose the path of modeling. Fancy, imagination, and memory, the world he has envisioned since his childhood. The most suitable way to express this world is through modeling. Mr. Fujimoto says he feels that modeling and music-making have something in common. He adds accompaniment (details) to the melody that serves as the axis (core), and then builds it up. He feels that this process and the process of modeling are the same way of using the brain. Fujimoto says, "There is no end to the things I want to create. There is always a line of things waiting to be created in the real world.

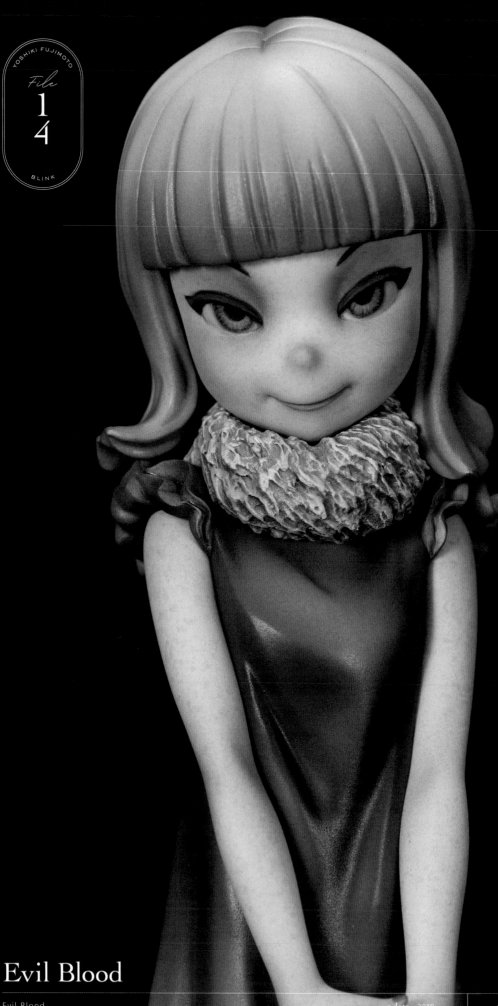

Evil Blood

Evil Blood

□data - 2019　　　□size - 全高約180㎜

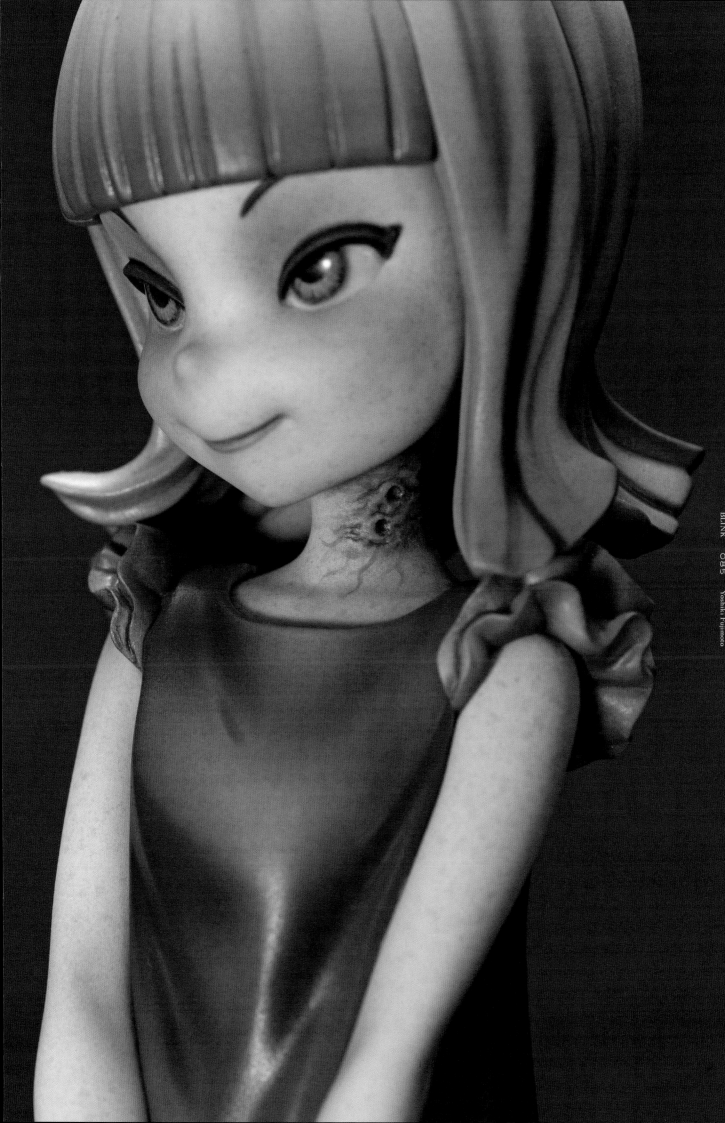

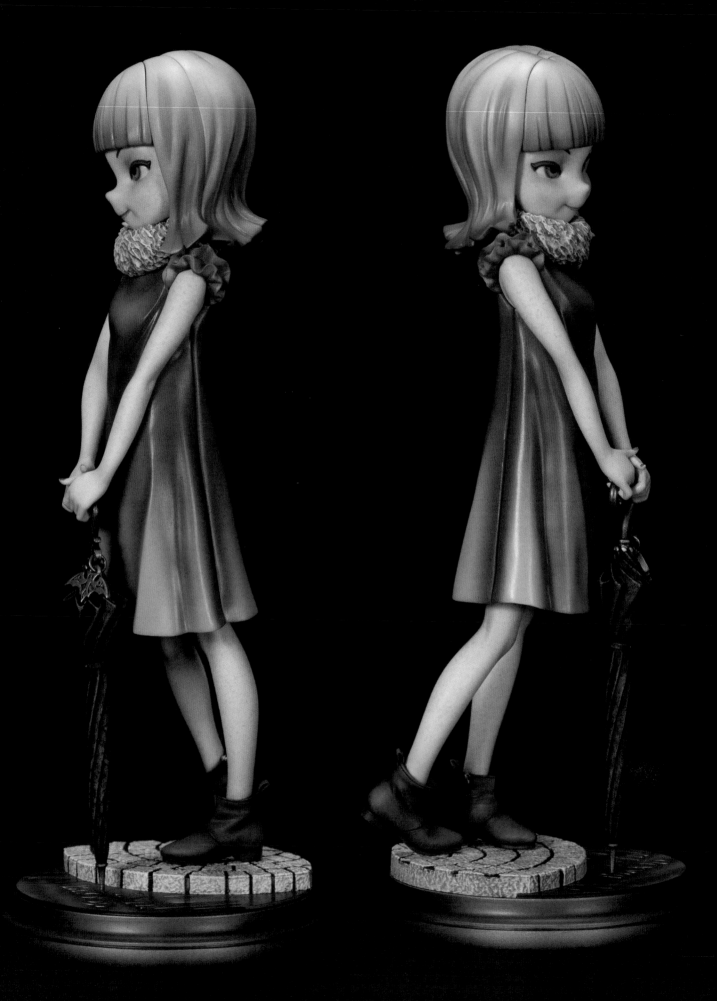

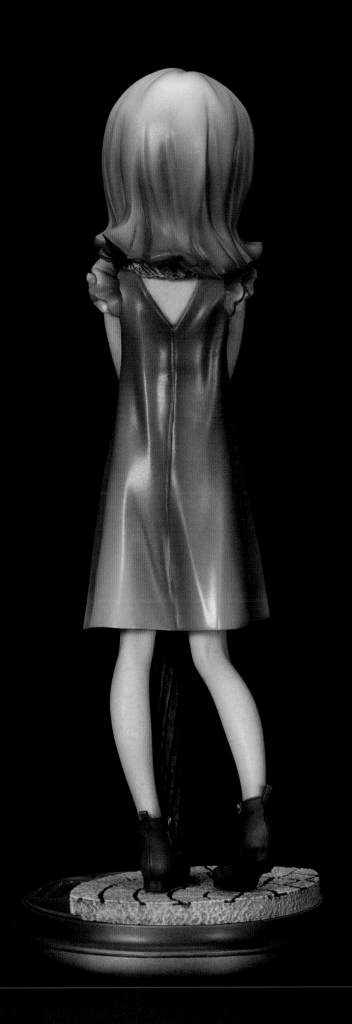
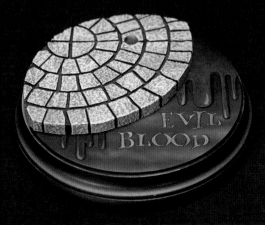
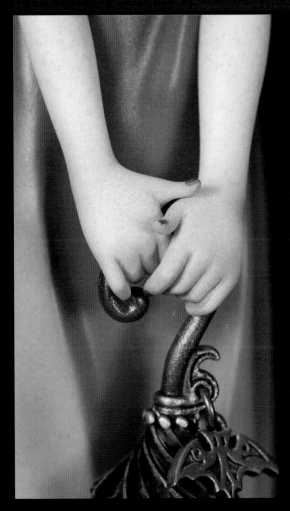

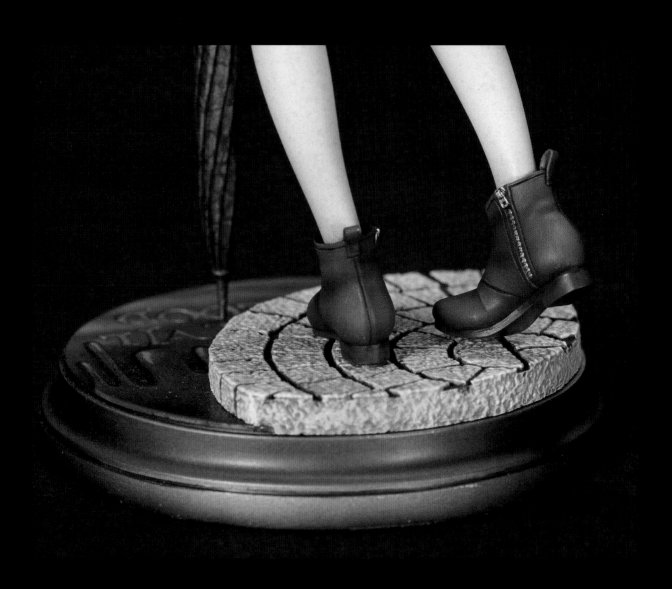

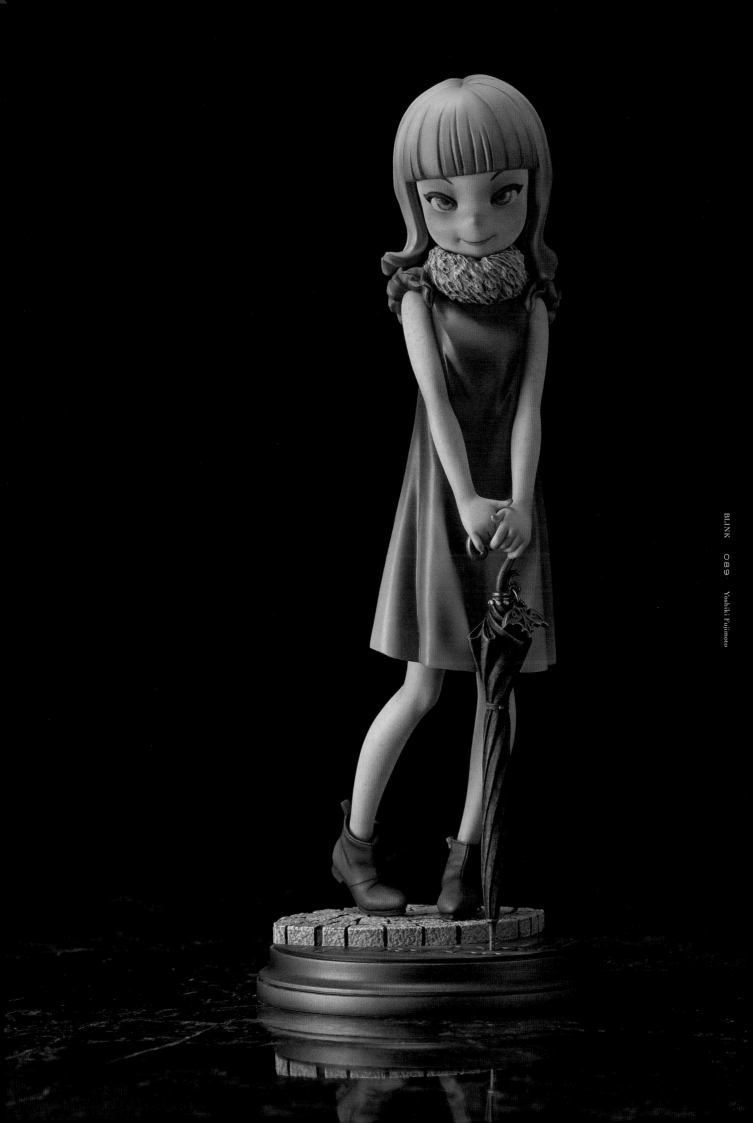

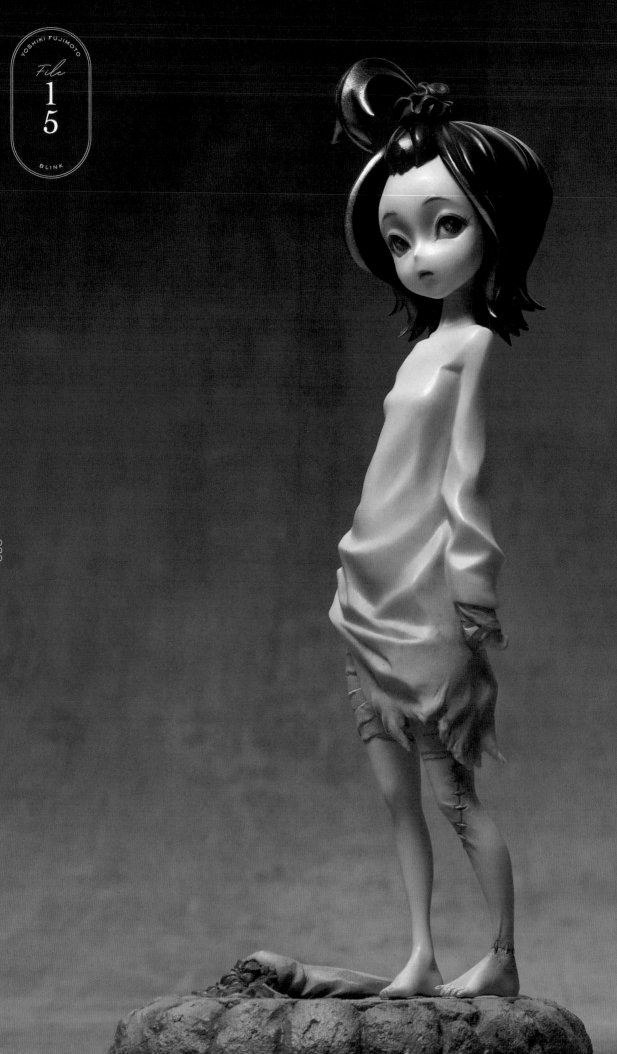

Little Bride

Little Bride

BLINK 091 Yoshiki Fujimoto

□data_2014 □size_全高約175㎜

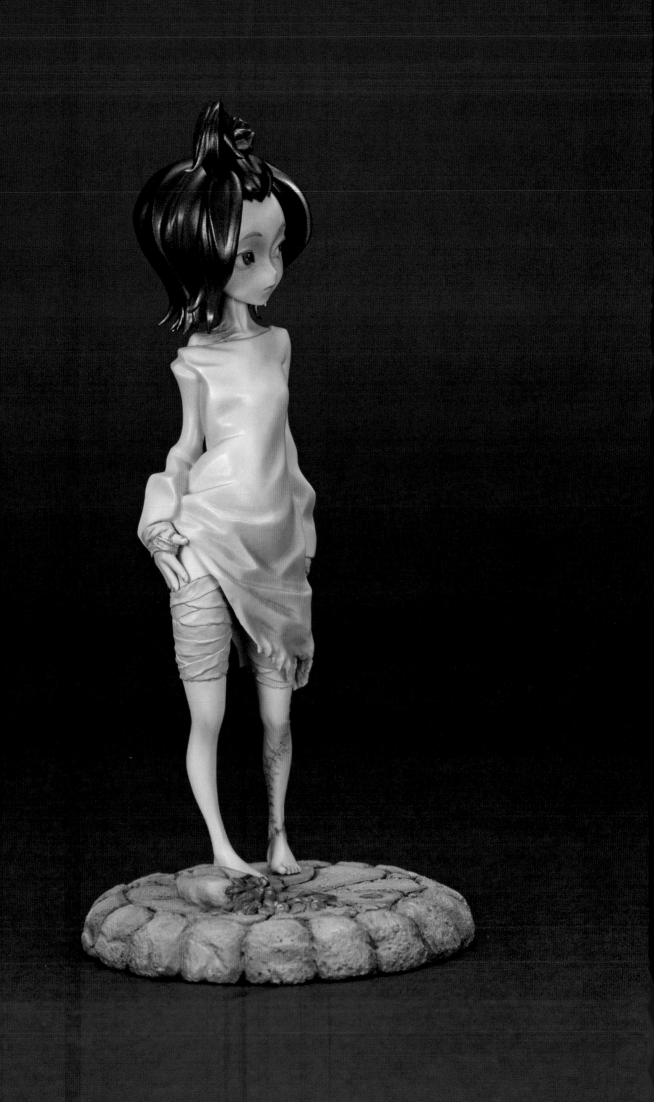

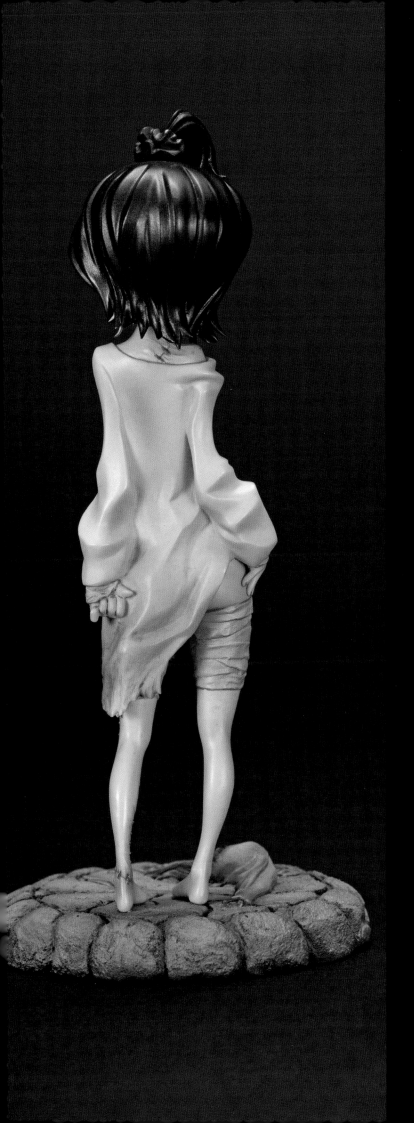
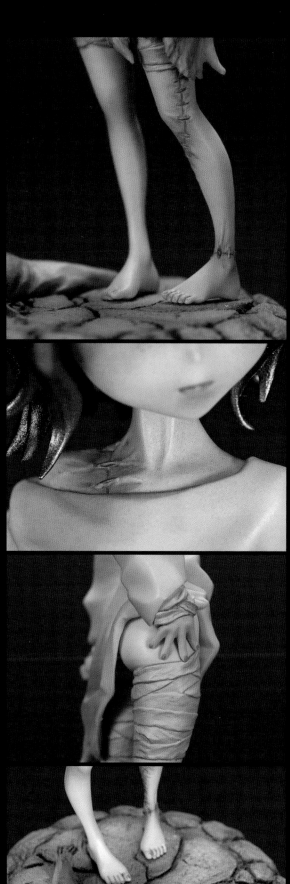

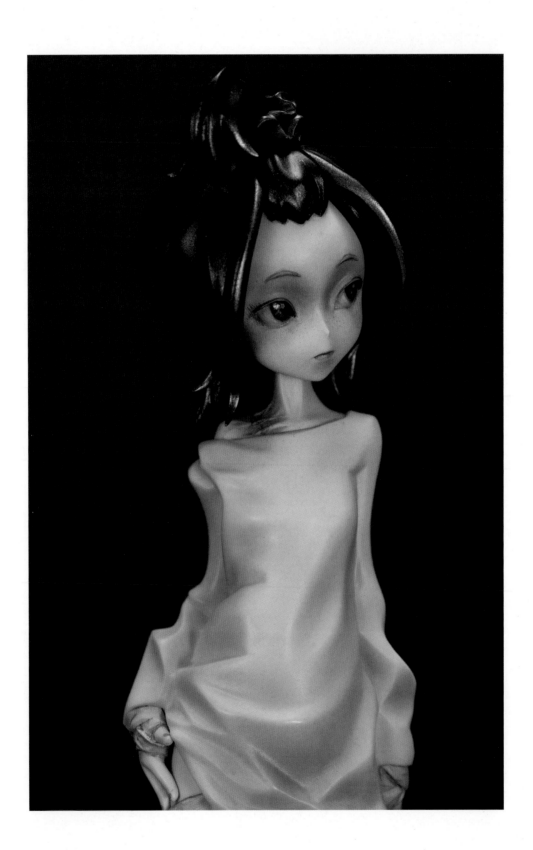

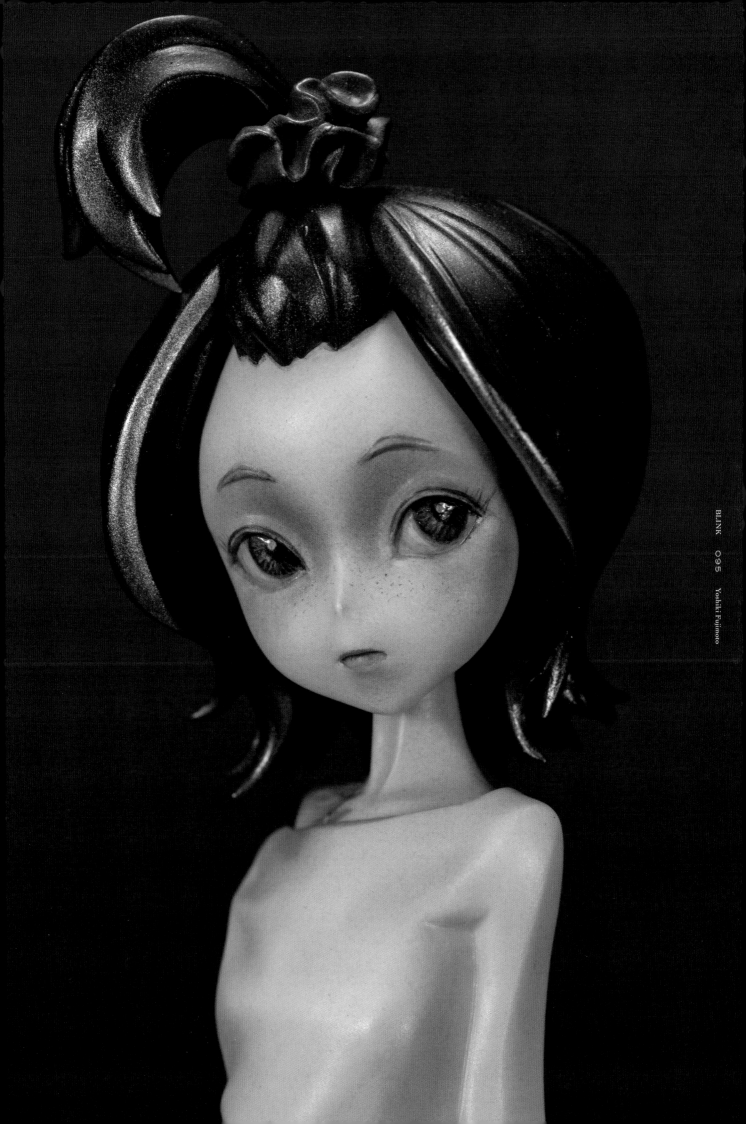

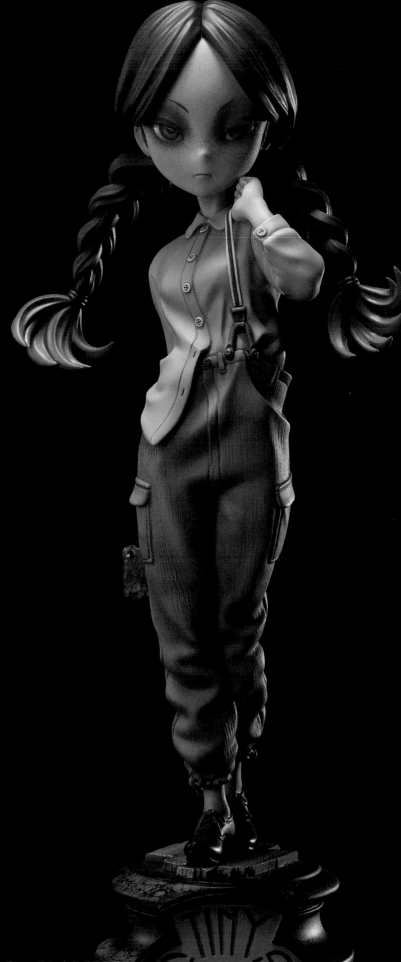

TINY CLEAVER

TINY CLEAVER

□data＿2018 □size＿全高約195㎜

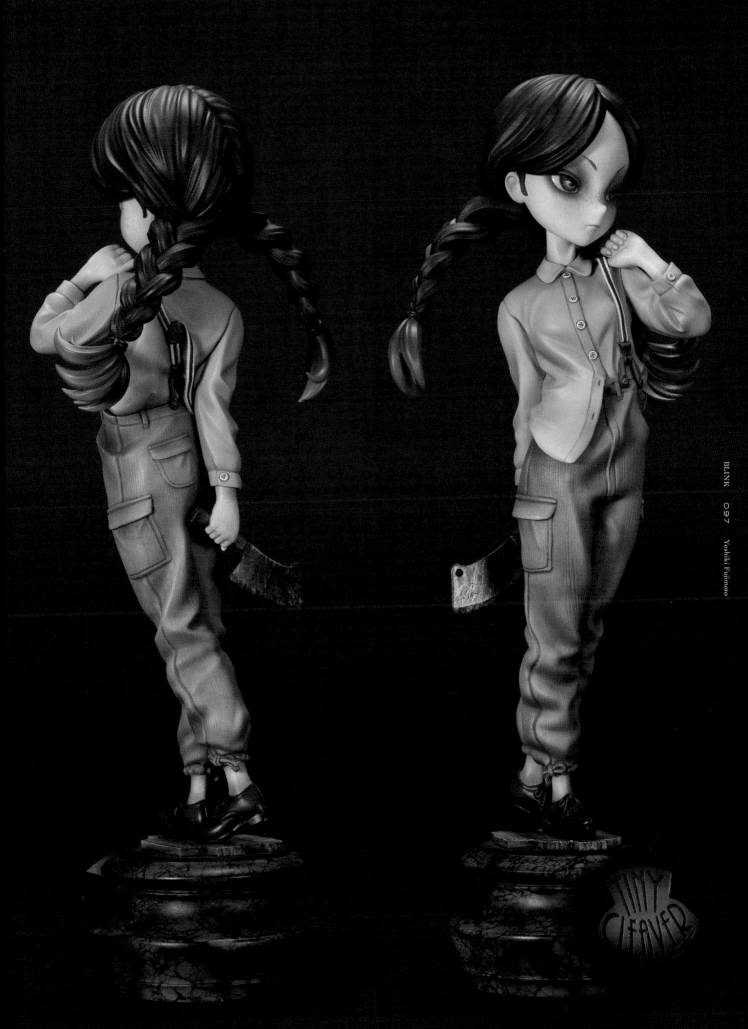

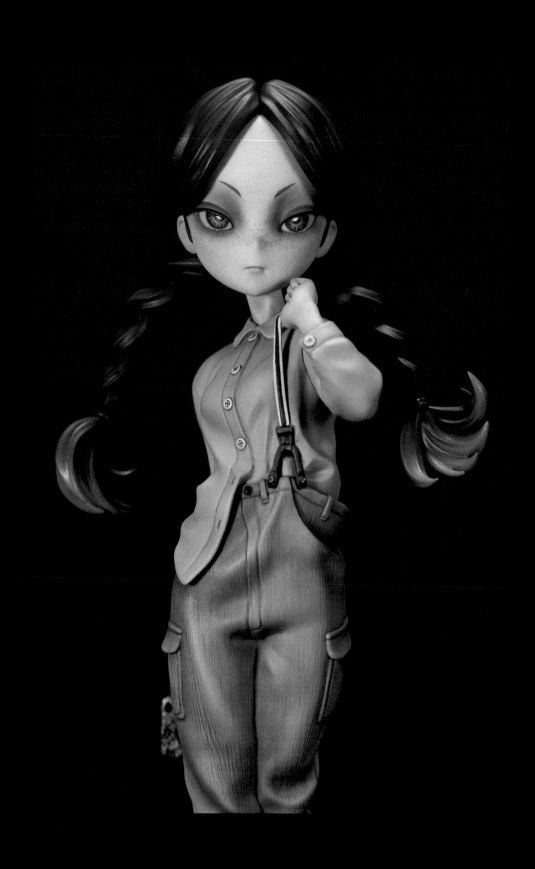

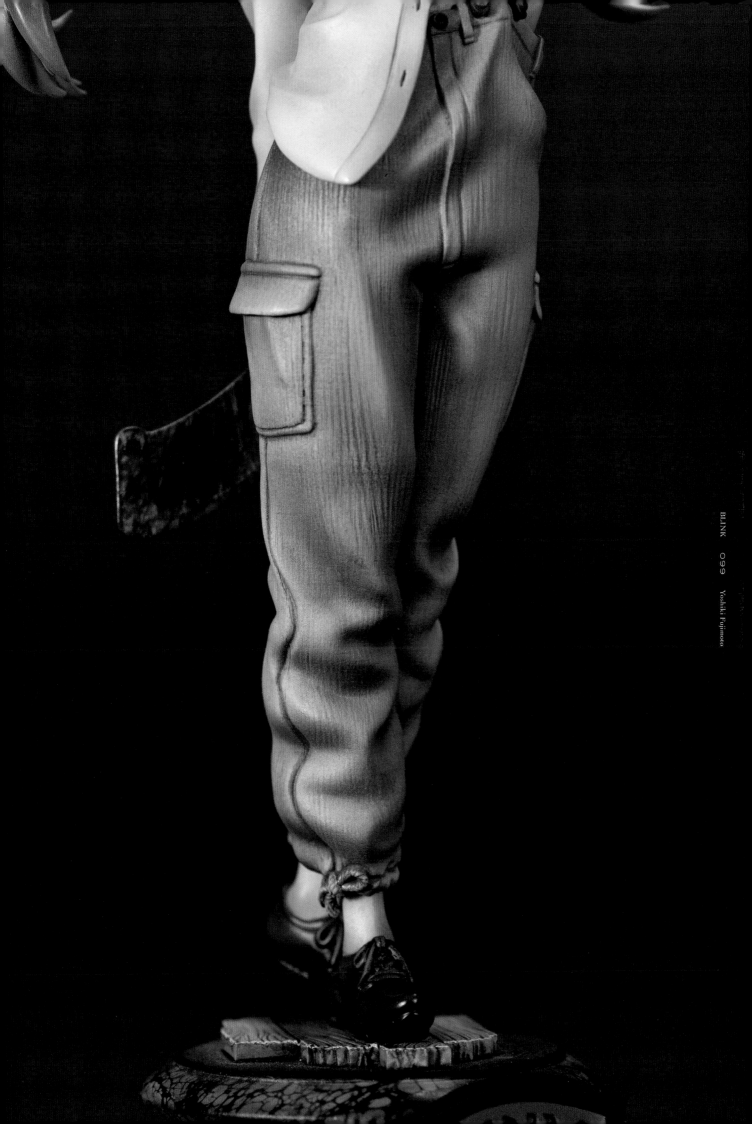

在工作室裡，主要進行數位原型輸出後的改進、整理以及上色等手雕作業。在主要的工作桌上放置一個訂製的大型NERO BOOTH噴漆台，且房間的通風也經過到充分的考量。金屬製噴漆台的內部裝上了磁鐵，用來配置固定經常使用的電動工具的鑽頭。此外，桌子抽屜中也配備了各種工具，用來整形和調整輸出後的原型。由於藤本一開始只以手雕作業的方式來製作原型，所以相關的工具種類非常豐富。3D列印機有三台，分別是Form2、Sonic Mini 8k以及Sonic Mighty 8K。像這樣隨時都能夠將數位檔案輸出成實體的工作環境，相信對於數位建模的造形創作者來說是必不可少的環境。塗裝作業所需要的所有用具都整齊地擺放在工作桌的右側。使用的塗料主要是硝基系和琺瑯系塗料。大部分的塗裝作業主要使用噴槍，臉部塗裝和細部修飾則是使用筆塗。由於藤本在原型製作公司工作時，曾有負責製作工廠塗裝上彩樣本（商業人物模型的量產上色樣本）的經驗，所以很習慣使用噴槍進行整體修飾。

In the workshop, analog work such as brushing up, finishing, and coloring of output prototypes is mainly performed. A custom-built large Nero booth is set up at the main work desk, and the room is well ventilated. The inside of the metal booth is fitted with magnets and bits for frequently used motor tools. The desk drawer is also fully equipped with tools for shaping and adjusting the output prototype. Three 3D printers are installed: Form2, Sonic Mini 8k, and Sonic Mighty 8K. The ability to output data at any time is an indispensable environment for modelers who do digital modeling. All necessary painting supplies are placed together on the right side of the work desk. The paints used are mainly lacquers and enamels. Most of the painting work is done with an airbrush, and brushes are used for painting faces and finishing details. He says he is accustomed to using mainly airbrushes because of his experience in making decoration masters (coloring samples for commercial figures, etc.) when he worked for a prototype production company.

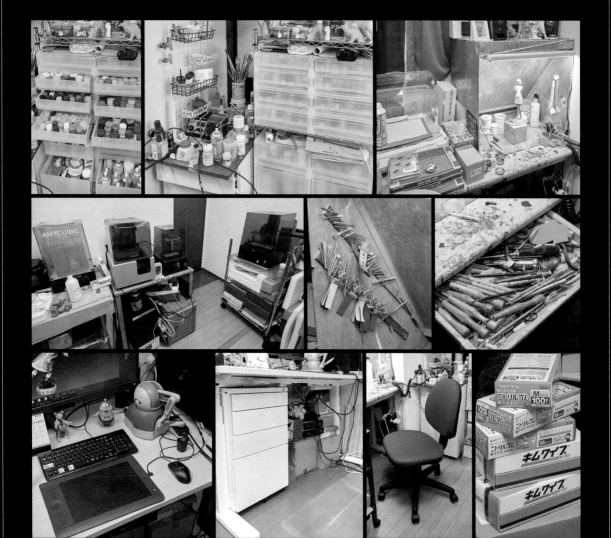

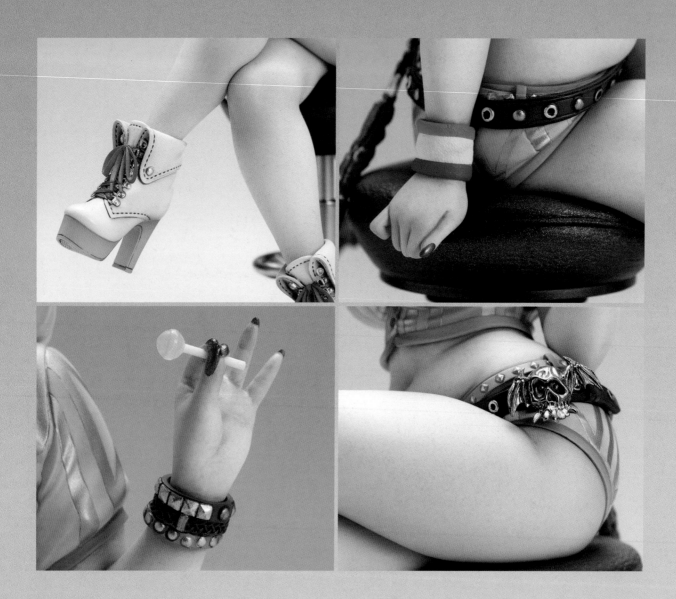

Trick or Treat

Trick or Treat

□data＿2021 ┃ □size＿全高約190㎜

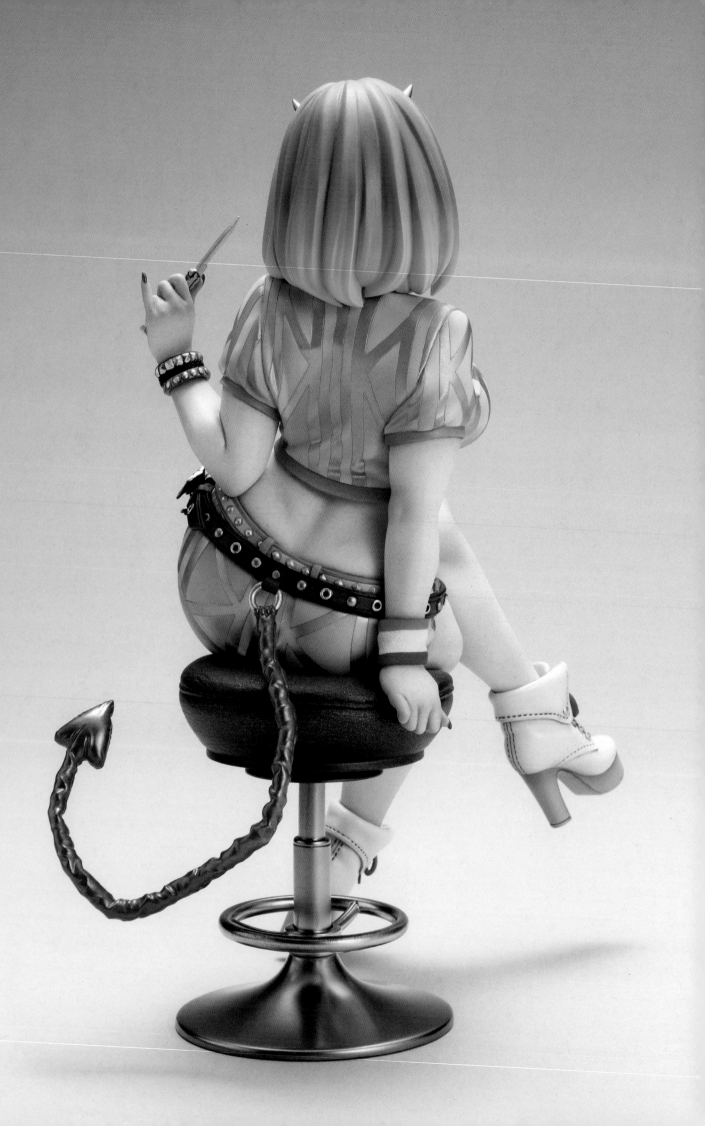

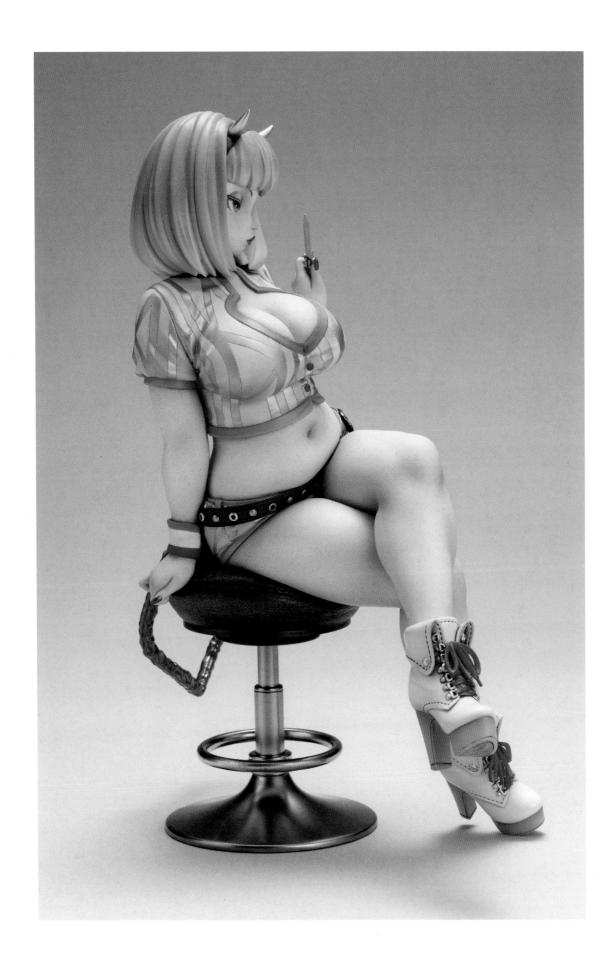

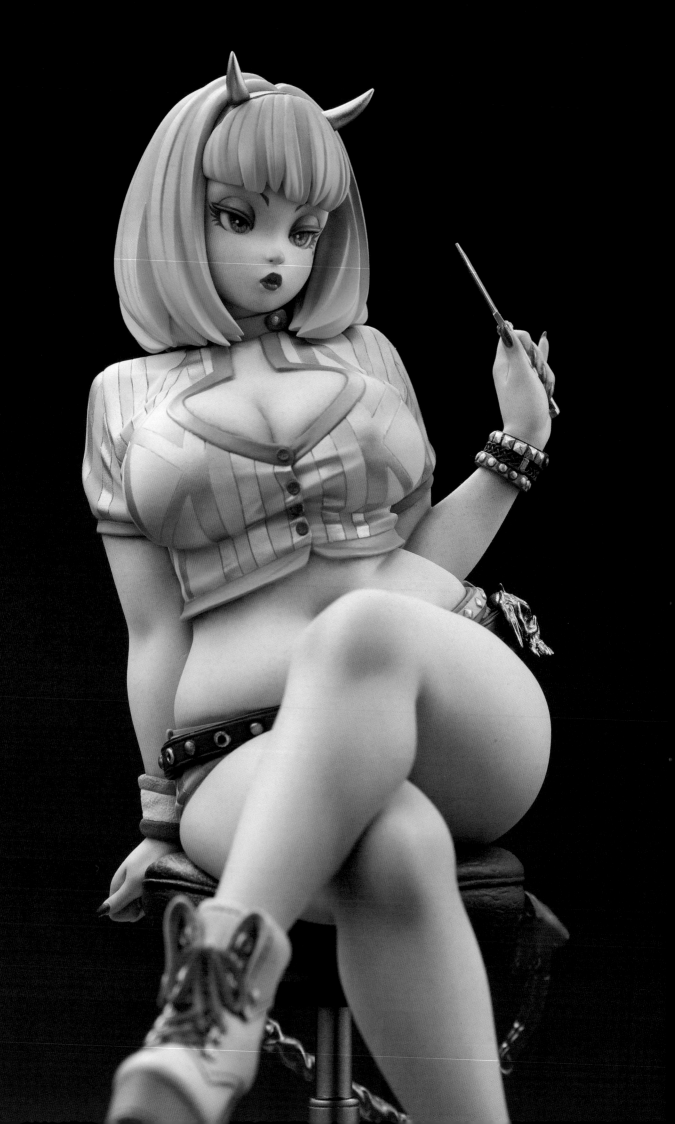

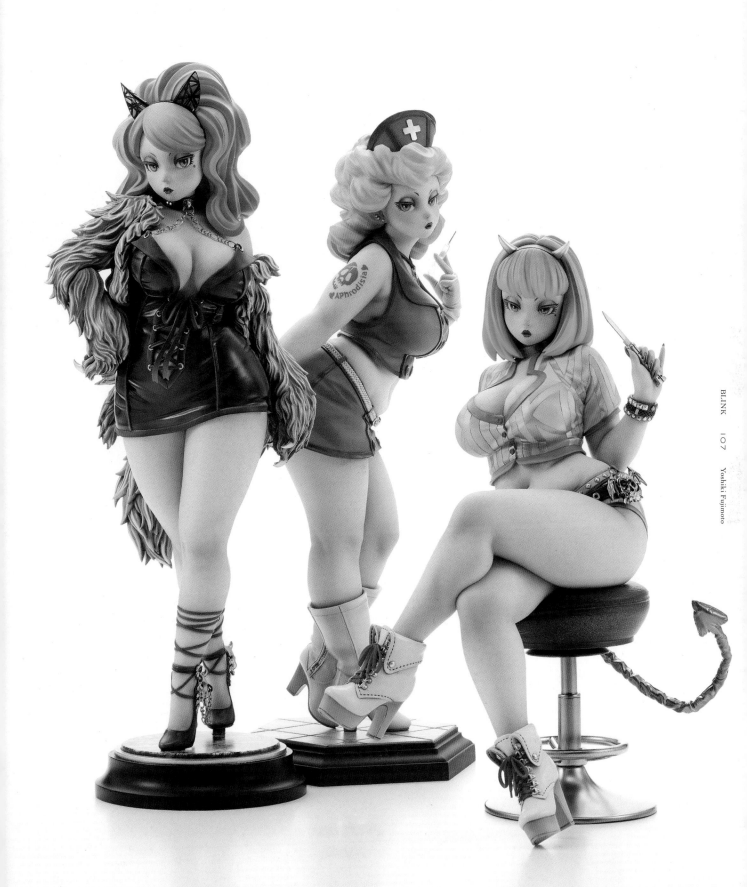

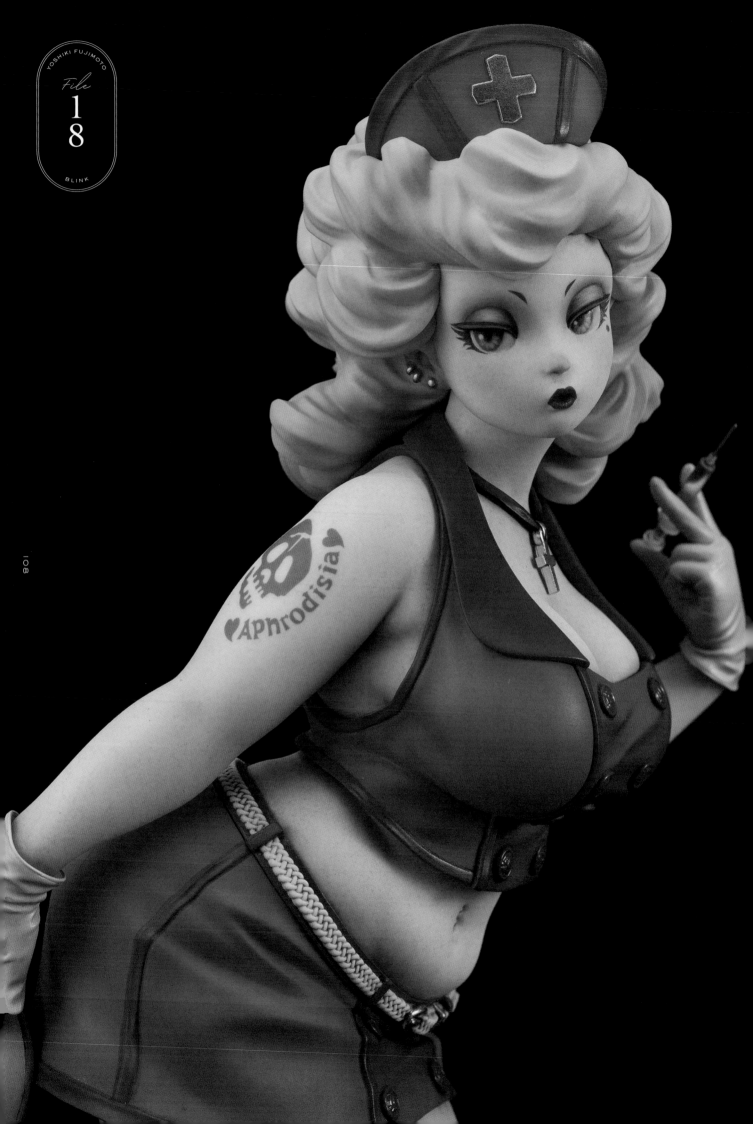

Playful Nurse

Playful Nurse

□data＿2022 □size＿全高約230㎜

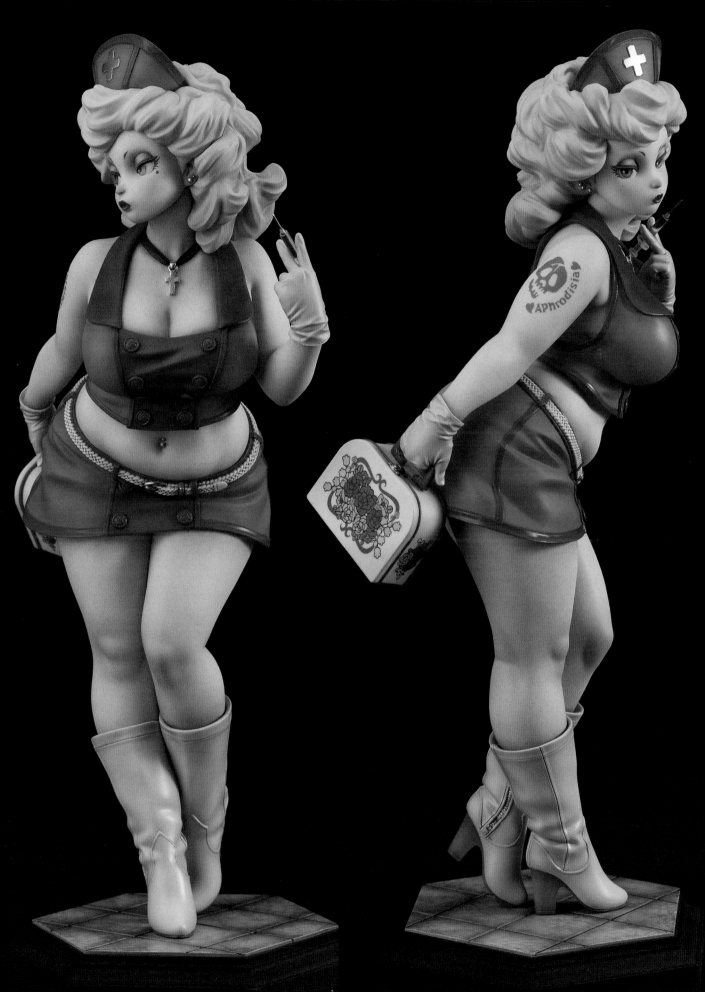

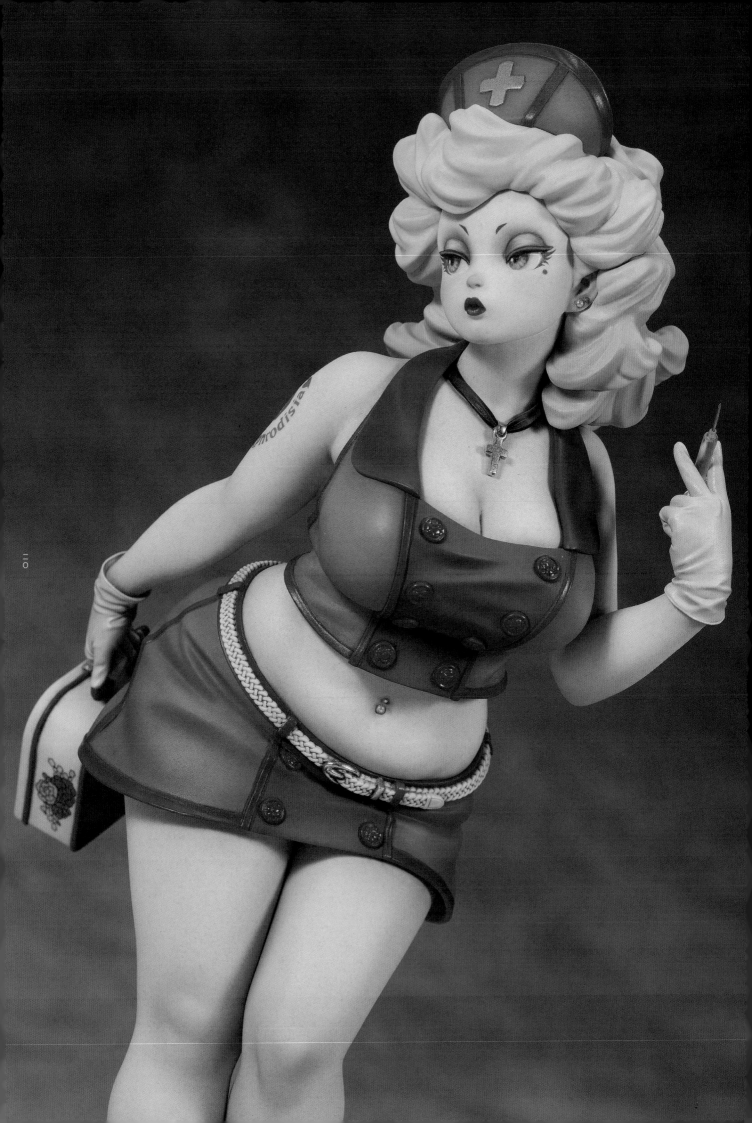

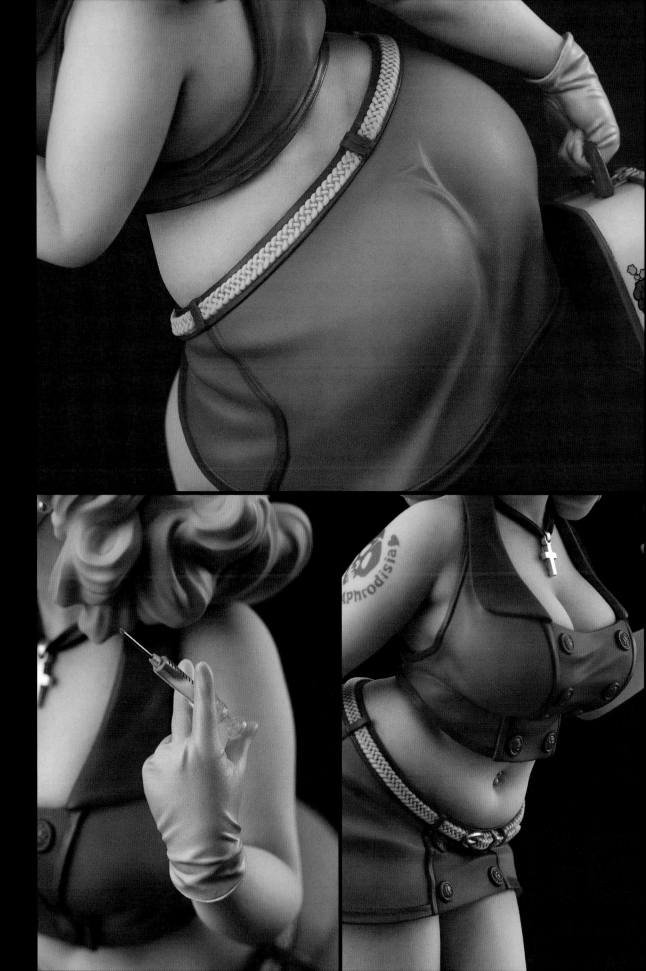

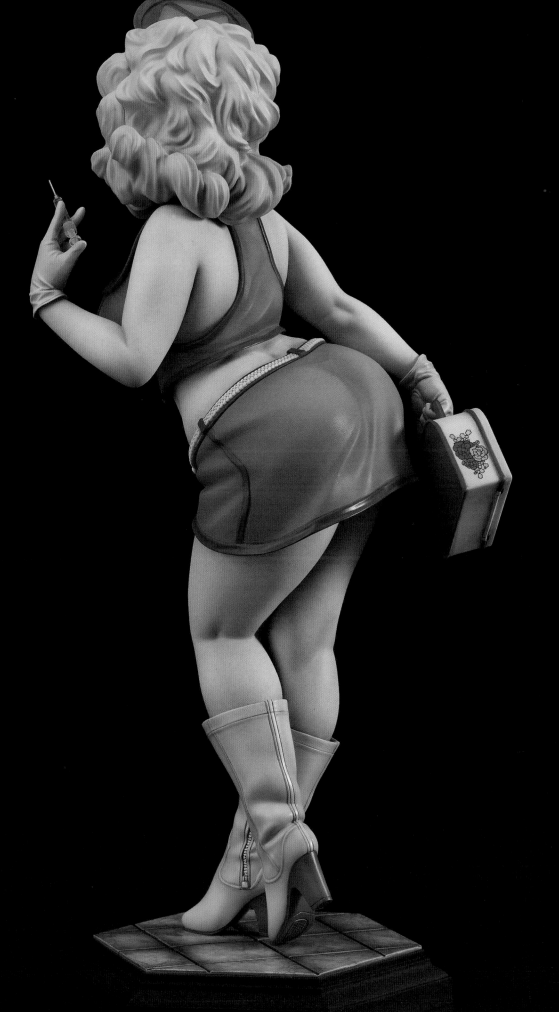

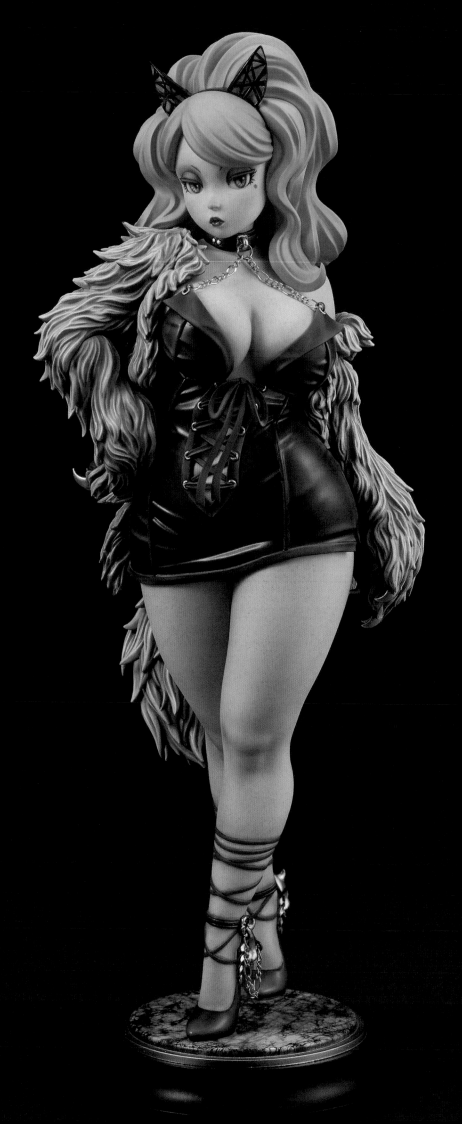

City of Cats

City of Cats

□data_2020 □size_全高約245㎜

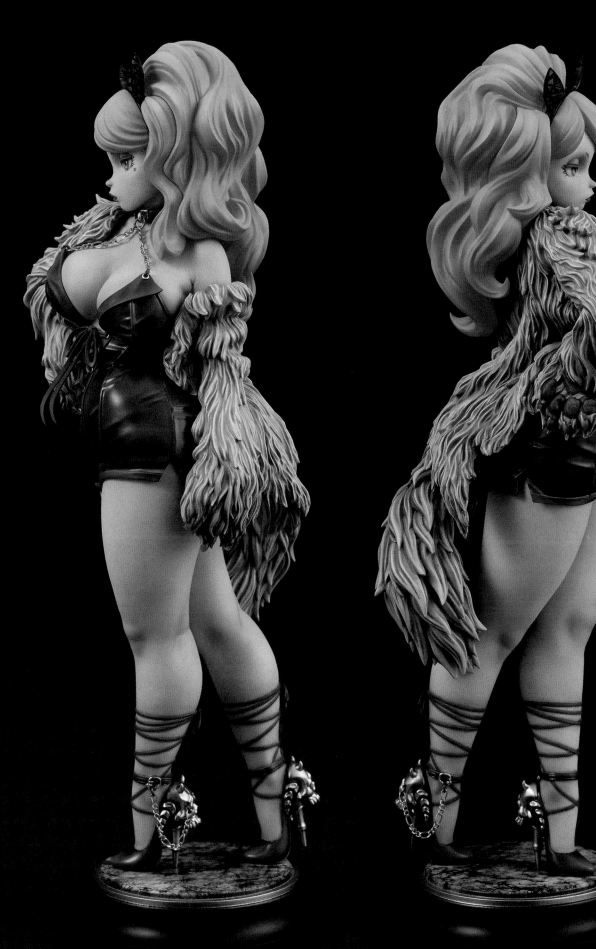

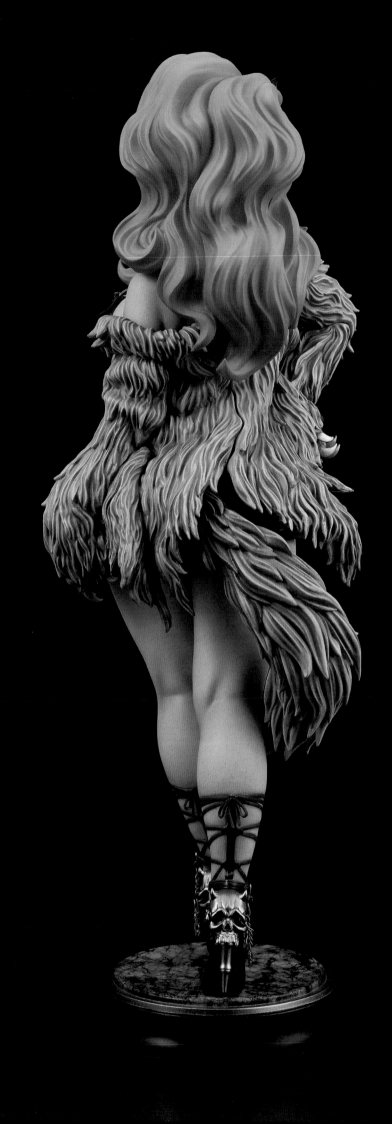

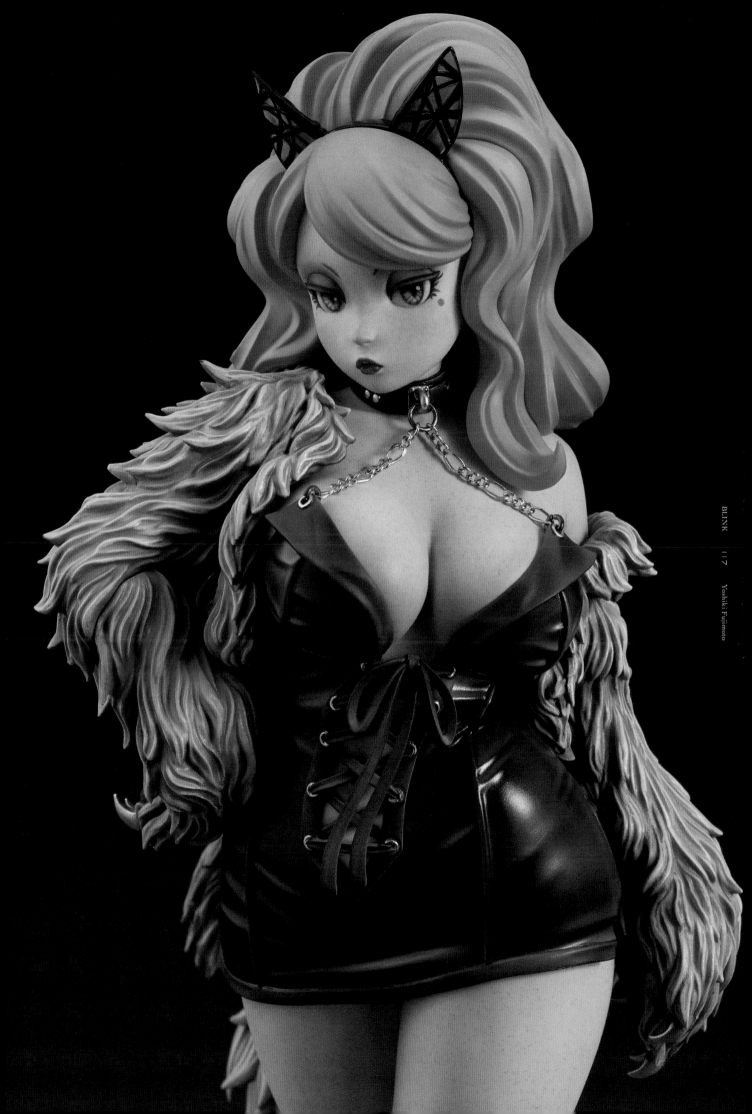

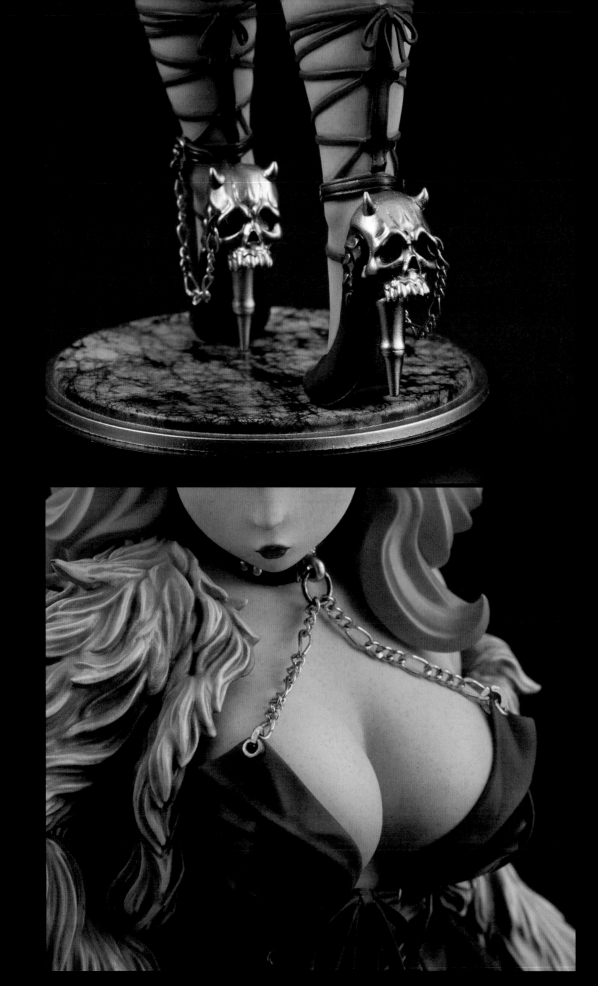

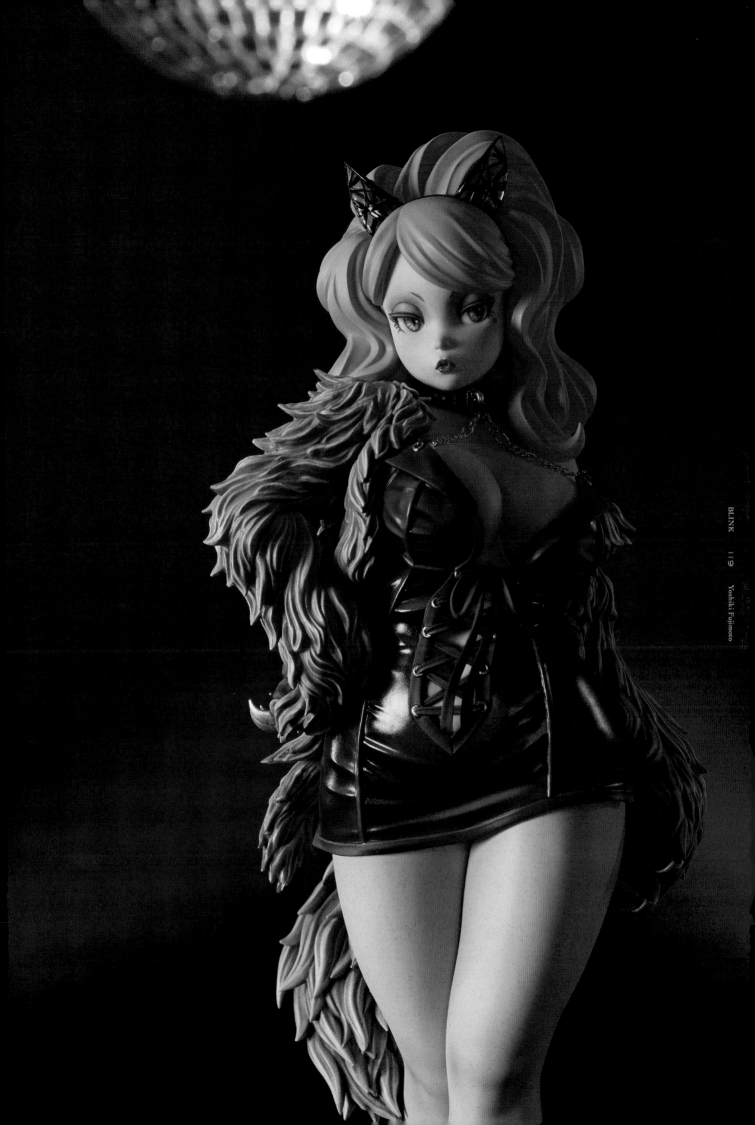

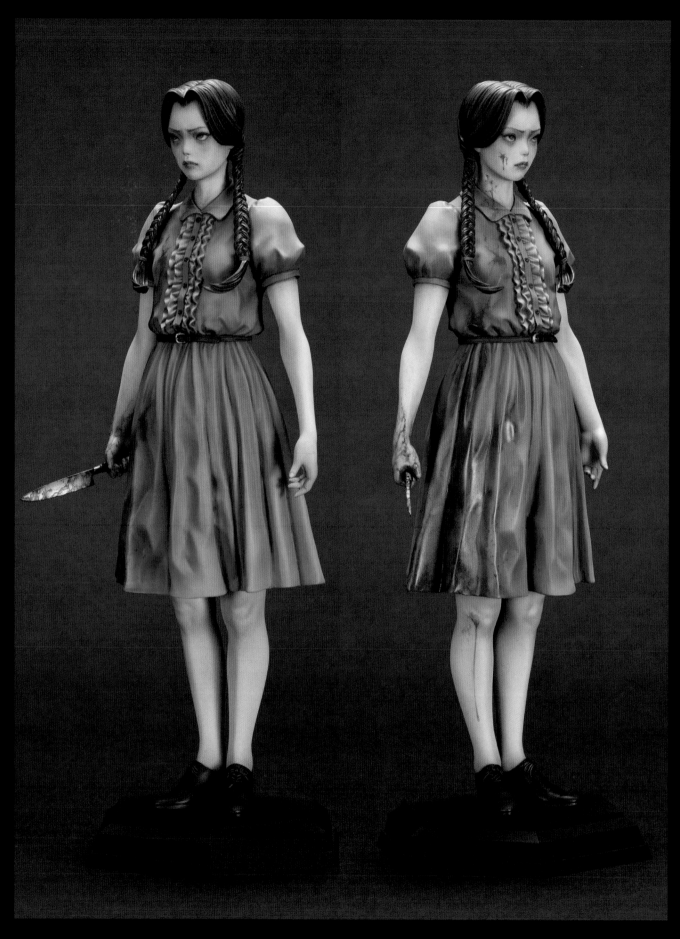

SPLATTER GIRL

SPLATTER GIRL

□data _ 2012　　　　□size _ 全高約260㎜

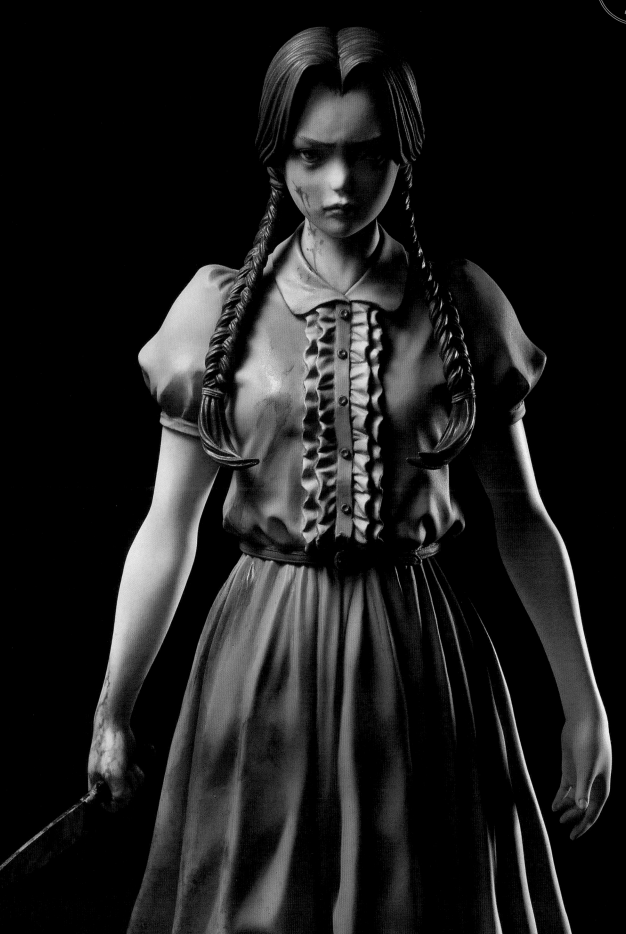

見習女巫

Minarai Witch

□data _ 2013　　　　□size _ 全高約215㎜

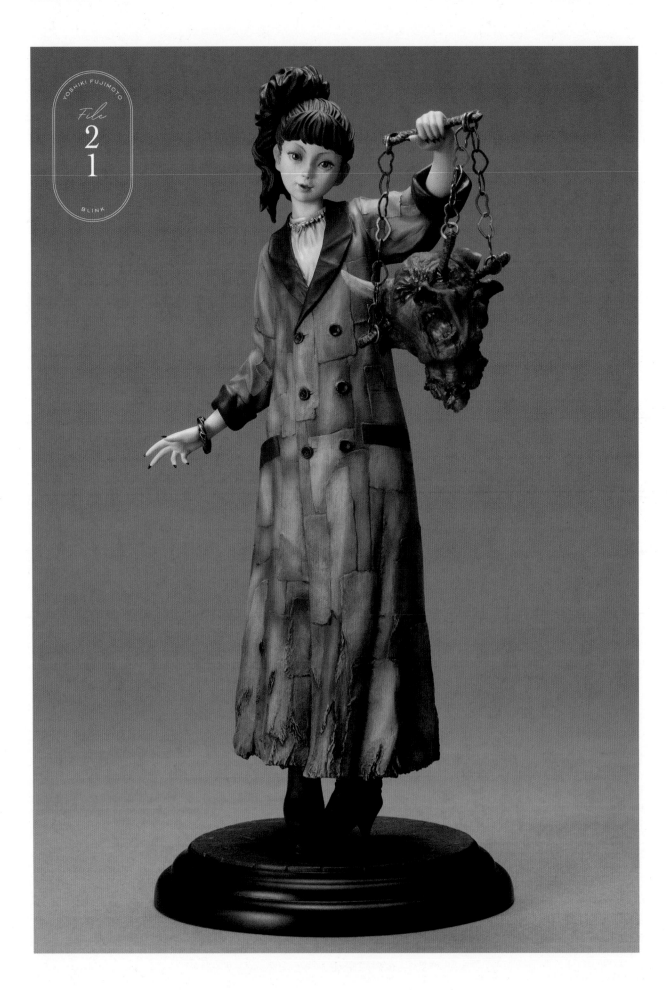

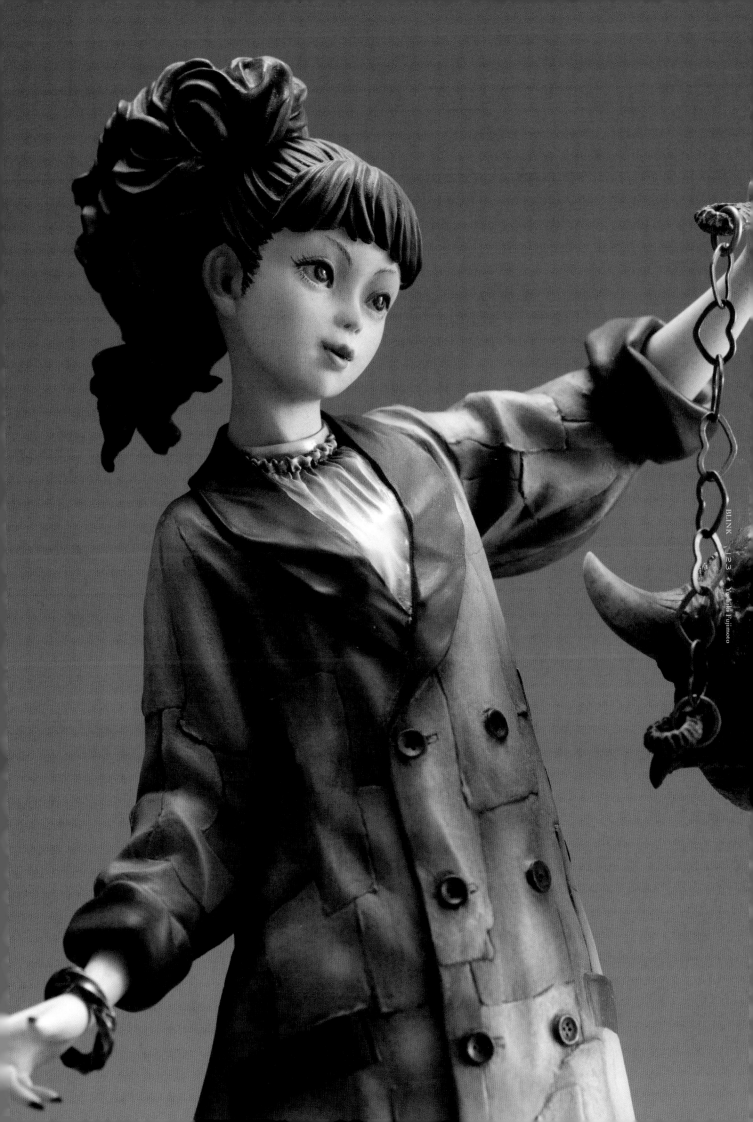

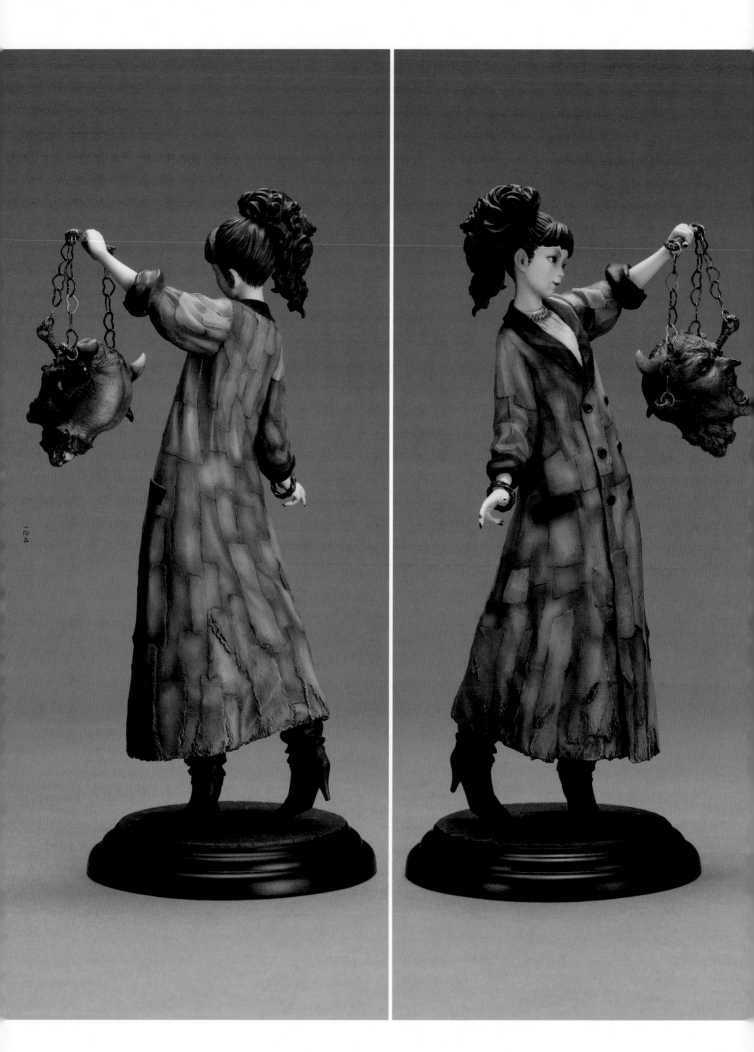

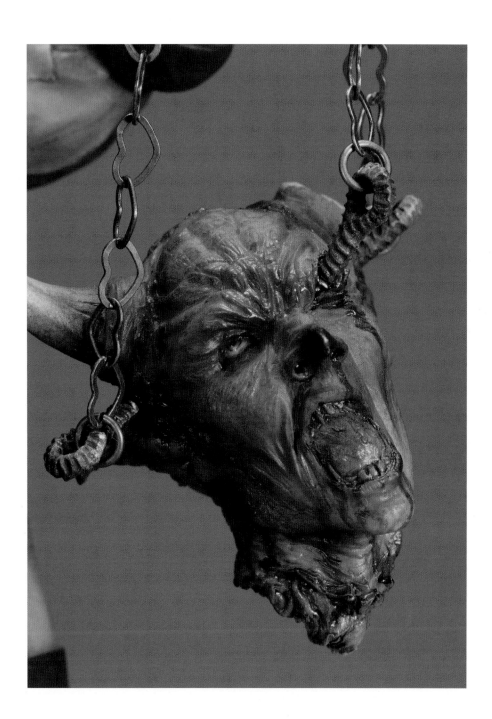

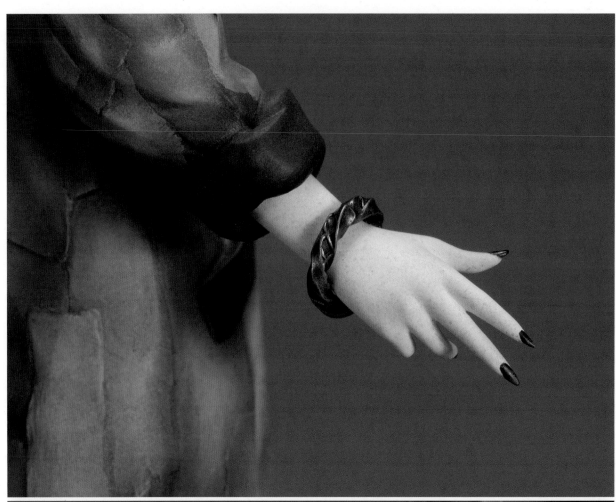

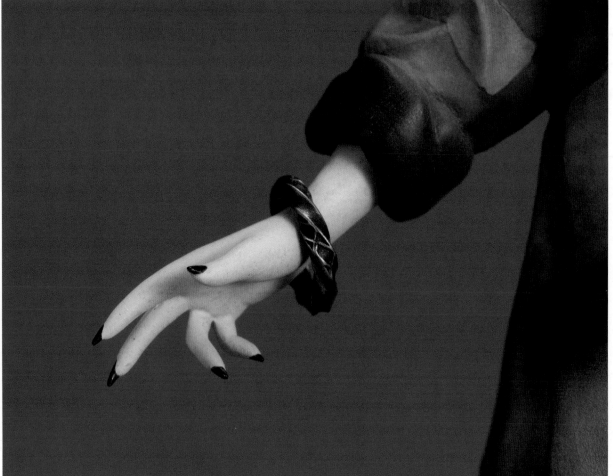

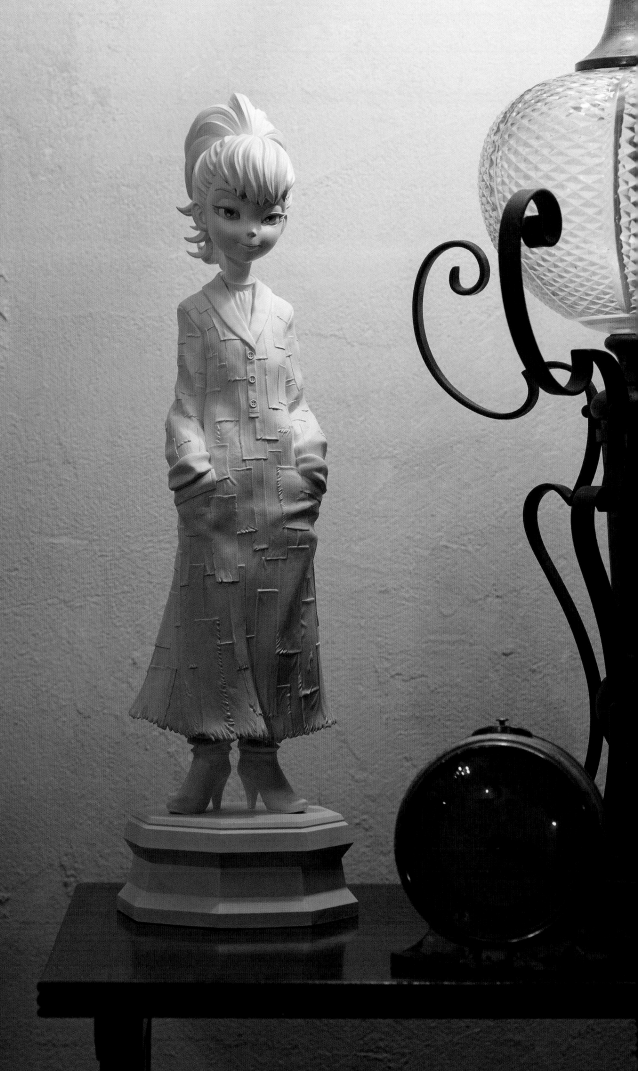

見習女巫 〜maquette〜

Minarai Witch 〜 maquette 〜 □data＿2022 □size＿全高約390㎜

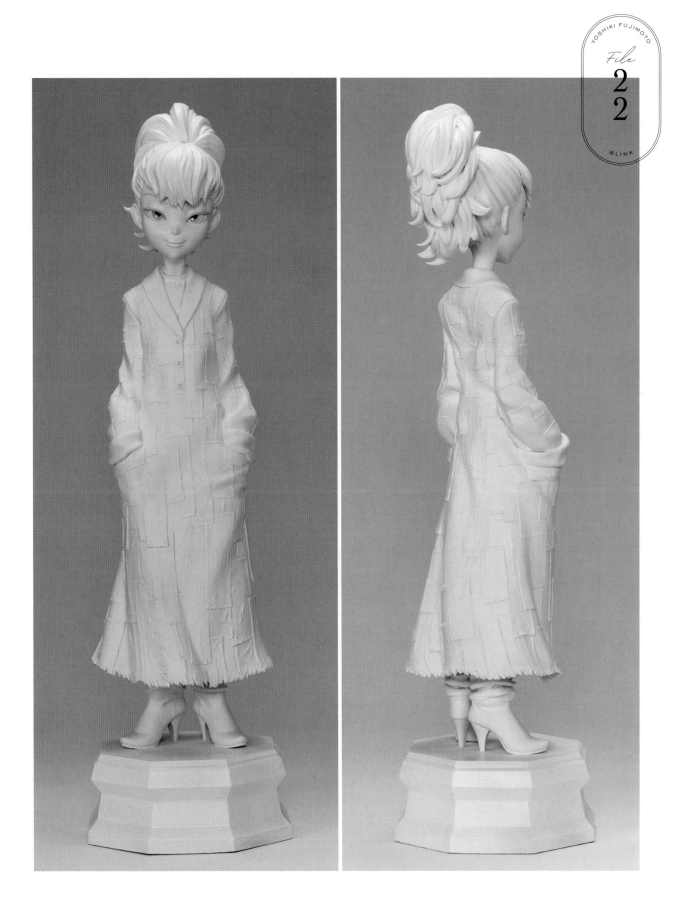

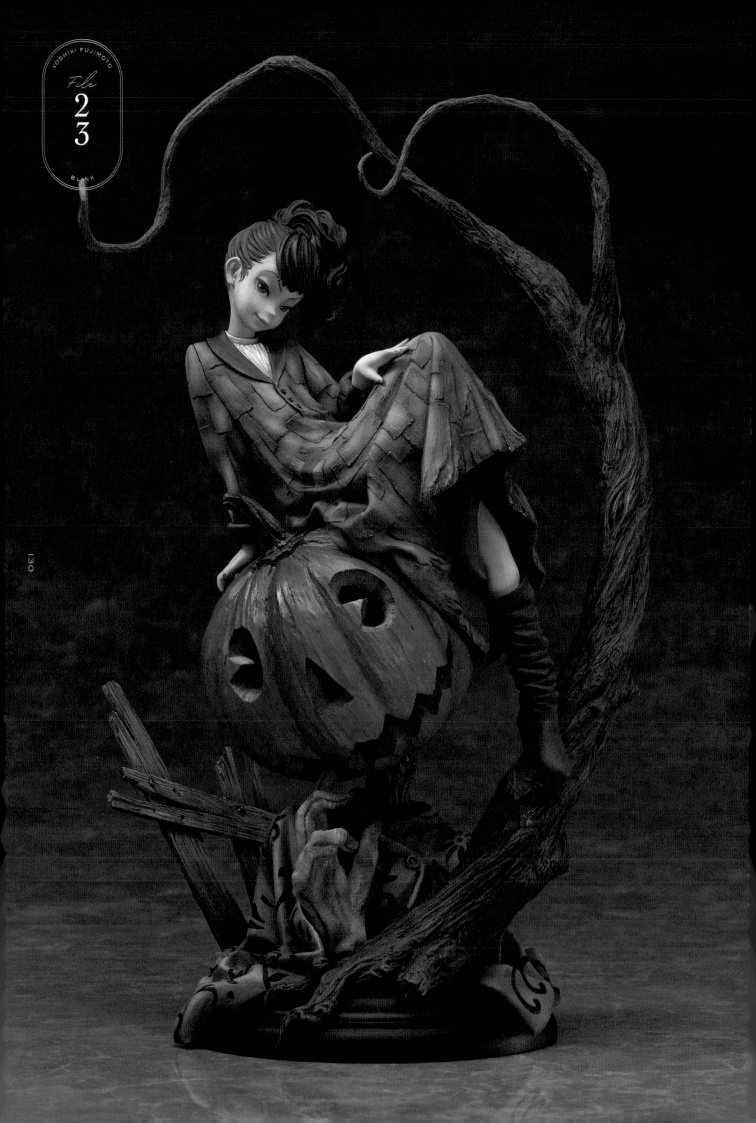

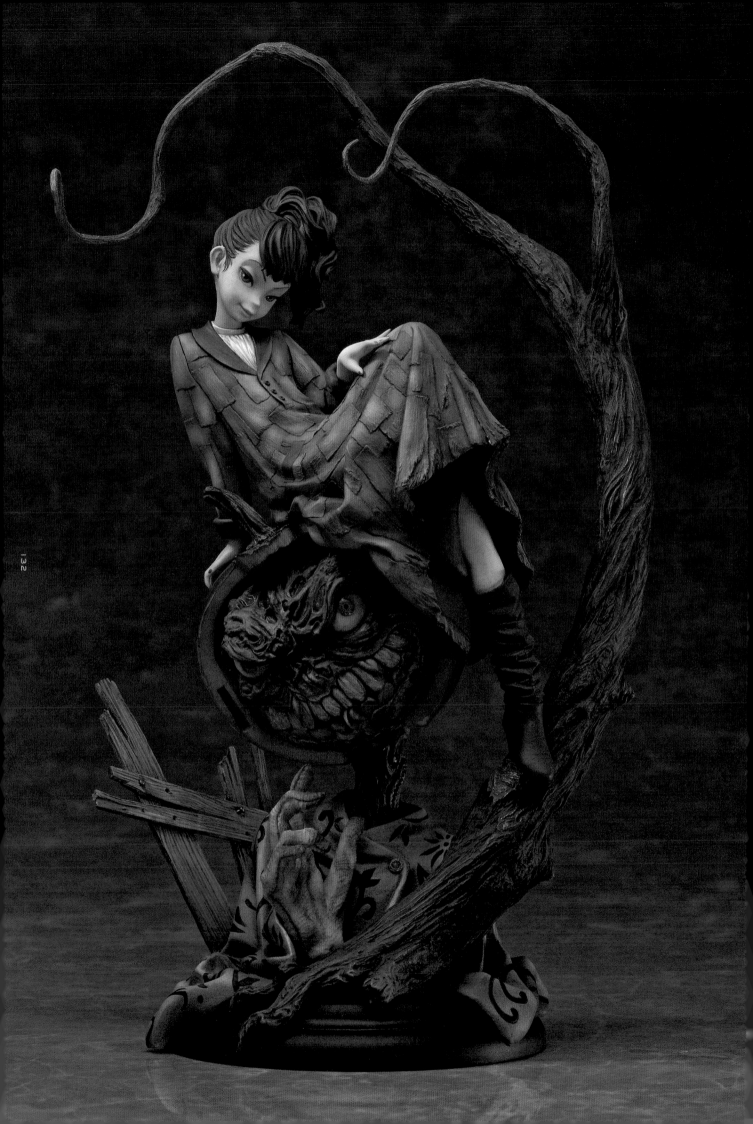

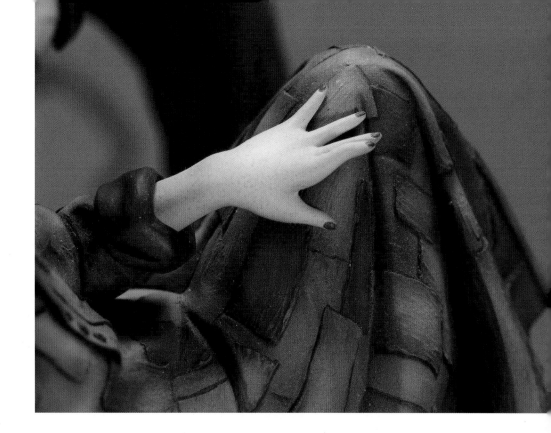

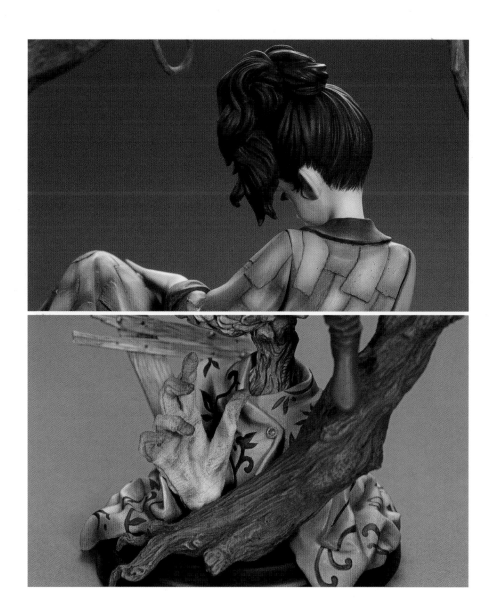

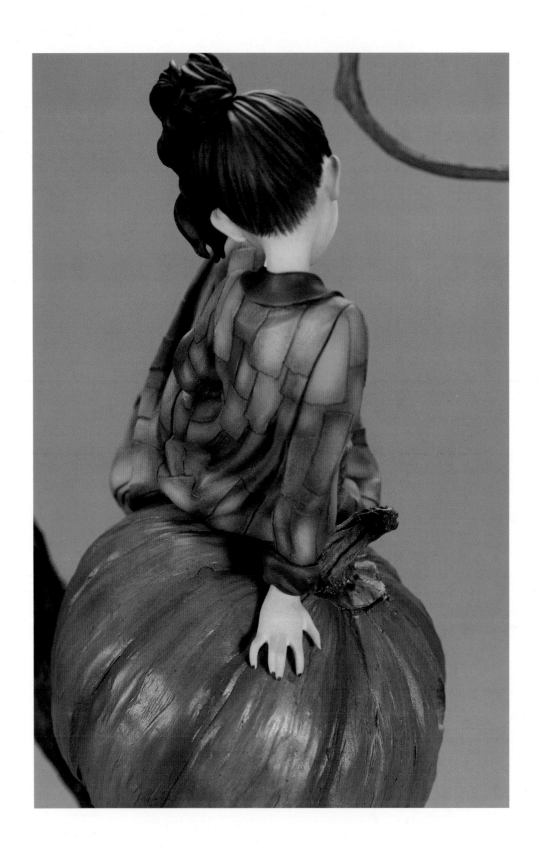

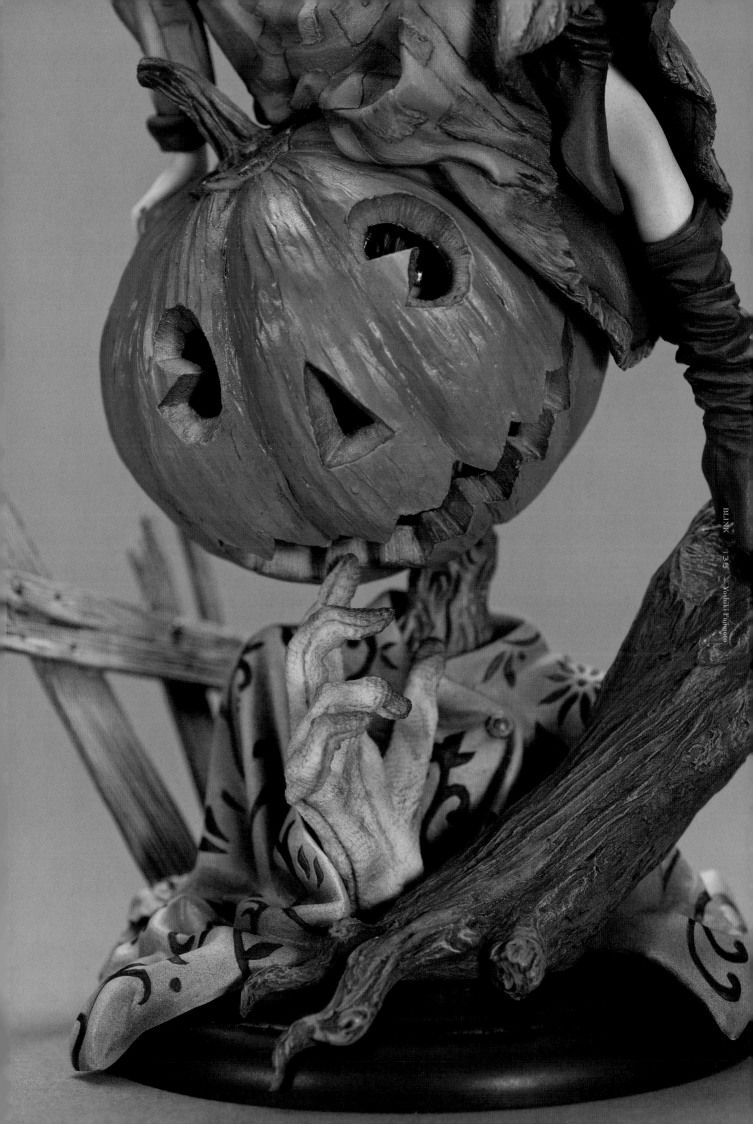

Yoshiki Fujimoto

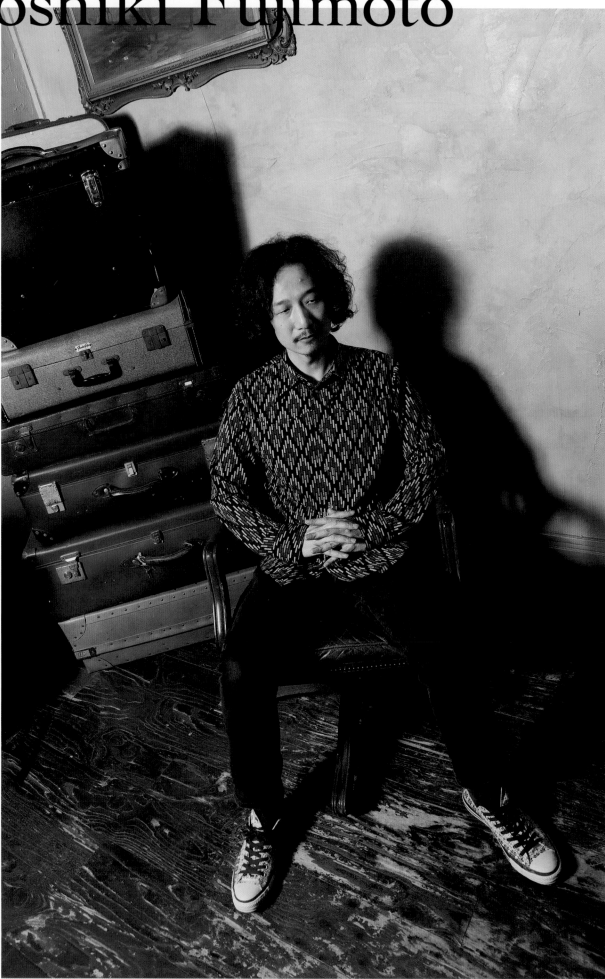

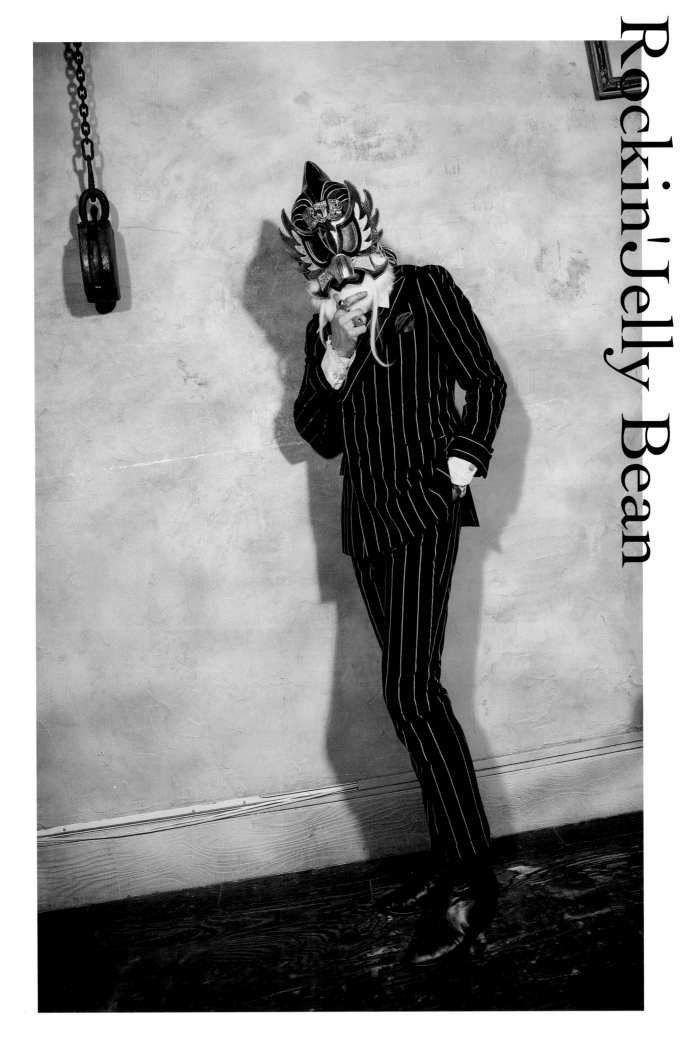

Rockin'Jelly Bean

Inevitable encounter of artists
兩位藝術家的邂逅相遇

本書的作者藤本所邀請的對談對象，是早自 1990 年代就以插畫家的身分在日本國內，
甚至是海外都相當活躍的蒙面畫家 Rockin'Jelly Bean。
在這裡，兩位藝術家深入探討了彼此的相遇、作品、造形以及身為藝術家的堅持之處。

與 Rockin'elly Bean 的相遇，可說是成就造形師 藤本的契機

Encounter with Rockin'Jelly Bean, the catalyst for the creation of the sculptor Fujimoto

兩件造形物作品
是這一切的開端

—— 這次在規劃藤本先生作品集的對談環節時，Rockin'Jelly Bean（以下簡稱 RJB）先生是最先被藤本先生提到希望對談的對象吧。

f：一聽到確定要製作這本作品集後，我馬上就想到了RJB先生。

r：真是榮幸。

f：我很早以前就知道RJB先生的作品了。但最終深深吸引我的還是由豆魚雷推出的那些人物模型。由RJB先生重新設計，矢竹先生（ACCEL的塗裝師、原型師矢竹剛教）負責原型和上色樣本的隱形女（2010年推出）以及魔形女（2014年推出）實在

是…從那個時候起，我就被深深迷住了。

r：哦哦～！那個時候你已經在東京了嗎？

f：是，我當時在東京。當產品發布時，我沒想到居然能讓原作和立體物搭配得這麼好，既感到震撼，又感到帥氣。充滿藝術性又尖銳的感覺，非常新鮮。之後過了幾年，我被點名製作吸血鬼女王梵蓓娜（一部由Dynamite Comics出版的漫畫角色）的立體化作品。居然我也有機會接替矢竹先生，和RJB先生一起合作的一天……！

r：原來這對你來說是意義那麼重大的大事啊。

f：意義非常重大。

r：在那之前你是不是有接受過豆魚雷的案子？

f：梵蓓娜是第一件合作案。我記得那是在

2015年或16年左右。那時我還不是自由工作者，是在另一家公司任職。

r：啊，我想起來是這樣沒錯！獨立之前你在哪裡工作呢？

f：在原型製作公司（株式會社 M.I.C.）任職。承接玩具和模型的原型製作工作。

—— 這麼說來，梵蓓娜是促成兩位首次合作的契機呢。

f：對，實際上我還去拜訪過RJB先生的工作室。

—— 藤本先生原本就知道RJB先生的事情，但是RJB先生在那之前卻不知道藤本先生的事情，是這樣嗎？

r：我是那時才第一次知道藤本先生的。當時我看到的還不是原創作品，而是某個知名角色的作品，當下我就覺得這真是一位

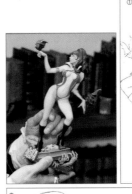
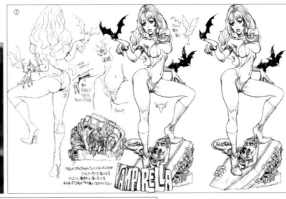
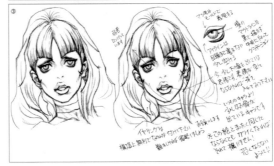

兩人合作製作的「梵蓓娜」人物模型及相關指示書。指示書中包含相當詳盡的指示，涵蓋了各種細節之處。

了不起的技術者。給我一種職人風格的印象。

f：哎呀…謝謝！謝謝！（害羞）。

r：在那之前我也有接過幾次將作品製作成人物模型的合作機會。但是像我這樣用繪畫來表達的東西，每個人看到後的詮釋都不一樣對吧。

在傳達形象時，雖然會有「是這樣的」或「是那樣的」的來回對話，但意外地很難準確溝通。但畢竟我們都是出身自日本關西地區，至少語言是共通的，這或多或少能更容易傳達出形象或感覺。

—— 在製作梵蓓娜的原型製作上也曾經有很多來回對話嗎？

r：與藤本先生見面之後，感覺可以輕鬆地交談，而且他也會聽我說話（笑）。原田先生（為本書提供前言的豆魚雷企劃負責人）事先告訴我，讓我可以按照我自己的喜好和方式進行，所以我盡可能地提出了非常詳盡、細緻的需求。……結果指示書的分量也相當驚人呢！

f：在我目前為止的工作中，RJB先生是最嚴格的（笑）。

r：除了指示書之外，我還發送了很多女性（裸體）的圖片。告訴藤本先生我要的就是底褲像這樣陷進臀部的感覺之類的。

f：將插畫立體化的過程中，我必須讓RJB先生的靈魂附身在其中才行。但我覺得程度還是差得遠了。

r：沒錯，差得遠了！情色感差太遠了（笑）。

f：哪裡是RJB先生的萌點？或者是在哪個點上投入熱情或感到痴迷呢？我覺得與其說是去解析，不如說可能得讓自己也要和RJB先生在相同的點上感到興奮才行。

r：嗯，最終確實是需要這樣。但首先還是要先從解析開始啦。像是在梵蓓娜的案子裡，光是指示圖上的內容，臉和整體形象就有好幾種。

f：另外還有只有底座的指示圖、只有身體的指示圖之類的對吧？

r：而藤本先生厲害的地方就在於他能夠超越那些指示圖要求的品質。尤其讓我感動的是底座的部分。那資訊量太大了！我自己都沒有畫到那種細節程度，但是他卻能做得更多。我當時的心情就是「這也太強了」。反過來說，用圖畫或照片提出指示要求是相對容易的。但是，立體作品卻能超越畫作的作者本人，展現出一種如同憤怒般高昂的造形創作魂，我只能說……實在太感謝你了（笑）。真的沒有什麼好抱怨的感覺。

f：那個瞬間真的很開心呢。我還記得很清楚。即使現在看，也覺得自己能做到這樣真的不容易。要是單靠我一個是無法達到這個程度的。在這份工作中，我不僅能夠和RJB先生一起合作，還讓自己的多了一個新領域的知識。那是我自己一個人即使想破腦袋也創作不出來的方向，真的是一個非常有收穫的學習過程。

如何能創造出引人入勝的「魔法」

r：原型師的工作，除了創作原創作品外，也會需要製作以原作或指定題材為基礎的商業原型吧。每次都能夠從平面的狀態在心裡湧現立體形象嗎？

f：這個嘛……。對我來說，是否喜歡那個主題，是一個相當大的原動力。因為我喜歡RJB先生的作品，所以我能夠對於這個梵蓓娜看見一個清晰的完成畫面。

r：梵蓓娜本身已經很出色，但藤本先生的骷髏頭真的太棒了。在指示圖中的這些部分記得只是隨手幾筆的草稿，但實際製作出來的時候，不光是品質水準極高，而且是我喜歡的那種骷髏頭類型！

f：聽你這麼說，實在太開心了。我反而覺得RJB先生對於自己的作品在製作成立體作品後的狀態，應該也是畫面非常清晰的。

r：你這個問題不是很好回答呢……。與其說是非常清晰，不如說是在我內心中有一個模糊的形象，當我實際看到初步立體化

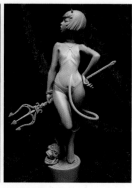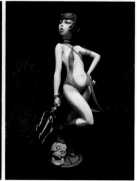

矢竹剛教原型的「DEVIE」。這是一件觸動藤本內心琴弦的作品。

「藤本先生展現出一種如同憤怒般高昂的造形創作魂，超越了我的想像⋯⋯⋯⋯只能說謝謝你了。」（RJB）

的作品時，有時會感到與自己內心形象不符合的違和感。為了消除這種違和感，我會需要花費大量的時間和精力來進行溝通和調整。

f：喔，這裡是個重要的點呢⋯！雖然像這樣來回溝通的創作過程真的很辛苦，但也是製造出好作品的一個歷程。

r：藤本先生製作的作品涵蓋了各種類型，其中尤其是動畫風格的美少女人物模型，原畫大多是由簡單的線條構成，那麼在進行立體化製作的時候，是如何處理這方面的呢？

f：動畫風格的人物模型，客戶所要求的正確解答就是「和原畫一樣」，那就是目標了。當然，平面畫作的線條是必須要去呈現的，但如何將包含線條在內的原畫角色特徵呈現出來，就成了一個挑戰。然而，RJB作品的立體化過程，則與這樣的見解方式不同。並不是去完全透寫複製、完全重現就能夠達到目標。所以這就變得很困難了⋯⋯。

r：若將我的畫作中所有線條都呈現出來，並加上相應的陰影，形狀的起起伏伏將會變得非常多，直接立體化似乎會讓人看起來感到有點不舒服。從這個意義上說，藤本先生的省略技巧真的非常厲害！所以才有了梵蓓娜這樣的成功立體作品。

f：很高興聽你這麼說。但當然，這也是有了RJB先生的原畫才有可能達成⋯⋯。但畢竟還是不能使用直接透寫複製原畫的方式製作。RJB先生的線條散發出的氛圍和感覺，有一種「正是因為這些線條，所以有了這張臉！」的看不見的目標在那裡。這可能是超越完全透寫複製的另一個境界了吧。

r：聽起來像是場出發尋找境界的旅程啊。

真是一個相當嚴苛的旅程呢。

f：我和豆魚雷的原田先生有過一段對話，這是我在另一項工作卡住時，在能夠透露的範圍內找他諮詢了一下。他給了我一個金句，他說：「客戶想看到的，其實是魔法。」這句話讓我深有感觸。

r：不愧是原田先生，真是說了很了不起的話呢。

f：我想，「另一個境界」的意思，可能就是客戶想看到的超越想像的魔法吧。

r：對，像這個梵蓓娜也是一樣。超越自己想像的另一個境界，也就是讓魔法發生在自己身上了。

—— 為了達到那個「另一個境界」，藤本先生平時有沒有什麼特別會去意識的事情呢？

f：我除了會去觀看各種作品之外，還會去聽音樂，看電影和畫畫等等。⋯⋯最近，我覺得氣味也可能會是一個線索。

r：哦！氣味！

f：像是香水的味道，或者是陽光的味道，從那裡引發的印象也成為凝聚想像的要素之一。我想試著從這些要素創造出魔法。

r：香水啊，怎麼不是納豆味（笑）。但是想要傳達氣味，感覺很深奧啊。這也是一段尋找「另一個境界」的旅程呢。

對藤本的作品產生影響的造形師

—— 看到這次作品集中收錄的原創人物模型，RJB先生似乎感到驚訝？

r：是的，沒錯。以我第一次看到他的作品時留下的印象，藤本先生的原創作品要表現的是童話風格的小女孩人物模型才對。所以這次看到他的作品，製作了各種不同

風格的作品，真的讓我非常驚訝！

—— 確實印象不斷地在轉變。有一些性感的，也有一些俐落帥氣的⋯⋯。

r：藤本先生的風格有點外國人的感覺，或者說在日本不太常見吧？他製作了各種不同風格的作品，其中有些是成熟的女性，感覺比較偏向寫實風格。我想是他透過「女性」這個形象來作為表現。我不太知道是否還有其他人在原創人物模型中採取這種表現方式，但粉絲們可能正是被這一風格所吸引吧。

f：說到我的原創人物模型的風格，最受影響的應該是來自矢竹先生。

r：噢～啊，原來如此，他的原創作品也是有獨特的世界觀呢。原來如此，你是繼承了那個風格，或者說是受到那方面的影響嗎？

f：影響⋯⋯確實有受到。如果說我感受到他的精神，可能有點太過誇張，但看到他的作品時，我確實感到一種形狀上的舒適感和看起來很美味的色調⋯⋯。

r：美味的色調！原來矢竹先生的作品看起來很美味（笑）！

f：在他的作品中，尤其是一件叫做《Devie》的作品，真的讓我深受觸動。簡直讓我興奮不已。（左照片）

r：原來如此。但是如果說美少女模型是王道的話，這樣的作品風格在當今社會中可能算不上主流派，對吧？

f：確實不是主流風格。在我剛開始從事造形創作的時候，大家的常識是製作原創人物模型根本沒有市場。但是在這其中，居然有人選擇製作這麼特立獨行的風格，真是讓我感觸良多。

r：原來如此，你說的是矢竹的作品⋯⋯！雖然我覺得他也是屬於小眾領域。他的表現方式並不完全像外國人，有種屬於日本人特有的寫實感覺。

f：正是如此！既有外國風格的大膽，同時也有日本獨特的細緻感。

r：矢竹先生和藤本先生共通的地方是你們兩個人都有著職人氣質，一點也不花俏。花俏的事就交給其他人吧（笑）。兩位就以造形師和職人的身分，專注在技藝上的較量。我覺得這樣很好，也深刻感受到兩位最重視的也是這個。

關於數位雕塑並非手工雕塑的升級互換這件事

—— 關於人物模型的製作方面，RJB先生有沒有什麼想向藤本先生請教的事情呢？

r：藤本先生從很早以前就是數位雕塑和手工雕塑（如黏土雕塑等）兩種方式都能掌握。最近只使用數位雕塑的人越來越多。藤本先生從梵蓓娜的時候就以兩種方式兼用，相信對於手工雕塑呈現的氛圍，以及數位雕塑呈現的氛圍，兩者的優缺點都有所感受吧。我很好奇，有手工雕塑經驗的人和沒有經歷過的人，兩者之間的區別是什麼呢？我對這點非常感興趣。

f：這個呢……優點和缺點都各有一大堆。我過去也經常提到，在數位螢幕上要正確掌握空間以及距離感是一件相當困難的事情。

r：咦？可是在顯示器上可以從任何角度觀看畫面，對吧？

f：雖然可以觀看，但顯示器的畫面畢竟是二次元平面的。所以對空間的感知就有些困難。我是一個創作立體物件的人，所以非常注重作品的空間構造。要以數位的方式達到自己滿意的水準，真的很困難，也很辛苦。

r：啊，現在也還在苦惱的狀態啊。這是否意味著，實際上只有透過3D列印機輸出之後才能確認呢？

f：我也不太清楚。不過我每次看到輸出後的狀態都感到絕望。怎麼我做得有這麼差嗎？每次都這樣想。

r：這樣的話，輸出、確認的次數也是得增加不少吧？

f：嗯，是的。實際上就是不斷進行暫時輸出、確認狀態的循環工作。而且即使是相同的數位造形工具，寫實風格和藝術風格等所追求的元素都會有所不同，所以各有不同的辛苦之處需要克服……

r：而且講到寫實風格，現在的技術已經可以將整個真人3D掃描下來了。

f：對，3D掃描人物模型。這就回到一開始提到的透寫複製的話題，實際上3D掃描已經是最終答案了。但同時我也想要追求不同表現的樂趣。

r：啊，我明白了。想要畫出整輛真車？還是同一車型的玩具車？之類的吧。

f：對呢！實際上就是變形處理。應該大家都是喜歡變形吧。

r：將那個形狀製成自己覺得有趣的大小，這就是重點。不過話說回來，你已經用這兩種方式做了10年以上了吧。即使如此，還是覺得有難度嗎？其中一種……，比方說，完全不使用數位雕塑的話，是否製作起來仍然難度很大？

f：如果那樣的話，問題在於會耗費太多時間。

r：說的也是，這在繪畫也是一樣的。時間確實是一個問題。像是左右對稱、尺寸要稍微放大或縮小百分之幾，數位工具在這方面是真的很方便。優點和缺點都有。

f：兩者都有各自的優勢和劣勢。梵蓓娜我是先用黏土製作出大致的形狀，然後掃描成數位檔案製作完成，以這樣的方法製作出來的。這樣的方法結合了數位和手雕的優點，所以非常好。

r：原來如此，你先用黏土做了一次，然後進行3D掃描。這樣應該是最容易製作方法的吧。不過，這些作業要是都可以在家裡完成就好了……。

f：啊，可以哦，確實可以！

r：真的可以啊？你在家裡就能進行掃描？

f：不過那樣的方法太花時間，所以有時候會先做出初步的輸出，然後手雕加工，然後再掃描一次。反正就是先把草稿列印出來！不過即便這樣，還是會有一些讓人在意的地方。

r：還會有讓人在意的地方啊？那麼，你最後還要再修一遍是吧？

f：是的，最後就得手雕作業了（笑）。有時候也是會遇到「沒辦法，只能重新來過了」的情形。

r：啊，這麼慘啊!?真是個嚴格的業界呢。你是不是有點太認真了啊（笑）？

f：哈哈，我常常被人家這麼說呢（笑）。雖然不是松本人志的原話，但是就像他說過的「或許達不到滿分，但至少要追求極致」。

r：哪個藝術家不是這樣想的呢。

f：就是想要自己對得起自己吧……就算技術不夠好，至少回頭看的時候能夠說「這是我盡力完成的」。或許我也只為了這個而在努力吧（笑）。

—— 真是一段很棒的佳話呢。

r：是啊，我自己都覺得驕傲了（笑）。

RJB期待今後的藤本作品是什麼？

f：今天最後一個話題……我想請教RJB先生，有沒有想看我日後創作哪種風格或主題的原創人物模型呢？

r：嗯，這個嘛。比起女性角色……你覺得超猛的肌肉男人物模型怎麼樣？畢竟藤本先生看著女性角色總會感到害羞嘛。

f：不會啦！你太誇張了！（笑）。

r：不，你一定是在害羞啦（笑）。當然，我想你也還是會創作一些女性角色的，不過我是想看看一些男人味十足的。就算不是人類也沒關係，可以是異形，也可以是終極戰士。你覺得這樣硬派、猛男風格的角色怎麼樣？

f：啊，原來是這樣，就是那種有男人味、全身散發汗臭味的傢伙嗎？

r：對，就是超級猛的那種！

f：挺有趣的呢，我明白了。

r：我想看到肉體以及金屬混搭在一起的感覺。

f：嗯嗯嗯。像這樣的靈感提示對我來說真的很有幫助。

r：那是我們兩人都自己無法單獨想到的地方啊。只要看看那個為了豆魚雷製作的1/3比例 " Big Chap " 異形，可以了解到那種充滿怨念的執著在細節、形狀以及製作過程。就是要像那樣盡情去做自己喜歡的事情，講究再講究，而且還是創作一個自己原創的角色，這樣不是很有趣嗎？奇幻作品當然也很棒，但相反過來，我也想看一些充滿男性荷爾蒙的作品。我很期待哦！

f：哎呀，太感謝你了。說不定哪天我真的會著手製作呢（笑）。

r：到時候你一定也會展現出超乎我想像之外的魔法，對吧？

f：嗯，我會努力的！

（2023年6月，於東京都澀谷區）

Rockin'Jelly Bean/蒙面畫家
自1990年以蒙面畫家的身分開始活動。以獨立搖滾場景作為展開活動的原點，於1996年前往美國，並在洛杉磯的LOW BLOW ART場景中嶄露頭角。在洛杉磯活動了七年後，自2005年起將活動據點移到日本，同時製作企劃了線上商店「EROSTIKA」，在各個領域提供酷炫的藝術作品。
http://www.rockinjellybean.com

Commentary

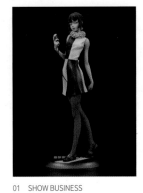

01 SHOW BUSINESS
275mm 2023年

這是一件將已經規劃好長一段時間的設計主題立體化的作品。藤本平時經常感到造形與音樂之間有著某種共通之處。努力展現出時尚的氛圍，追求颯爽的線條和外形輪廓，致力於「展現魅力」。

A motif that has been on his mind for some time has been sculpted into a three-dimensional form. He has always felt something in common between his art and music. For this work he dedicated show it's stylish atmospher, dashing form and silhouette

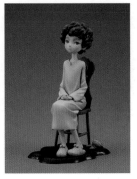

02 A little spooky night -premonition-
150mm 2023年

一個感到不安而難以入眠的夜晚，預感就要陷入惡夢，讓人害怕的夜晚。即便如此，夜晚仍然在延伸擴散。這個新系列以「夜晚」為主題並以簡單的元素和簡潔的結構，表現出敘事性和世界觀。

A night when you feel uneasy and can't sleep, a night when you feel like you are going to have a a nightmare. Still, the night is coming. This new series is based on the theme of "Night," which expresses a narrative and world view with few elements and simple structure.

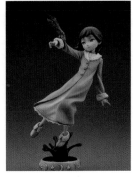

03 A little spooky night -beginning-
195mm 2023年

這是系列作品的第二作。被夜晚吞噬的少女，在一個難以區分夢幻與現實的世界中，突然被人牽著手。那是救贖之手，還是其他呢？具有漂浮感的結構令人印象深刻的一件作品。

This is the second work in the series. Swallowed by the night, the girl is suddenly withdrawn by someone in a world where she can't tell whether it's dream or reality. Is that a saving grace? The floaty composition is impressive.

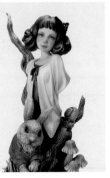

04 The Garden
205mm 2018年

最初的計劃只是一個少女半身像模型，但隨著製作進展，逐漸添加各種元素。看似華麗，但同時帶有奇異感，有如童話一般的氛圍令人著迷。

He initially planned for only bust model of a girl, but as the production progressed, various elements were added. At first glance, it looks fancy, but at the same time, it has an eerie, fairytale feel to it.

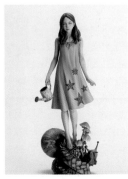

05 The Garden ~Awakening~
270mm 2020年

將The Garden的世界觀以更清晰的形象製作而成的作品。一位少女在一個充滿奇異生物的世界中清醒過來。她手裡拿著的澆水壺用途為何？她自己的目的地又是什麼？一切都從這裡開始。

Made with worldview of "The Garden"to further define the image. A girl wakes up in a world of strange creatures. This is where her journey to find her purpose and use of the watering can begin.

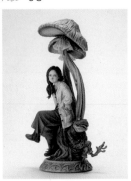

06 The Garden ～Take your time～
290mm 2021年

The Garden系列的續篇。在旅途中，少女突然被雨所困。少女心情不開心的表情，和一派輕鬆的青蛙形成鮮明對比。這部作品受到廣泛歡迎，由豆魚雷以完成品的形式推出商品化販售。

Sequel to" The Garden" series. A girl is stranded by sudden rain during her journey . The girl's grumpy expression contrasts sharply with Mr. Frog's literally nonchalant attitude.

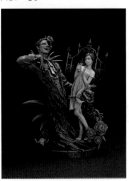

07 The Garden ～Rose of Passion～
250mm 2023年

The Garden系列的最新作。少女在旅途中遇到玫瑰花園。玫瑰都無精打采，當她用水壺澆水時，玫瑰迅速恢復活力，最終轉變成一位紳士。於是，心滿意足的紳士堅持以歌聲向她致謝，但是……

The latest work of the series. A visit to the Rose Garden during her journey. The roses were listless, but when she watered them with her watering can, they quickly regained their vitality, and soon the roses transformed into the appearance of gentlemen. The satisfied gentleman wants to send her a song in return.....

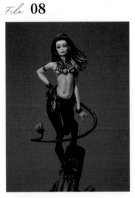

08 DUEL
340mm 2019年

這件作品結合了當時「想嘗試製作的」元素為基礎，包括野獸的腳，雷鬼頭和柔韌的尾巴。事實上，她是一隻巨大的人面獅身史芬克斯（Sphinx），受到狄浦斯謎語場景的啟發製作而成。

With its animal legs, dreadlocks, and supple tail, this work was solidified with his desire to make it with all the elements he wants to put in one work at the time. She is actually a giant sphinx, produced in the image of the riddle to Oedipus scene.

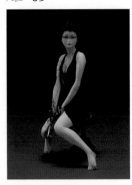

09 黑色禮服與裁縫剪刀
160mm 2013年

這件作品是為了追求奇異的氛圍而製作的。雖然是早期的作品，但值得注意的是，本作中已經展現了藤本獨有的風格和身形線條。那獨特而富有個性的面容也顯得相當迷人。

Aimed to create a bizarre atmosphere. Although this is an early work, it already depicts the style and body lines typical of Fujimoto's work.The somewhat peculiar and unique facial feature is also attractive.

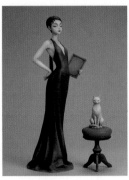

10 貓咪與鋼琴家
260mm 2022年

這件作品擁有簡單且如陶器般美麗的特質。從女性的姿態中可以感受到藝術家那堂皇而自信的風采。一旁坐著表情幽默的貓咪，更加突顯了女性冷靜的表情。

The work is simple yet have the beauty of pottery. The woman's appearance exudes an imposing, artist-like confidence.The humorous cat sitting beside her further enhances the cool expression on the woman's face.

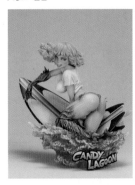

11 Candy Lagoon
190mm 2019年

一位開朗親切又可愛的半魚人女孩，她現在正處於熱情洋溢地攻擊衝浪者的時期。構圖和空間結構都極為講究，包括衝浪板的佈局方式等都有精心安排。

A pop and cute girl mermaid, she is in the midst of a vigorous assault on surfers right now. Composition and spatial structure are carefully selected, including the placement of the surfboard.

File **12**

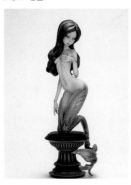

12　魅伊
300mm　2017年

這是導入ZBrush後的第一件作品。設計的重點在於強調身體線條和外形輪廓的美感。在製作下半身時，特意避免使用特微過於明顯的鱗片細節，呈現出一個獨特的美人魚形象。

The first work after the introduction of Zbrush. It focuses on the beauty of the body line and silhouette. Unique mermaid figure is depicted, such as finishing the lower half of the body without using obvious fish scale details.

File **13**

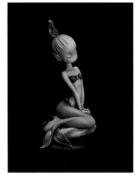

13　Embrace the Pain
180mm　2022年

最初的設計是獸足妖精，但在原田的建議下改為製作成美人魚。以少量元素營造敘事性。雖然造形簡單，但姿勢、坐姿和身體線條都融入了藤本作品獨有的特色。

At first, it was a theropod fairy, but on the advice of Mr. Harada, he decided to make it as a mermaid. A small number of elements are used to create a story. Although the modeling is simple, the posture, sitting posture, and body lines incorporate characteristics unique to Fujimoto's work.

File **14**

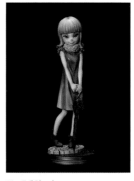

14　Evil Blood
180mm　2019年

在雨停後，回頭一看，一個小女孩的身影就在那裡。一個以蝙蝠傘為魅力所在的吸血鬼。迷人的表情和令人看了心疼的頸部咬痕形成鮮明對比，令人印象深刻且引人注目。

After the rain, I looked back and saw a little girl.... She is a vampire with a charming umbrella. The contrast between her charming expression and the painful bite marks on his neck is striking and eye-catching.

File **15**

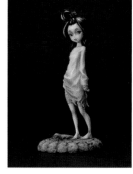

15　Little Bride
175mm　2014年

靈感來自於「科學怪人法蘭克斯坦的新娘」。不是採用動畫風格，而是以木偶動畫人偶的氛圍為目標進行製作。頸部為可動式，能夠讓表情呈現一些變化。

The motif is "Bride of Frankenstein". This work was created to have the feel of a puppet animation doll, rather than a cartoonish or approach.

File **16**

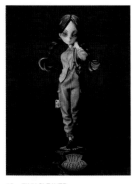

16　TINY CLEAVER
195mm　2018年

與Little Bride相同設計概念的系列作品。頸部同樣可以活動。作品的標題中「Cleaver」指的是切肉刀。少女手中的切肉刀，究竟是用來做什麼呢？

A part of the series which based on the same concept as "Little Bride." The neck is also movable. What exactly is a cleaver in a girl's hand used for?

File **17**

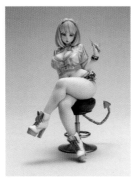

17　Trick or Treat
190mm　2021年

Katie Moon（凱蒂‧穆恩）系列的第二彈。豐滿的體態與鮮豔的色彩使得角色極具衝擊力。這件作品也廣受歡迎，由KOTOBUKIYA以完成品的狀態販售商品。

The second work of the Katie Moon series. The glamorous style and vivid colors of this work have a very strong impact. This work also gained popularity and has been commercialized as an assembled figure by Kotobukiya.

File **18**

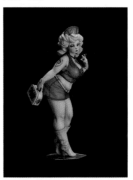

18　Playful Nurse
230mm　2022年

Katie Moon（凱蒂‧穆恩）系列，這次是護士裝。臉部有普通造型和口罩造型兩種，視線的角度各不相同，藉由改變視線，可以享受兩種不同拍攝角度的樂趣。

One of the Katie Moon series works. Dressed in the nurse costume. The face comes in two types: a normal face and a masked face, and by changing her line of sight, the viewer can enjoy two different posing angles.

File **19**

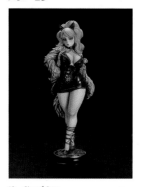

19　City of Cats
245mm　2020年

Katie Moon（凱蒂‧穆恩）系列的第一彈。打扮成貓咪的凱蒂實際上是一位角色扮演者。在設計時有意識地將服裝設計成能夠實際製作的款式，這也是本系列的設計概念之一。

This is the first work of the Katie Moon series. Katie, dressed as a cat, is actually a cosplayer. The costume is consciously designed so that it can actually be made. This is also the concept behind this series.

File **20**

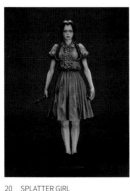

20　SPLATTER GIRL
260mm　2012年

原創人物模型的首件作品。其流露著憤怒眼神的作品，雖然是處女作，卻散發著異彩。這次刊載的是時隔10年的重新上色版。重新接觸當年的作品，讓藤本再次感受到某些不應該被遺忘的事物。

The first original figure. The angry eyes are unique even though this is his first work. This time, he repainted it for the first time in 10 years. By coming into contact with the work from that time, he felt something that should not be forgotten.

File **21**

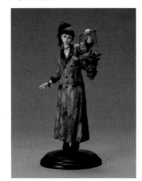

21　見習女巫
215mm　2013年

以正在見習中的女巫學員形象為目標，主要使用Super Sculpey樹脂黏土進行造形。這件作品被選為豆魚雷的Amazing Artist Collection系列的第3彈，並且以完成品的狀態限量販售。

She was sculpted mainly with the Sculpey with the image of an Apprentice Witch student. This work was selected for the third product of Mamegyorai's Amazing Artists Collection, with a limited number of finished pieces available for sale.

File **22**

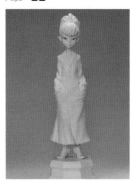

22　見習女巫~maquette~
390mm　2022年

為了明確化藤本自己很喜愛的見習女巫形象，特地製作成一個大尺寸的初模原型（在美術用語中指的是雛形）。純白單色的塗裝營造出更豐厚的立體感，給人留下新鮮印象的作品。

In order to clarify the image of Apprentice Witch, it was produced as a large-sized maquette.This is a work with a fresh impression where the solid white coloring creates a more three-dimensional feel.

File **23**

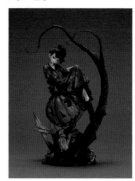

23　見習女巫~THEGREAT PUMPKIN~
250mm　2017年

得意洋洋的見習女巫操控著自己創造出來的南瓜大王。然而，南瓜大王卻變得狂暴無法控制……。這是一件以Vignette插畫場景風格完成的大作，也是以手雕造形的最後一件作品。

She look so proud to control the Great Pumpkin , which she created herself. But then, The Great Pumpkin is getting out of controll..... It is a large work finished in the style of a vignette, and is also the last analog modeling work.

B
L
I
N
K

BLINK
藤本圭紀原創人物模型作品集

YOSHIKI FUJIMOTO
ORIGINAL FIGURE WORKS

作　　者　藤本圭紀

翻　　譯　楊哲群

發　　行　陳偉祥

出　　版　北星圖書事業股份有限公司

地　　址　234 新北市永和區中正路 462 號 B1

電　　話　886-2-29229000

傳　　真　886-2-29229041

網　　址　www.nsbooks.com.tw

E–MAIL　nsbook@nsbooks.com.tw

劃撥帳戶　北星文化事業有限公司

劃撥帳號　50042987

製版印刷　皇甫彩藝印刷股份有限公司

出 版 日　2024 年 06 月

【印刷版】

I S B N　978-626-7409-64-0

定　　價　新台幣 700 元

BLINK FUJIMOTO YOSHIKI ORIGINAL FIGURE SAKUHINSHU
© YOSHIKI FUJIMOTO 2023
Originally published in Japan in 2023 by DAINIPPON KAIGA CO., LTD.,
TOKYO.
Traditional Chinese Characters translation rights arranged with
DAINIPPON KAIGA CO., LTD., TOKYO, through TOHAN CORPORATION,
TOKYO and KEIO CULTURAL ENTERPRISE CO., LTD., NEW TAIPEI CITY.
Printed in Taiwan

國家圖書館出版品預行編目資料

BLINK藤本圭紀原創人物模型作品集 = Yoshiki
Fujimoto original figure works /
藤本圭紀作；楊哲群翻譯. --
新北市 : 北星圖書事業股份有限公司, 2024.06
144面；21×29.7公分
ISBN 978-626-7409-64-0(精裝)
1.CST: 模型 2.CST: 工藝美術 3.CST: 作品集
999　　　　　　　　　　　113004600

SPECIAL
THANKS

伊藤潤二
インタニヤ
KEN U
村上昇平
原田 隼
ほっぺふき子
Rockin'Jelly Bean
豆魚雷
もやし
矢竹剛教

| 臉書官網 | 北星官網 |

| LINE | 蝦皮商城 |